PRINTMAKING
AT THE EDGE

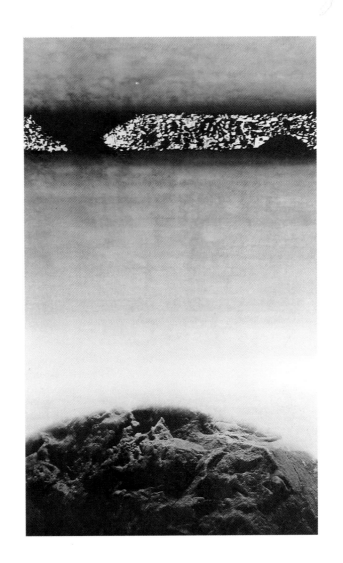

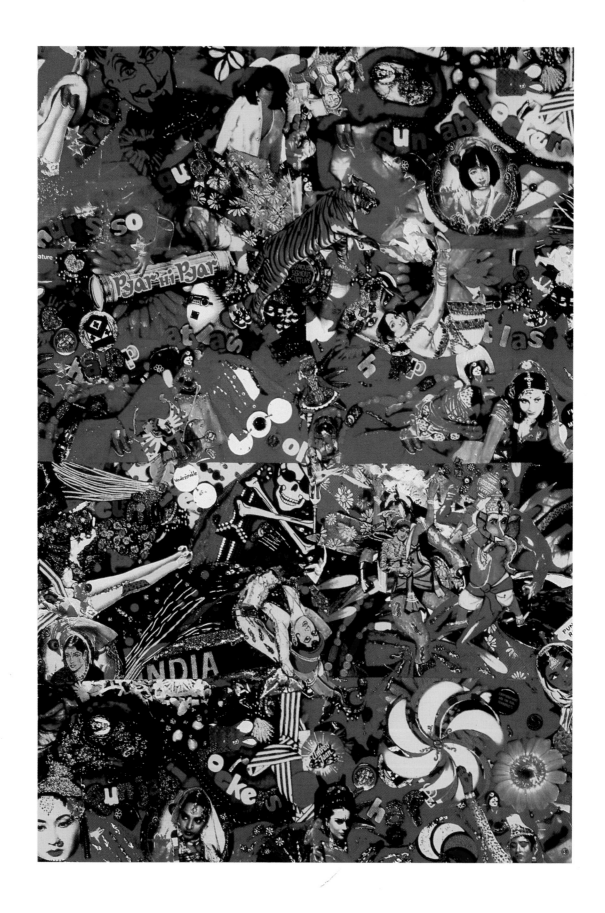

PRINTMAKING AT THE EDGE

Richard Noyce

A & C Black
London

First published in Great Britain in 2006
A & C Black Publishers Limited
38 Soho Square
London W1D 3HB
www.acblack.com

ISBN-10: 0-7136-6784-2
ISBN-13: 978-0-7136-6784-4

CIP Catalogue records for this book are available from the British Library and the U.S. Library of Congress.

Book design by Susan McIntyre
Cover design by Peter Bailey
Copyedited by Julian Beecroft
Proofread by Paige Weber
Project Manager: Susan Kelly
Editorial Assistant: Sophie Page

Printed and bound in China by C&C Offset Printing Co., Ltd.

A & C Black uses paper produced with elemental chlorine-free pulp, harvested from managed sustainable forests.

TITLE PAGE Michael Schneider *Rekonstrukt Lithographie II*
Woodblock print with polymer intaglio, black Indian ink and printing ink on Japanese paper; 84 x 51 cm (33 x 20 in.); 2003

FRONTISPIECE Chila Kumari Burman *Punjabi Rockers*
Ink-jet print and collage; 118.8 x 84.4 cm
(3 ft. 11¾ in. x 2 ft. 9¼ in.); 2003

CONTENTS

ACKNOWLEDGEMENTS

THIS BOOK IS THE RESULT of a long process of researching, collecting images and writing between February 2003 and January 2005. During these two years I received a great deal of assistance from a large number of people in countries around the world; without them the task would not only have been more complex but also a great deal less pleasurable.

The artists included in the book deserve my thanks for their willing cooperation and the information they provided, not only on their work but on the work of colleagues. Professor Witold Skulicz and his colleagues at SMTG, Krakow, have continued to widen my horizons, and I thank them for this gift. Mare Pedanik at Tallinn Print Triennial gave me valuable information on new directions at the fringes of printmaking. Dr Arūnas Gelūnas in Vilnius provided a unique link with artists in Lithuania, for which my thanks. I am pleased to acknowledge the assistance of Natalia Kossolapova of the M'ARS Association, Moscow, in gaining a considerable amount of information on the work of Konstantin Khudyakov.

Laura Berman and Hugh Merrill in Kansas City, Missouri and Davida Kidd, Maria Anna Parolin and Wayne Eastcott in Vancouver, BC made me welcome in their cities and assisted me greatly as guides, providing links to their printmaking communities. Ted Lederer, Director of the Elliott Louis Gallery, Vancouver, BC, provided me with introductions to artists and an insight into the art world in that city.

Susan Kelly and Michelle Tiernan, and their colleagues at A&C Black, London, have worked hard to make this book possible, and deserve my gratitude. I would also like to thank Rosemary Simmons, for pointing the way.

Finally, I cannot refrain from thanking those who first developed and those who now maintain the Internet, without which much of the work on this book would have been impossible. But, above all, I thank my wife Fiona for her good-humoured support and advice and for sharing the adventure of making this book.

1. THE EDGE

BEGINNINGS

TOWARDS THE EDGES OF ANCIENT MAPS can sometimes be seen the legend, 'Here be dragons'. The fear of the unknown leads to the sleep of unreason that brings forth monsters. We are warned not to go too close to the edge of the cliff – or precipice, or sudden drop – lest we fall. The wary keep to the inside edge of a footway, close to the security of buildings; the moderately brave walk in the centre of the footway; only the wild and reckless venture to walk along the edge nearest the roadway. Travellers in strange places are advised when walking at night through the darker parts of a city to keep to the centre of the road, avoiding the shadows at the edge, where dangers may lurk. It seems that we spend much of our lives avoiding edges, or otherwise risking all in challenging them. Stepping off the edge of a precipice into the unknown will result in one of two possibilities, either falling or flying – it is all a matter of faith. The making of art is a bit like that.

Ken Kesey and the Merry Pranksters travelled around the West Coast of America in the late 1960s in a converted and psychedelically painted school bus, spreading the message of the hippie generation. On the destination board of the bus was just one word, 'FURTHER', and one of the signs they displayed at the notorious 'Acid Tests' read, 'Hail to All Edges'.

In his autobiography *Ways of Escape* Graham Greene quotes a line, 'Our interest's on the dangerous edge of things', taken from a poem by Robert Browning, 'Bishop Blougram's Apology', written in 1855. The relevant stanza reads:

> Our interest's on the dangerous edge of things
> The honest thief, the tender murderer,
> The superstitious atheist, demirep
> That loves and saves her soul in new French books.

'Demirep' is a word not used much these days; it means, according to the 1913 *Webster's Dictionary*, 'a woman of doubtful reputation or suspected character; an adventuress'. It may not be stretching a point to suggest that this definition, or the quotation above, sums up the role of the artist in contemporary life.

A geometric shape or form is defined by its edges, where a line or plane changes direction in a precise manner. However, we can also get away with ideas such as 'the edge of the forest' or 'the river's edge', when in fact those edges are anything but precisely defined. When applied to the arts the notion of the edge becomes even more vague. The edge, the avant-garde, cannot be reliably defined, because it exists in a world that transcends national boundaries as well as the normal conception of what art is. This book attempts to identify and describe ideas and works that in their originality move that imaginary edge a little bit 'FURTHER'. During its research, writing and production, of course, the edge has moved on. The book is therefore one man's view of the world of printmaking in early 2005. By the time it is published it will have already become history.

A TRAVEL ANECDOTE

I am in one of the noisy and crowded terminal buildings at O'Hare Airport in Chicago. It is my first visit to North America and I have watched the world change beneath the aircraft's wings on the flight from London, from the green fields of springtime England to the endless grey ocean, from the frozen immensity of northern Canada to grey-green fields with straight black highways and lingering traces of snow to the northern lake shoreline still trapped in ice, and onwards to the open water of Lake Michigan with Chicago rising in a cluster of distant sunlit towers.

Because I am still in transit I am not yet officially in the United States, but I have walked on American concrete from one terminal to another, through a neon-artwork tunnel and a cacophony of consumerism, to wait at the crowded departure gate for my connecting flight. There is an announcement, informing passengers that the flight has been delayed because (and, unbelievably, these are the exact words) 'the plane is broken'. The waiting passengers laugh nervously and shuffle about, expecting further information. Eventually we are directed to another gate at the opposite end of the terminal, and we walk there in a straggling procession of travellers and baggage. I stand waiting with them at the newly assigned gate, between a small group of high-ranking Salvation Army members, busily consulting their shiny, tiny PDAs and mobile phones, and a noisy group of teenagers belonging to a high-school choir, returning from a singing tour of Europe. The boys suddenly break into an a cappella version of 'Silhouettes on the Shade' in finely balanced harmonies. They are applauded by everyone except the Salvationists. Finally the passengers are allowed aboard the aircraft and it takes off. I look around the worn and somewhat scruffy cabin. It strikes me that this seems like a commuter flight, and in fact it seems that some of the passengers are indeed commuters on their way home after work. I think about that song and how I last heard it many years ago, when I was around the same age as the young men who have just given it such a lusty rendition. The plane lands at sunset, with a golden glow beneath the dark clouds threatening rain over the flatlands. I enter the United States and wait to be met in the almost empty terminal. I have arrived rather later than expected in Kansas City, close to the geographical centre of the country, to look for some evidence of what is happening at the edge.

Later I am told that Kansas City is on the edge of the Missouri River, and at the edge of the Western Plains, near to the place that Lewis and Clark reached on 26th June 1804 on their epic journey west to discover the unknown. In the almost two centuries between their journey and mine the nature of the unknown, and the edge beyond which it may be found, has changed: the world is a smaller and perhaps even stranger place than the one Lewis and Clark encountered or could ever have imagined.

TOWARDS DEFINITION

The edge can be a literal place, a geographical edge, or it can be a conceptual place, the melting point of imagination and technique. In either case the character of those places will contribute to the range of influences that helps to shape the art that is produced there. Exploring the notion of the edge in search of some of the current limits that the arts of printmaking have reached is to venture towards the unknown. As with the exploration of the physical world, such an exploration is not without its dangers: the risk of misunderstanding my direction and losing my way is a very real one.

It is said that a disciple once asked Buddha, 'Master, are you the way?', to which the reply was given, 'No, I am the finger pointing the way'. One summer in the South of France I came upon a painted sign at the edge of a forest, not far from the places Cézanne had painted a century earlier, which read, 'Sentier Perdu' (literally 'Lost Path'). The narrow winding path could be clearly seen, and led through dusty trees full of the sound of cicadas to come suddenly upon a deep rocky cleft in the earth, with a dry stream bed and the littered evidence of winter storms. It was a dislocating moment in the dry heat of the Midi, and returning by the same lost path to the car park at the edge of the forest felt like moving through a changed world. The biologist J.B.S. Haldane once remarked, 'The universe is not only queerer than we

suppose, it is queerer than we can suppose'. This remark is certainly true when applied to the world of contemporary art. It is certain that the conceptual dangers artists will face in the future, as well as those that they face at the present time, will offer unforeseeable challenges not only to the development of techniques but also to the possibilities of ideas. The success of artists and their work will depend on, among other factors, their ability to negotiate their way up to and beyond the edge.

In the chapter 'Loners or "Anything Goes"?' in his book *Contemporary Art* (Taschen, 1992), Klaus Honnef writes:

> Art history has always known artists who refused to be pigeon-holed in any of the great styles, from Hieronymous Bosch and Francisco de Goya to Édouard Manet and Francis Bacon. With regard to artistic quality it is irrelevant whether an artist has had a decisive influence on the development of mainstream art or whether his art combines an equal amount of old and new, of traditional and innovative elements. To the extent, however, that art is becoming more and more subject to the dictates of fashion, there is also an increasing tendency among artists to reclaim for themselves the position of lone wolves.

While some artists do undoubtedly claim the position of lone wolves, others take such roles as hierophant, shaman, standard-bearer, prophet, protester, cynic, philosopher, iconoclast, politician, agitator, or teacher. Some take on a mixture of roles, or adopt different roles at different times and in response to changing imperatives. Some are innovators, seeking out new ways of working and the development of new relationships between ideas, materials and audiences; others are keepers of craft traditions and guard jealously the techniques which have served artists so well in the past and which they consider worthy of conservation. This plurality is wholly healthy and is certainly to be nurtured, because the making of art is about the search for possibilities. However, if the work of an artist is to have strength and resilience in the face of the torrential output of visual information of all kinds that is one of the characteristics of the increasingly globalised world of art, then it has to be derived from a strong philosophical foundation, lest it become mere repetition, pastiche, or at worst a shallow homage, ill-perceived and incompletely understood, to another artist or artwork.

Stanisław Fijałkowski is a highly respected senior member of the international printmaking community and has worked in printmaking, painting and drawing for many years from a small and immaculate studio at the top of an apartment block in the industrial city of Łódź in central Poland. On first visiting his studio in 1986 I was struck by the sense of order and by the fundamental calmness of his working place, qualities that were manifest also in the work he showed me. He told me on that occasion that much of his quiet and meditative work is influenced by his study of the Talmud, while relating when necessary to the times through which he has lived. In his essay 'Some Timid Remarks on Transcendency' (in *Sightlines*, edited by Walter Jule, University of Alberta Press, 1997) Fijałkowski writes, 'Creation is not merely something which happens by chance but a conscious act aimed at strengthening order, of placing sense against senselessness and harmony against chaos.' And, 'The original creation encourages progress and sustains the material and spiritual equilibrium of the cosmos, or at least the small part of it for which we are responsible. It would seem that art is one of the sources of energy which prevents the world from sinking into darkness and bestiality. Through art we are able to see beyond appearances and imitation. Freed from rubbish and untruth, we can move to a level of dignity and ethics – in effect, transcend.' These quotations have a powerful relevance to all those who wish seriously to make art (and stand in direct opposition to the cynically commercial stance of some artist-superstars), touching directly on the need for art to relate to as many people, and on as many levels, as possible.

THE SHIFTING EDGE

To operate at the edge requires the acceptance of risk, particularly the risk of failure. The artistic sensibility is generally well adapted to accepting that risk, but in this century such acceptance will require a closer engagement with the world at large than that experienced by the bohemian artist in the mythical garret. More in these troubled days than at any other time in history the work of artists, if it is to have any relevance beyond the satisfaction of immediate sensations, should be enmeshed in the widest possible knowledge of what is going on in the world. The frescos in ancient churches, and later the stained-glass windows, told moral tales from the Bible for the edification of a largely illiterate population. There are parallels to this function of the visual arts in many other historical cultures, and in all of them the knowledge of the learned few was transmitted in symbolic form to others in the community, and became part of the system of power and social domination that prevailed. We live in times that are very different and, while there are still some artists who accept commissions that oblige them to fulfil much the same role as artists of the distant past, most artists choose to work in very different ways. The responsibility of artists has changed from being the (often anonymous) agents of the ruling class to being the critical opponent, or at best the critical friend, of the establishment's power and influence.

The changes in emphasis have not been sudden, or exclusively recent. Visionaries and iconoclasts have pointed the way in their writings and comments for many years. Tristan Tzara, in his 'Lecture on Dada' (given in 1922) said, 'Art is not the most precious manifestation of life. Art has not the celestial and universal value that people like to attribute to it. Life is far more interesting.' And in an excerpt taken from 'Some very individual points/valid on 8th June 1965, 17.00 hrs', quoted by A. Alvarez in the introduction to Miroslav Holub's *Selected Poems* (Penguin, London, 1967), the Czech clinical pathologist and poet Miroslav Holub wrote:

> Art has to be the product of a complete personality aware of all information and assumptions valid for the citizen of the modern world. Superstitious exclusion of science from arts and humanities does not preserve creativity; it preserves only old approaches and old reactions, which become more and more confused in the modern world.

Bruce Lacey has consistently pushed out the boundaries of what the visual arts can contain and should strive to achieve. In a statement published in the bulletin of the Institute of Contemporary Arts (London, August–September 1967) he wrote:

> The future of man will be determined by the amount of success he achieves in adapting psychologically to the machines and devices he has created, to enable him to adapt physically to his environment. One problem man experiences is that of time-lag in understanding the significance of what he has invented; others are of feed-back from the invention to man (to influence his behaviour to his fellow-man) and the use of an invention sometimes in a manner unforeseen at the birth of the invention.

Jean-Jacques Lebel, the French creator of vast happenings in the 1960s, said, 'In societies where thought-control is common, where human instincts, impulses and general activities are industrialised on a grand scale, we can no longer be satisfied with "ART" unless it helps to expand Man's consciousness' (taken from an interview with Lebel in *Icteric 2*, Newcastle-upon-Tyne, June 1967). Marshall McLuhan wrote in his very influential *The Medium is the Massage* (Penguin, London, 1967), 'There is absolutely no inevitability as long as there is a willingness to contemplate what is happening'. All these statements were very definitely made at the edge, and well before the emergence of computer technology on a widespread and domestic scale. Despite the passing of four decades they still resound at the edge that we have now reached.

EDGES NOT EDGE

The nature of the edge is impossible to define, for it will take on a different form for each person who cares to explore it, and is in any case subject to individual perception and interpretation. This book seeks to explore one view of some of the edges – for there is more than one – that contemporary art, and in particular contemporary printmaking, has reached at this stage in our history. In exploring that edge there will be references to social and environmental politics, to the nature of the human figure and its part in the making of art, to the role of history and its interpretation, and to the parts that technology and the Internet play in the dissemination of art and ideas about art. The role of the edge in the international scale of exchanges between artists and printmaking facilities will be explored, as will the innovative and challenging developments in techniques. The edge will also feature in a consideration of spirituality in contemporary art, as will the constant need to be moving ever onwards, pushing out the barriers that keep us away from the edge. These explorations will not follow the tried and tested route, and might well prove controversial; but that will be fine, because any art (or for that matter any describing of art) that does not take risks is still clinging to the shadows on the inside edge of the footpath.

At this stage of the writing of the book the destination is still not clear to me, and the edge has still not been reached. However, I can be fairly certain that the exploration will be predicated on many factors, and the following quotation, taken from 'The Texture of Memory: Historical Process and Contemporary Art', by Rayna Green (in *Contemporary Art and Multicultural Education*, edited by Susan Cahan and Zoya Kocur, New Museum of Contemporary Art, New York, 1996), hints at one of them:

> No matter how much historians say that history is simply the process of observing objective reality, in fact it is a process of observing and documenting all sorts of realities, none of which are ever wholly objective. They are the collective reflections of people who are in the middle of the experience. Art lives to let us have different versions of vision and imagination, different versions of who we are, where we come from, where we are going, and what might be.

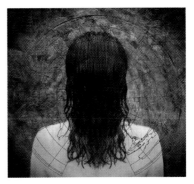

Alicia Candiani, *Orphan Glances (Triptych) (from: Conquest series)* Digital print on Arches paper mounted on wood with relief processes; 64 x 210 cm (2 ft 1¼ in. x 6ft 10¾ in.); 2004

2. CONTEMPORARY ART

EDUCATION, ENLIGHTENMENT AND ENTERTAINMENT

CONTEMPORARY ART presents a problem in that there is so much of it. The continuing enthusiasm of amateur artists is symptomatic of a genuine level of interest in the pursuit of the visual arts as a leisure activity. The number of practising artists who make some or all of their living from the visual arts does not decrease, and many derive some part of their income from work with community projects: this too is to be welcomed. Art education – in British schools at least – is rarely afforded as high a place within the curriculum as it deserves, but there are isolated examples of excellent practice that deserve to be emulated. Institutes of higher art education continue to offer an increasingly bewildering range of courses, linking art to itself as well as to industry, technology and a vast range of subjects in the humanities. It continues to be a sad fact that too few institutions base their courses on a sound understanding of the skills of drawing as a means of making the connection between what is perceived through the eye, processed by the brain, and transmitted to the paper by means of the acquisition of hard-learned hand skills. That is another matter, but one that does impinge on the making of all manner of visual arts objects, and also on the ways in which they are perceived.

While art-education institutions do as much as they choose (or are able) to do in advancing the cause of developing a deeper understanding of the visual arts, it is in the number of art galleries and museums that the biggest growth in activity can be seen. The range of smaller publicly funded galleries in urban centres continues to grow, with the opening of more high-quality venues capable of showing the best among the work of contemporary and historic artists. But this growth in the promotion of interest has gained an even higher profile with the opening of each new mega-gallery, such as Tate Modern in London or Baltic in Gateshead; the unveiling of both venues attracted the kind of attention to the museums and their architects that is usually reserved for stars of the entertainment world. Private individuals, companies (and some of the more adventurous local authorities) vie with each other to fund and create the most innovative and challenging temples of art, and in some of these hallowed halls there is a risk that the building will dominate the art it is intended to contain and serve. Successful major galleries can give a welcome boost to the regeneration of the areas in which they are situated, and are seen by many as a positive force for community development. As a consequence the number of major exhibitions grows as these galleries thrive, with spin-off benefits in the form of educational and social-outreach projects. That such initiatives increase the knowledge and enjoyment of contemporary art is doubtless true.

THE SEE-AND-BE-SEEN SCENE

On the other hand major exhibition openings have become, more than ever, social events, places in which to see and be seen, venues for gatherings of the glitterati. There is a risk that at such events paintings are merely a fleetingly seen background to animated conversation, sculpture is stumbled over on the way to the bar, and installations present little more than a distraction from the social intercourse of opening celebrations. While the social aspect of such events acts somewhat against the possibility of people actually experiencing the art in any deep sense, nevertheless these functions do serve as a means of widening the acceptability of the visual arts as a part of our social landscape. But, in the end, however well they perform the role of engendering publicity for the gallery or the work of

the artist, exhibition openings are bad places in which to try to see art and have the chance to think about what it offers.

It sometimes seems as if contemporary art has joined the world of entertainment, with all its glitz and its opportunities for ephemeral fame, and at the same time the cult of the artist as celebrity has grown. Television programmes on art, complete with lavish elements of location filming, dramatic recreation and flashy special effects, presented by critics – or dubiously in one British pop-television series by an Australian singer and entertainer – have attained a prominent place in the schedules. Too often it seems as if the makers of art programmes are more concerned with spreading the appeal of such programmes as widely as possible and too little concerned with conveying something of the depth of the work that is shown and described. The lowest-common-denominator effect seems to be placing an ever-greater pressure on the imperatives faced by the television channels in an increasingly competitive ratings 'fish-tank', and one cannot but wonder how long it will be before a group of artists is coerced into appearing in a reality-TV show. It is not hard to envisage the volunteer (or selected) artists, locked up in a studio with 24-hour television surveillance, being challenged to produce works of art to be judged by the viewing public, with one artist being voted off each week until the winner remains to claim a dubious prize. Such a vision is hardly enlightening, and it is to be hoped that such a programme never reaches the programme schedules. As it is, the televising of the Turner Prize awards ceremony achieves little except to increase the confusion of many who watch it and offer the chance for a moment of *schadenfreude* when the winner is announced. The betting shops run a brisk sideline to horseracing and football by setting the odds on the short-listed artists, and for some art lovers a flutter on the results serves to raise the adrenalin levels in the weeks before the announcement dinner and ceremony. Tabloid newspapers the following day will inevitably decry the result, heaping vitriol and scorn on the unfortunate artists selected to share the £40,000 prize-money for work that the vast majority of the public simply doesn't comprehend and certainly wouldn't want to own. It can be argued that events such as the Turner Prize do little to enhance the credibility or understanding of the contemporary visual arts in Britain.

The result of all these factors is that art is perceived increasingly as a commodity, a fashion item to be bought and sold, to be taken up and put down, hyped to the limit one moment, dumped in the charity shop the next.

LESSONS FROM HISTORY

This malaise, if that is indeed what afflicts the contemporary art scene, is no less reflective of the society in which it exists than the condition of the art scene of any other time or place in history. The drawings and paintings of Leonardo da Vinci speak to us of Renaissance Italy as clearly as do the bronze portrait heads created by unknown artists in Benin, West Africa at around the same time of their society. Both forms were dependent on the patronage of rich rulers and also the latest available technology. The differences between these two and, say, the Ukiyo-e prints of Japan, or the ceramics of the Hopi in North America, or the many other disparate styles and forms in world art, are those that distinguish the cultures from which they sprang. The study of art history therefore widens to become the study of the development of human society.

Art history, presented in a comprehensive and sensitive manner, can assist cross-cultural understanding in our society, breaking down artificial cultural barriers. However, if art history is seen primarily as an academic classification of artistic development rather than the discipline of studying art as just one part of the evidence of the changing conditions of life and society, then it becomes a dry and self-referential subject with little meaning to those outside its narrow realm and largely irrelevant to any but a mutual-admiration society of narrow-minded academics. If evidence is required of what this can mean a cursory examination of some academic art magazines and books will reveal a version of the English language that confuses many readers rather than enlightens them, the rarefied chatter of a coterie of self-elected experts.

A cynic could be forgiven for dismissing the contemporary art scene as being irrelevant in anything but an ephemeral sense. Any of the genuine benefits that art can and should afford us, such as its redemptive value or its capacity as an agent of social change, would from the cynical point of view seem to be little in evidence. However, art has long had a central position in society, moving from being a tool of shamanism in ancient societies to being the ultimate manifestation of wealth in the age of patronage by Church or State, to being the vehicle for social comment and humanist protest in the 19th century; and so into the 20th century, in the age of modernism and afterwards, in which it became enmeshed in the cacophony of interpretations, the expression of social pride and angst, the conflict between the forces of order and unreason. In the increasingly global society developing in the 21st century, where traditional values are threatened from all sides by multinational exploitation, excessive consumption, environmental despoliation, opportunistic politics and commodified spirituality, the role of the artist has shifted once more. With this shift has come the need for a re-evaluation of the role and importance of art within society. What is certain is that there is little room for art to develop unless artists and galleries accept the need for a process of re-engagement with the roots of what art is and its functions in relating to other people.

TELEVISION, THE INTERNET AND THE GLOBAL BRAND

Central to developments in the visual arts in recent years has been the exponential growth in the communication media. Satellite television, with its ability to transmit instant live coverage of news – coupled with an ability to diffuse the cultural hegemony of the television companies and programme makers – has effectively shrunk distances and rendered international borders less relevant. At the same time it has enabled a new and far-reaching cultural imperialism and has become an unprecedented vehicle for propaganda. If witness to this is required, a recollection of the nightly battles between CNN and Al Jazeera at the time of the 2003 Iraq conflict should suffice to illustrate the point.

The aggressive expansion of the pop-music industry, carried along by the powerful influence of MTV, has spread musical styles across the planet so that, for example, the rap music that originated in African-American street culture can now be heard in a wide range of languages around the world – for example, the rap singers joining in the protests against the Ukrainian election results in November 2004. Of equal influence on a global scale has been the growing availability of the music of a wide range of cultures, leading to a wealth of influences and cross-fertilisations that has given the creation of new music a powerful potential for touching the lives of millions in a way that Bach might well have considered impossible. The visual arts, in particular the digital arts, have been integral to the MTV revolution, which has employed cutting-edge technologies and mediums. As at so many times in the past the symbiotic relationship between the process of imagining a work of art and the technology that is available for its realisation has resulted in a continually increasing pace of development, resulting in new technologies that in their turn enable ever wilder and more adventurous imagery and realisation. The same manifestation and development of creative visual imagery is found in computer- and console-game software, in which increasingly lifelike virtual worlds are constructed through which the player can move and interact in a four-dimensional matrix. It is a wholly different issue, though one that is equally reflective of the times in which we live, that many of these games are predicated on essentially bloodthirsty and violent themes, success being dependent on killing as many as possible of the characters in the game, rather than solving conundrums or developing strategies.

Of even greater significance has been the extraordinary growth of the Internet, with its ability to render irrelevant the boundaries of space, time, politics and nations. The easy availability on a 24-hour, year-round basis of something approaching the sum total of human knowledge offers both a major educational resource and an increasingly potent means of entertainment. The potential of the Internet as a readily accessible commercial tool has been realised through the success of now-large companies that sell books, recorded music and consumer goods, of holiday companies that deliver their product to

anyone with computer access, and of online banks that have enabled some revolutionary developments in the way in which money is handled. Online galleries and personal websites enable artists to show and sell their work in previously unimaginable ways. At the same time the Internet has become an outlet for all manner of personal visions and obsessions, not to mention the furthermost reaches of political extremism and the insidious depths of pornography. Given the extraordinarily rapid and seemingly unstoppable growth of the medium, the full spectrum of future developments would seem to be unimaginable; but there is no doubt that the wired-up world will continue to have a powerful influence on all aspects of life – including access to and publicity for the arts, and to the making of art itself.

Combined with all these factors has been the increasingly global promotion and availability of fashions in clothing, accessories and music, not to mention global brands of food and drink. It is remarkable in the light of such onslaughts that so many distinct cultural identities throughout the world have managed with reasonable success thus far to withstand total homogenisation – due in no small part to the stubborn adherence of many nations to their traditional values.

Thus it is that the arts in general and the visual arts in particular are tied to an increasingly complex pattern of influences. It is no longer (and may never truly have been) possible to study one art form in isolation from others, or from the many social, historical, political and cultural influences that affect it. Indeed, to gain a full and inclusive understanding of the arts it is essential to take the widest possible view, considering the art form in the full context of its conception and creation. To do this brings not only the fuller understanding of the work itself but also the possibility for learning much else besides, a process of enrichment that can lead to something approaching wisdom.

ANSWERS AND QUESTIONS

In the end, anyone with an interest in the visual arts must take one of two courses: either to judge a work by raw gut feeling, an instinctive sense of whether or not it appeals or could be placed comfortably within the home or workplace; or, alternatively, to become more fully educated in the complex range of social and intellectual issues that affect and are contained within the particular work, and ultimately any work of art. The first alternative can be personally satisfying in a limited sense, and can carry with it, for those who wish to acknowledge this factor, an element of gambling on future worth that can enliven the collecting of art. The second is fraught with difficulties, most of which are predicated on the notion of, 'The answer you get depends on the question you ask and the manner in which you ask it, and your understanding depends on whether or not you listen to the answer'. The concept of relationship applies in this latter course of action; that is to say, the need to view the artist and the art sympathetically so that a fuller understanding can result. This process necessarily takes time and does not lend itself to instant gratification. An artist may take weeks or months in the making of an object, in addition to which the making of the object is the result of a lifetime of experience. It was once estimated that the average time a viewer spends looking at an individual painting in a public gallery is seven seconds. If a viewer spends only a short time in front of a work, then anything more than a superficial understanding is very unlikely. Fast art is forgettable.

A very original strategy for engaging the viewer's attention and enhancing their understanding of art has been devised far from the usually accepted centres of art. The Savitsky Regional Gallery in Penza, some 560km south-east of Moscow, maintains a branch gallery with a unique approach to the showing and understanding of art. In the One Picture Gallery a programme of presentations, based on a single selected painting, was initiated in 1983. Since then the programme has developed and, according to an interview in *Museum* magazine (1986) with Valery Petrovich Sazonov, Director of the Savitsky Gallery, presentations operate in the following manner. A picture from the local collection or from a major national museum is selected for a presentation season lasting several months. The picture is hung and concealed by curtains in a comfortably furnished room with seats for around 35 people, who have to buy tickets in advance. At the beginning of each presentation, which lasts 40 minutes and is repeated

several times a day, an audio-visual programme of slides and an explanatory soundtrack is given to provide a context for the chosen work, following which the screen is raised and the curtains are opened to reveal the painting under discussion. Visitors to the One Picture Gallery can then study the painting, accompanied by specially selected music. It is, as Director Sazonov admitted, a form of theatre, but one which has engaged the attention of many people and has widened their appreciation of both the way in which art is made and its deeper relevance. Despite all the changes in Russia since 1983 the One Picture Gallery is still functioning, and indeed features on the 2004 official website of the Penza region. It is interesting to consider how such a gallery might be received in other countries with more liberal histories, but it is probable that the audience for such a programme would be small.

The contemporary visual arts have a unique place in our world, with the potential to become even more influential in reflecting our times and in helping us to choose ways forward. The arts can be didactic, supportive of an already-held attitude, or persuasive of other, new ways of looking at the world. The arts can play an important part either in confirming our sense of the world or offering alternative ideas for interpretation and action. This range of choices is dependent on an increasing number of people encountering the work of artists. With the growing number of contemporary art spaces in many countries, such encounters are becoming more possible and the work of a wider range of artists more accessible. The increasing number of major galleries, and their success in attracting large numbers of visitors, has contributed to the fact that many painters and sculptors now engage in the making of large works that can only find their place in the public realm of museums, galleries or open spaces. By contrast, the work of many printmakers is relatively small in size, and therefore potentially suited to a more private, domestic setting. At the same time, printmaking is also developing in many innovative directions, among which are moves towards ever-larger images, the developments in print installations and the challenges of public art. The old divisions are no longer so secure and the old definitions no longer hold as true. It is becoming harder than ever to predict what might happen next. What is certain, however, is that the edge is becoming an increasingly interesting, and an increasingly risky, place.

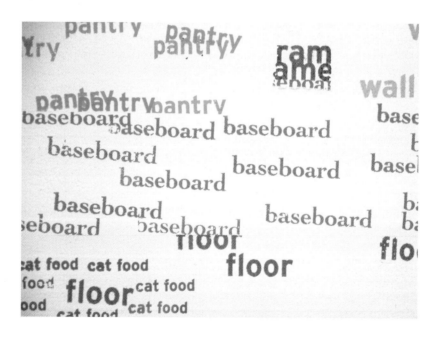

Laura Berman *I Can Make Food but I Can't Cook* Installation using silk-screen prints placed directly on walls; 458 x 916 cm (15 x 30 ft.); 2004

3. PRINTMAKING

THE DEMOCRACY OF PRINT

CONTEMPORARY PRINTMAKING presents a problem in that there is so much of it. Printmaking is the most democratic of the visual arts. From the humble potato-cut, through silk-screen prints, to the most delicate and highly skilled intaglio prints, and on to the still-new frontier of digital imaging, the means of making and distributing print images are readily available to a much greater number of artists – professional, amateur and potential – than any other single visual art form. With this accessibility comes the possibility, for any artist who is sufficiently motivated, of expressing inner emotions, beliefs or observations in an image that can be reproduced many times over.

From the point of view of the art lover and collector, printmaking represents the possibility of building up a collection, for pleasure, study or display, of a range of work by artists from anywhere in the world. The cost of purchasing each print can be low, and even at higher levels much less than the cost of purchasing an equivalent painting or piece of sculpture. In addition, the cost and effort needed to transport it are much less. Travellers can buy and take home with them prints by artists from the countries they visit, as reminders of a newly experienced culture, a place seen, or an event encountered. Prints, at least those in two-dimensional form, can be ordered by post, or via the Internet, from artists in far-off places and sent through the mail system in a postal tube, obviating the need to travel to see the work in the first place. The potential of this means of collecting should not be discounted.

From the artist's point of view, the making of an edition – limited or unlimited – of a print can offer the possibility of a reliable and steady income stream, one not reliant on the opportunity for the sale of a single painting or sculpture at a much higher price, but in the end having the potential to result in a total income equal to, or even better than, the sale of such one-off works of art. Print artists have the advantage over makers of unique objects in that they can conceive, develop and produce a work in the clear knowledge that it can be aimed at a wide variety of purchasers, thereby being assured that their work has the potential to interact with the lives of a greater number of people. This interaction becomes even more potent when printmaking techniques are used to create posters or other forms that are used in protest, or as a polemical statement, or to encourage social debate. At the same time the editioned work can find its place within one or more of the many public collections of prints, or it can prove an attractive and affordable source of contemporary art for commercial and industrial institutions, as can be seen in the predominance of prints in the interior-design schemes of large numbers of hotels, offices and corporate buildings.

The inherent portability of the products of printmaking processes offers the additional advantage of enabling artists to send their work around the world to the many international print competitions and exhibitions. The ease with which this can be done has been one of the factors behind the popularity and spread of such printmaking events. The expanding network of information exchange and debate between artists and collectors that has resulted from these gatherings is one of the main reasons why printmaking techniques and aesthetics have continued to grow so quickly in recent years.

It can therefore be said that in printmaking, given the right circumstances and a substantial measure of good fortune coupled with a fair degree of business acumen, there are no losers.

This democracy is not a new phenomenon, but is a constant feature of the history of printmaking, whether that be the classic woodblock prints in Japan, the etchings of views of Europe at the time of

the Grand Tour, or the engravings and lithographs based on celebrated paintings from the 19th century onwards. The paintings of the Impressionists, and some by Van Gogh, bear witness to the commercial availability of images in the form of prints of paintings by other artists included within some of their works. Considering why an artist might depict in their own painting the print of a painting by another artist offers considerable food for thought. On a simple level this practice reflects the fact that such prints were so readily available, and at a price that allowed the dissemination of work by European artists and even Japanese printmakers too, as can be seen in the work of Van Gogh. The increasing availability of art in these forms was one of the factors that led towards the commodification of art that is so much a part of the contemporary art scene.

TECHNOLOGICAL ACCELERATION

The broadening market for visual art has been largely dependent on the continuing evolution of printing technology, which started to gather pace in the mid-19th century with the developments in commercial lithography and the new chemical pigments that facilitated the production of, for example, posters by Toulouse-Lautrec. These technological advances in turn heralded a new direction for art at the dawn of the communication age. One of the finest examples of this trend can be seen in the long and honourable history of Polish poster art, which reached its zenith in the Communist era when richly coloured and detailed posters were produced to advertise, for example, the performance of a Shakespeare play, but with a decipherable political message and a profoundly critical meaning also built into the design. By this means the artist could fulfil a multiple role, bridging the void between the political will of the Communist bureaucracy and the Polish inclination to protest with a poster advertising the work of a European cultural icon but containing a subliminal message as well. A poster artist prominent during the Communist era and renowned for his use of satire and irony subsequently became the art director for the Polish edition of *Playboy*® magazine in the period following the fall of the Iron Curtain – in itself an ironic turn of events.

With the development of more generally affordable multiples of an image came the effect of undermining the uniqueness of the art object and the intrinsic value that it was perceived to contain. Another result was the shift in ownership of an art work from being the sole property of a wealthy patron or collector to becoming an object shared among all who could afford one of the growing number of commercial reproductions of that object. This shift reached its nadir (and examples are still very common) in such things as da Vinci's *Mona Lisa* printed on a tea towel or Van Gogh's *Sunflowers* on a T-shirt. While a shift in attitudes in this regard can be traced from the manufacture of souvenirs for a new generation of tourists at the beginning of the 20th century to the conscious adoption of such iconic images as emblems of postmodern irony at the end of that century, it can hardly be denied that the intrinsic power of such images has been diminished through low-quality industrial mass reproduction.

The development of printing technologies suited to reproduction on such a scale has had an effect not unlike that caused by the rapid development of photography in the mid-19th century. Photography was held by some to signal the death of painting, but the rumours of that demise, oft-repeated, have proved to be not only premature, but based on a false premise. As Michèle Grandbois writes in the essay 'The Québec Experience' (in *Sightlines*, edited by Walter Jule, University of Alberta Press, 1997):

In the 19th century the invention of photography was believed to have dealt the deciding blow. Let us not forget the consequences of what was then considered as crisis. Photography had a profound impact on the means of print production and circulation. To eliminate any confusion with other reproductive processes and guarantee their validity as art, prints had to meet the authenticity and originality criteria established for works of art. Armed with both the concept of the original print – with its focus on the authentic, albeit not unique, nature of this artist-made multiple – and an ethical code second to none, prints were respected by artists and art critics

throughout much of the 20th century. A historical review of international printmaking shows how flexible it has been. It also shows that prints have had a starring role in many major art movements of this century.

Grandbois's point echoes in part the writings of Walter Benjamin, who, whether by prescience or cold analytical thought, foresaw a major problem that would arise in particular with the coming of the digital image. In 'The Work of Art in the Age of Mechanical Reproduction', published in 1935, he set out some of the problems of uniqueness and authorial validity in the 20th century that arose as increasingly sophisticated methods of reproduction were devised. He wrote, 'Even the most perfect reproduction of a work of art is lacking in one element: its presence in time and space, its unique existence at the place where it happens to be.' The problem that Benjamin foresaw has mutated out of all proportion to circumstances he might have envisaged, and one can but wonder at what his reaction might have been to encountering a reproduction of Van Gogh's *Sunflowers* on a T-shirt on a beach in Ibiza. But perhaps he would have taken a sanguine view, since he understood very well the way that art has always created a desire to transcend the means available for expression at a particular place and time, requiring either an advance in technology or the development of an entirely new art form.

DIGITAL INTRUSION

In recent years the process of democratisation that began with mass-produced reproductions has extended still further to include digital technology and the Internet, by which means the relationship between producer and consumer has become even easier, extending still further the process of producing the object – including 'print on demand' – and at the same time bringing a whole new range of potential problems. Questions of uniqueness, of intellectual property rights and copyright are brought to the fore by some in the field of digital imaging, and there is clearly some way to go before the pitfalls and drawbacks of this exciting way of making art are overcome. The rapid development of digital imaging, and all the complex factors that accompany its emergence into the mainstream, has put added pressure on the ethical code to which Grandbois alludes, but it seems probable that the quintessential flexibility of print artists will enable them to brush aside even the most troublesome of those concerns.

In the latter part of the 20th century and the opening years of the new millennium a keenly fought argument has developed around the role of digital imaging in printmaking. For some of the keepers of the traditional, craft-based forms, with all the arcane and jealously guarded knowledge that such forms inevitably (and quite rightly) accumulate, the emergence of the brightly blooming 'new kid on the block' of digital imaging must have been something akin to the utterance of a brash and unwelcome heresy. The technical skills required in the creation of prints using woodcut and wood-engraving, as well as the finely sophisticated methods used in making and printing from intaglio plates and lithographic stones, not to mention the more recent techniques evolved for silk-screen printing, have all been developed over long periods of time and offer a rich array of possibilities to the dedicated craftsman-printmaker. All such techniques need to be learned, ideally through a combination of studio practice, a period of apprenticeship with a more experienced practitioner, and the gradually evolving understanding of the complex processes involved in making the image on the plate, stone or screen. It takes time to learn the subtleties of choosing and preparing the paper, mixing and applying inks, and producing the prints on often-venerable presses. There has also been a requirement that the artist creating the original image should be skilled in drawing and colour theory as well as being fully aware of the printmaking processes themselves. It is interesting to note that, while many artists take responsibility for the whole process, for others less versed in the necessary technical skills the creation of a limited edition of prints has meant cooperating with a master printmaker, the resulting edition being a joint effort in these cases.

By contrast it must have appeared to such traditional practitioners as if the skills required to create a digital image on a computer and to print it out (in potentially unlimited quantities) on a cheap

desktop printer were the equivalent of those required to use a painting-by-numbers kit. In some ways there is, relatively speaking, a greater degree of accessibility in the techniques involved in taking digital photographs or making digital scans of other images and objects, then manipulating and combining them using computer software to produce a digital image file that can be turned into a potentially limitless edition on a printer, or even transmitted digitally across the world. Such skills can be learned by anyone with access to the basic equipment, and applied in the corner of a living room rather than needing a great deal of specialised equipment and a dedicated studio/workshop space. But it is of course never quite that simple. Any printmaking technique, digital or traditional, can be used at a number of skill levels, from those that can be taught to children in junior schools through to the levels of expertise attained by professional users of the Photoshop® program. At this level the technique itself becomes something of a 'black art', with its own cabals guarding secret knowledge known only to a few.

Digital imaging has found a power and potential of its own, as can be seen in some of the work featured in this book. The serial quantum leaps of the digital form and the techniques that support it mean that, as an example, conservators at the Nelson-Atkins Museum of Art in Kansas City now use digital photography to record pictures in the collection at full size and in such detail that the digital images attain greater clarity than the originals. As a practical means of ensuring that future conservation can be as accurate as possible the technique clearly has great benefits. That it can also transcend the original in technical clarity is more worrying for those who value, quite rightly, the uniqueness of the original work. The future development of such techniques will be interesting to observe.

CHANGING CHANGES

In recent years, at least from the evidence found in some of the major international printmaking exhibitions, it seems as if the argument over the digital image has been resolved, if only partially. The gulf between traditional and digital techniques has narrowed, even though it has not entirely disappeared. It now seems far more acceptable that, just as more than one traditional technique can be used (and justified) in the creation of an image, so can a digital technique be used in conjunction with a traditional technique, often to very good effect. This is, however, nothing new, because, as Karen Kunc writes, 'Printmakers have always adopted the latest thing in communication arts', and, 'There has always been a flow back and forth, between printmaking and commercial innovations', and also, 'Printmakers continue to be innovators and tinkerers, adapting concepts and skills from one thousand years of tradition'. (All quotations from 'Teaching Printmaking – an American View', Karen Kunc, in *Sightlines*, edited by Walter Jule, University of Alberta Press, 1997.)

The diehards will of course continue to complain at the subversion of their craft but in the end they too will have to accept that digital is just another technique, an additional means to an end among an exciting range of possible choices, and one that has limitless and exciting possibilities for artists in the 21st century. Of course the arguments will continue to rage – such disputes are an inherent part of the printmaking world – as to whether one variation on a technique is better than another, or which technique is superior, or what is really meant by 'original print' and 'limited edition'. But in the end even the most conservative of printmakers will have to accept that the nature of the art object is undergoing another of the regular mutations that have occurred throughout the history of art. Just as the spread of electronic communications is changing the way we receive entertainment, and indeed the way we see the world through the medium of television news, so too will the electronic connections of the wired-up world affect the nature of what constitutes an art object, as well as the way the work produced by artists is consumed.

MOVING ON

The minefield of aspects of the contemporary printmaking scene that this book seeks to explore includes the need to begin to understand better the relationship between cause and effect in the making of art, the need to recognise the gulf between the commodification of art and the yearning for uniqueness, the need to appreciate further the implications of the globalisation of art and the universal quest for expression, and the importance of describing some of the new aspects of the role of printmaking in a changing world. Artists on whatever level they operate at benefit from an expanding knowledge and a keener awareness of what the work of being an artist entails. It is hard work, and getting harder in a world where many of the older values that somehow managed to sustain society are breaking down, to be replaced by other values that are less humanistic and have far more tenuous links to a shared history, which are potentially far less durable and are certainly less well endowed with a sense of spiritual depth. So artists have a choice, either to link their work with the shallow values of so much else in the contemporary world, or to seek to understand in greater depth what has gone before and how the arts can assist in the building of a fairer, kinder and more just society. Such a view may not be very fashionable, but it does merit proper consideration. As Raphaela Francis writes in 'A Message for Youth' (in *Contemporary Art and Multicultural Education*, edited by Susan Cahan and Zoya Kocur, New Museum of Contemporary Art, New York, 1996):

> I feel that the motivations of contemporary artists are understandable and dignified. I have learned about what art means today: it means knowledge, courage and love – things that everyone can relate to. It doesn't just take good technique or a great sculpting hand to be an artist in our society today. It takes a great deal of love for others and, most of all, compassion.

This view is applicable to all forms of contemporary art practice and activity, but seems to be particularly relevant to printmaking, with its strongly democratic traditions and possibilities. What is happening with printmaking as it develops at the edge is very interesting. How it might have a widening effect on the world from which it springs is something else, but intrinsically it is unlikely to be lacking in interest, challenge or possibilities. Printmaking has had a long history and has rightly earned its proper place within the world of cultural achievement. The traditional skills and techniques will not be lost; indeed they will develop, and will likely take on new forms as they do so. The fascination with the creation of such forms will continue to absorb the interest of students, often to the point of obsession. But at the same time the new techniques will continue to develop at a rapid pace and will take their place alongside such traditional forms. There is likely to be a continuing cross-fertilisation of ideas and fusions of technique and this will be to the good of printmaking, adding new ways of making a multiple image and strengthening those processes that already exist. If the power of the new communication media can be harnessed to enable the dissemination of ideas and diffusion of images, then the potential of printmaking for taking its rightful place among the other visual art forms will be realised to an ever-greater extent. To reiterate an earlier thought: in printmaking there will be no losers. All that is required, apart from a continuing faith in the redemptive powers of art and a measure of good fortune, will be 'a willingness to contemplate what is happening'.

4. THE DIGITAL EMPIRE

THE (PARTLY) WIRED-UP WORLD

THERE IS NO DOUBT that the emergence of the Internet as a major force in international communication has had a far greater effect on the world than any other development in communications since Gutenberg developed printing with movable type. What started out as a means of transmitting and sharing scientific information at CERN in Geneva has now grown to encompass all of the developed and much of the developing worlds. Hugh Merrill, an artist and lecturer in Kansas City, told me of his travels in rural Kenya and how he had talked for some time with a Masai farmer. Before leaving the village Merrill had asked the farmer how he could keep in contact with him, at which the farmer replied that e-mail would be best, because he used the computer in the local community centre. And backpackers travelling in remote parts of the world head for the local Internet cafe in order to keep in touch with family and friends via e-mail. Neither of these situations is surprising any longer. However, the situation is not as simple as it might at first appear. While those of us who live in the developed world take for granted our ready access to the necessary technology, for the vast proportion of people in the developing world such access remains an unrealistic dream.

The Argentinian artist and writer Alicia Candiani, in 'Poetics from the Periphery', a paper delivered at the Sharjah International Art Biennale Symposium in 2003, has written about an e-mail that circulated some time ago, comparing the total world population with a small village. This e-mail describes how, if the total world population was represented by a village of exactly 100 inhabitants, 70 of them would not know how to read and only 1 of them would have access to a computer in the sense of being able to buy it and having the skills to use it. In this scenario six of the inhabitants would possess 59 per cent of all the wealth, these six coming from the United States. Candiani concludes that, 'It would not be foolish to infer that the only person in the village owning a computer would be male, white, American and most probably not an artist. When considering the world from this compressed perspective the statistics overwhelm us.' In the same paper she refers to a report entitled 'Falling Through the Net: Defining the Digital Divide', published in October 2000 by the National Telecommunications and Information Administration in the United States, which suggests that there is a wider 'digital frontier' in that country between those who 'have' and those who 'have not'. Among those who have limited or no access to the new technologies are 'racial minorities, people on low incomes, those with a lower cultural level, youth, single-parent children and the inhabitants of rural areas'. It is an inevitable conclusion of the report that, considering that most use of the Internet occurs in the Northern hemisphere, the overabundance of information technology in developed countries coincides with the almost total lack of such technology in underdeveloped regions.

FALL AND RISE

The colonial empires built up in the 19th century have been dismantled, and the Communist empire is no more: for the majority of people in the colonised countries of those empires the benefits were few and limited. It would seem that a digital empire now exists, one that excludes the majority of the world population no less than the former empires did. This empire is expanding exponentially hand in hand with the growth in power and influence of multinational companies, resulting in a widening gulf

between the rich and poor participants in the information economy. The task of enabling equality of access and opportunity will be far greater in the digital empire than it ever was after the dissolution of the old empires.

While the Internet is still by no means accessible to all, it remains a potent force in enabling the rapid exchange of information and ideas. In the context of printmaking it allows not just for the exchange of verbal information but also, and most importantly, access to images. Artists can set up websites, either as individuals or through galleries and workshops, in which a range of images can be shown and orders placed and paid for by those wishing to purchase art works. Online virtual galleries will never replicate the visceral and cerebral experience of being in a real space and looking at real work, but they do allow unprecedented access to the work of artists from all over the world, and as a means of communicating what is being produced they should not be underrated. In addition to enabling a personal exploration of the new world of printmaking, the Internet also facilitates the task of selecting artists for participation in international exhibitions, and increases the opportunities for such events to gain widespread publicity. Prior to the 2003 International Print Triennale in Kraków, the organisers set up a web forum to discuss issues connected with contemporary printmaking, and a number of artists and critics from around the world contributed to the debate. The Internet allows participation and a degree of interaction by those with access to a computer that would otherwise be enabled only through face-to-face meetings at conferences. The importance of electronic dialogues such as these should not be discounted.

From the point of view of the working artist the Internet has opened up other new possibilities. For example, those artists working with digital print techniques can transmit images to printing facilities electronically, a means of production that, particularly with the rapid spread of broadband technology, is becoming ever-more accessible. By contrast with more traditional forms of printmaking, in which an edition is created over a short period of time, digital prints, whether involving digital photography or other means of computer-based image creation, can be made one at a time, with the length of the edition being theoretically infinite. There are of course many contentious issues surrounding this aspect of making prints (not the least of which is the problem of copyright), but the attitudes of galleries and art buyers seem to be changing to accommodate this relatively new form. Print on demand, in which a print is made to order on paper, canvas or other substrate, seems likely to be a permanent feature of the art world. While the transmission of images that is enabled through computer technology has had a noticeable effect on the world of printmaking as a whole, the resulting prints still have to be distributed by the more conventional means of post or freight. The creation and transmission of virtual images can, however, be entirely electronic, crossing international boundaries with ease and at a speed that is close to instantaneous. It is now possible to build up a substantial virtual collection within a very short space of time spent sitting at a computer, and to edit and annotate that collection for onward transmission to a remote computer with equal ease and speed. While the potential of this process alarms many more conventionally minded artists, the electronic, virtual world has the potential to be a very liberating, and liberated, space for both the artist and the consumer. One negative aspect is that once the image is 'out there' it cannot be recalled or deleted, becoming enmeshed in the fabric of the Internet and thus beyond the artist's control. For this reason many artists and online galleries very wisely put only small, low-resolution images on their websites, to avoid the risk of unauthorised duplication.

It is a striking aspect of the digital empire that the original image created by the artist can exist purely in digital form, owing nothing to the use of conventional materials, and having no physical presence other than its place as an assemblage of fragments of digital information stored within the components of a computer. Having been created and transmitted digitally, it can never be considered to have the same physical reality as, for example, an etching or a lithograph, or for that matter a photograph. The digital image can be endlessly modified, resized and distorted, its colours altered with a few clicks of the mouse, annotated with text, combined with other images and generally made subject to an infinite process of change. Digital images can be used to make either editions or unique prints. In the

case of unique prints the technique can involve simply the creation of a digital image and then the production of a single print, after which the digital file is deleted from the artist's computer. Alternatively, a series of original prints derived from a single original image can be made, with successive variations being created by altering each successive individual print, each new image being saved as a modified digital file, with the file of the preceding variation being deleted. This aspect of digital printmaking brings it far closer as a process to conventional printmaking than has sometimes been admitted, echoing the notions of both the edition (whether limited or unlimited) and the unique print that have formed the mainstay of the tradition.

PHOTOGRAPHY IS DEAD, LONG LIVE PHOTOGRAPHY

The rapid rise of digital photography as a medium has led to a whole new area of artistic expression, akin to the conventional silver-based film technique but offering a far wider range of possibilities. The result of rapid technological development and increasing miniaturisation, digital cameras can now be built into mobile telephones (another technology which has led to the revolution in communication), with images being sent via those phones almost as soon as they have been captured. While it can be argued that this development has not exactly pushed back the boundaries of artistic creativity, it has led to a redefinition of the way in which many people interpret the world around them. On a more creative level digital photography can now replicate the full range of approaches and techniques available to film-based photography, at the same time making it accessible to those for whom the alchemical magic of the darkroom, upon which so much fine-art photography has hitherto been based, remains an arcane and impenetrable secret. For many people the availability and ease of use of the technology has led them to replace film cameras and photo albums with digital cameras and computer files, enabling a more rapid and infinitely more flexible sharing of family and holiday photographs through the use of e-mail and CD-ROM disks. On this basic level it can be said that a revolution has occurred no less far-reaching than the development of silver-based photography in the mid-19th century, and certainly the equivalent to the introduction of the Box Brownie camera. Taking the technology beyond the most basic level, digital photographers untutored in conventional darkroom techniques can modify their photographs through the medium of user-friendly software packages, and in so doing can learn valuable new skills.

For professional photographers the changes are even more far-reaching, enabling news photographers on assignment to e-mail images directly from their laptop computers to their offices, and sports photographers to obtain dramatic shots through the use of remotely operated cameras, as could recently be seen in the ranks of such cameras beside the tracks and jumping pits at the Athens Olympics . For artists, the availability and extraordinary flexibility of the medium has led to an opening-up of new realms of expression. Digital photography and the use of software such as Adobe Photoshop®, together with the use of imaging tools such as tablets that virtually replicate conventional art tools, have resulted in a new genre of printmaking, either used as a medium in itself or incorporated with other techniques. It is certain that the limits have not yet been reached and that this particular edge in the world of creative printmaking will continue to extend still further.

(UN)REALITY

There is a continuing debate regarding the manner in which digital photography can be said to represent the real world: it can also be said that the medium represents an unreal, or rather an alternative, world. For artists this represents a great challenge, but one that is in many respects in symbiosis with the creative imagination itself. The artist working with a computer can achieve the creation of a digital art work in which there is an intimate and intuitive link between imagination and image that requires no other mediation. The basic equipment and software that allows this has been available in some form for a

number of years, but the recent rapid evolution in technology has led to the possibility of much larger-scale images and a far wider range of possible mediums with which to make prints. At the same time, the cost of the technology has been steadily falling, putting it within the reach of many more people.

The argument about the reality or otherwise of digital photography that has absorbed some critics in recent years is little more than an extension of the arguments about the degree to which conventional photography records and depicts the world. The tales of the distortion of historical fact through the retouching of photographs during the Stalin era have been much repeated. In 2004 a quiet controversy arose regarding the celebrated photographs taken by the Australian photographer Frank Hurley, who accompanied Sir Ernest Shackleton on the ill-fated *Endurance* expedition to Antarctica in 1914–17. It has been claimed by some that through his use of composites – that is, the combination in the darkroom of elements from different photographs – or by simply reversing the image, Hurley altered the historical facts of the events that he recorded in order to produce an artistic interpretation of what he experienced. Such techniques were in fact commonplace at the time, and even resulted in convincing hoaxes such as the celebrated case of the 'Cottingley Fairies' in the early 20th century. In addition, from the time of the Second World War until the commercial introduction of computers in the 1970s most of the work of preparing photographs for use in magazines and advertising was done by skilled retouchers whose expertise with the scalpel and the stippling brush earned them high status and equally high salaries. The technology available to contemporary digital photographers allows such altered realities to be produced with far greater ease and at much lower cost, the main difference being that the skills required to manipulate images digitally are more accessible to a far wider range of people than were the highly developed and very precise skills of hand-retouching in the mid-20th century. The notion of reality is challenged still further, but at the same time the creative arsenal of artists has received yet another readily available set of tools through which mediations between reality and imagination may be produced.

The world is richer for these developments in artistic expression, and the responsibility for their wise and appropriate use now lies with a far broader constituency. At the same time more people are aware of the degree to which reality can be altered in the print media, and perhaps more cynical about the manipulation of press and television images. There is a growing awareness of where the power lies, and how it can lie. The digital empire holds great promise for the creative artist but poses an equal threat to truth through the manner in which that truth is portrayed. This challenging and threatening domain does indeed occupy a dangerous edge, which will continue to interest artists for the foreseeable future.

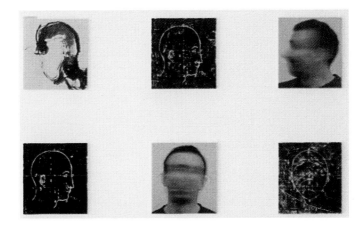

Arūnas Gelūnas *Wind in My Head, Dotted Line Identity*
(detail) Woodcut, ink painting, digital photography on Japanese
hosokawa paper; 2003

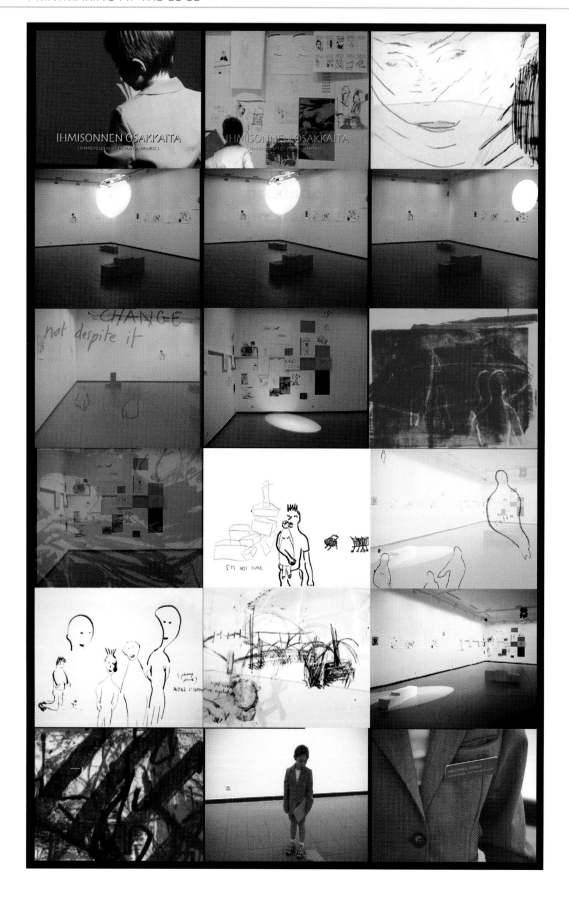

PRINTMAKING AT THE EDGE – AN ANNOTATED PORTFOLIO

THE ARTISTS REPRESENTED within the following sections are from many countries and pursue a wide variety of printmaking methods within their art. I have placed them in informal groups in order to give some form to what in truth are very different artists. Each of the sections is preceded by a short introduction to the general theme. However, it should be noted that these groupings are not prescriptive; many of these artists' work falls into more than one of my invented categories. Other thematic or critical connections between the works of individual artists can be made by anyone referring to this book; alternatively each artist can be considered in isolation. What will emerge is a matter for personal reflection, but it should become clear that the energy and diversity of approach demonstrated by these artists is considerable, offering a broad range of insights into some of the approaches and techniques being explored in the many countries represented.

Equally, I admit that there are gaps, with some countries and groupings of artists not represented. Also that the selection is necessarily a personal one, driven partly by what I discovered during a long period of research and travel, partly through contacts made during the research for my previous two books and other writings, and partly by artists suggesting colleagues of theirs in other places who were worth investigating. A number of interesting international contacts came about following a request for information that was posted on the printmaking website message board of Middle Tennessee State University. Other valuable contacts came through the 'Directory of Print' CD-ROM published by the Kraków International Print Triennale Society. The selection in many ways does little more than scratch the surface of the extensive, and growing, number of artists throughout the world for whom printmaking mediums offer a useful means of developing and depicting their personal visions. The edges at which the selected artists have been discovered, or at which they consider themselves to be, offer a matrix of possibilities for further exploration and discovery. There is for certain a great deal more 'out there at the edges', and it is equally certain that those edges are constantly on the move.

OPPOSITE Joris Martens *Ihmisonnen Osakkaita (Shareholders of Human Happiness)* Collage of mixed-media prints and watercolours; 2001

5. DIGITAL CITIES

INTRODUCTION

THE INCREASING DOMINANCE of digital photography over silver-based photographic image-making is encouraging more and more people to explore the potential of this readily accessible art form. The sheer versatility of the medium can be quite overwhelming, as digital techniques can replicate – or at least imitate – a very wide range of traditional techniques. Apart from the four artists chosen to be included in this discrete section of the portfolio, all of whom use digital photography as their main medium for expression, elsewhere in the portfolio there are artists who also use digital techniques, though in conjunction with other forms or with a different emphasis.

Two of the four artists in this section – Yuan Goang-Ming and Chang-Soo Kim – are from countries on the Pacific Rim, and two – Konstantin Khudyakov and Hanna Haska – are from Eastern Europe. There are certain similarities in the approaches of each pair of artists, but equally there are distinct differences that emphasise their individuality. All, however, are concerned with the human condition, and their work refers implicitly to the dilemmas and concerns that face world society at the beginning of a new millennium. Each of the artists uses similar technology, but the extraordinary diversity in the results they obtain is a sure sign that, far from digital technology having the effect of levelling out individual creativity, it has now matured into just another technique available to the artist or printmaker.

The fears of traditional printmakers that the technologies of the digital world would subvert their craft seem now to have been unfounded. Far from overshadowing techniques with a noble and long-standing heritage, the new world of the digital print has done no more than add another technique to the available range, and in so doing it has encouraged the continuing expansion of the world of printmaking. These four artists between them demonstrate with skill and assurance how the new technologies can enlarge our appreciation of the work of the artist and of the news ways in which the creative force can find expression.

1. Yuan Goang-Ming

Yuan Goang-Ming was born in Taiwan in 1965, where he still lives, and educated in Taiwan and Germany. His work featured prominently in the Taiwan exhibition 'Limbo Zone', which was staged in the Palazzo delle Prigioni, the historic prison linked to the Doge's Palace by the Bridge of Sighs, as part of the 2003 Venice Biennale. Entering the air-conditioned chill of the palace from the crowded heat of the Venetian summer on the Riva degli Schiavoni was like taking a step back in time and encountering a different world, an experience that is wholly consistent with Yuan's work. Among the works shown were two large-format, high-resolution, digital images from his series entitled *City Disqualified*. These depict, the one by day, the other by night, a major road intersection in the Ximen district of Taipei, seen from a high angle, a crowded urban scene in which there are no people or vehicles. Yuan has gained an international reputation since he started working with video in 1986, but these photographic works have taken his work to a new level. Technically assured and contextually complex they raise issues about the nature of urban life in an era of advancing technology.

Each of the images is derived from over 70 frames selected from more than 300 medium-format (film) photographs taken by the artist over a period of one month. The photographs were scanned into a computer and gradually superimposed on each other with all traces of the images of people and vehicles erased, the whole of each final image being carefully manipulated to give the impression of having been taken at one moment in time. In fact, the creation of each of these images from the original photographs took over two months, an

City Disqualified – Ximen District in Daytime
Digital photography; 270 x 340 cm (8 ft. 10 in x 11 ft. 1 in.); 2002

City Disqualified – Ximen District at Night Digital photography; 240 x 300 cm (7 ft. 10 in. x 9 ft. 10 in.); 2002

experience that the artist likens to working with video – 'the simultaneous representation of different moments of time' – and similar to the principle of animation. For the viewer the images are perplexing: a dreamlike representation perhaps, or the aftermath of some dreadful event that has eliminated vehicles and people but left the buildings standing. The presence of human life is indicated by its absence, implied in all the details of these images: traffic signs and road markings, advertising signs and planted verges. For those who do not know Taipei, these photographs offer fascinating insights into another culture, even though Taipei itself is not unlike most other major modern cities around the world. To observe such stillness in a place in which there should be constant hubbub and bustle is somewhat unnerving.

In an interview with Amy Cheng Huei-Hua the artist was asked if the choice of 'city' as subject matter had anything to do with the experience of city living in the age of consumption and technology. He agreed that it probably did, but added that he is 'a bit pessimistic about technology and even tired of it. It sounds a bit paradoxical because that's what I do. It's probably a love-hate relationship.' He went on to comment that, although the images contain no people or cars, a careful examination would show that the shops are open, and that, 'Actually, the "city" is still closely related to people. Although you can't see anybody in the photograph, it still has something to do with people.'

Yuan Goang-Ming is clearly fully engaged with the environment in which he chooses to live, and is capable of delineating one place in the city through a delicate manipulation of a series of realities taken over a period

of time. In coming to a realisation of the manner in which time is compressed into a single image, he offers an opportunity to consider the nature of urban living, in which the finding of that moment of stillness – something that is taken for granted in the countryside – is reliant on the skilful use of advanced technology. The resulting images have an elegiac quality, something akin to a vast memento mori, hinting at the transience of human life without losing the fascination for observing in detail what it is that human beings can achieve through the creation of cities and the ordinary business of living in them.

RIGHT *City Disqualified – Chunghsaio E. Road* Digital photography; 150 x 180 cm (4 ft. 11 in. x 5 ft. 11 in.); 2001
BELOW *City Disqualified – Original Picture of Ximen District in Daytime* 4 x 5 photography; 270 x 340 cm (8 ft. 10 in. x 11 ft. 1 in.); 2002

2. Chang-Soo Kim

For this artist the human face is not only the building block of his painstakingly constructed images, but also the subject matter. These works are thus a form of meditation on the nature of humanity. Just as the pixel is the basic constituent of a digital image, so Chang-Soo Kim begins with digital images of human faces at a scale close to the single-pixel level and then manipulates large numbers of them with precision to create images of other faces and places. It is a profoundly humanist approach to the making of art, one that he is currently extending into new areas. Kim studied in Korea and in Germany, and lives in Seoul, South Korea, where he is a professor at the college of art at Kyungwon University; he has exhibited internationally with considerable success. The process of his work is a direct link between the images of anonymous strangers and the creation of images of Everyman. In doing so he creates prints that bring to mind the saying, 'Our lives are linked by the thread of our humanity – if we break it we are undone.'

Chang-Soo Kim makes digital video films of the crowds of strangers that he encounters in the street and then extracts still images for subsequent digital manipulation and combination into larger images. Although the technique itself is fairly straightforward, combining carefully selected images through imaging software, Kim uses it with considerable skill and an awareness of the values of light and colour (in both photographic and fine-art terms) necessary to create the required result; in effect he is 'painting with faces'. He describes the technique as 'configuring the contemplations and questions of meanings of relationships between an individual and society as well as between a human and his/her environment', and, 'collected images of people closely related to questions including the meaning of an individual constituting society as an environment, and the passage of time and space around countless encounters among people'. This process enables the recording of his accidental encounters with strangers on the street and the subsequent encounters of individual fragments of those micro-images in forming larger images that transcend time and space and render familiar the unseen and unknown faces of a distant city.

By exploring the faces he encounters by chance in the street, and the technology that renders them in some form of immortality, the artist has melded a deep philosophical insight with a masterful grasp of digital imaging. There is a

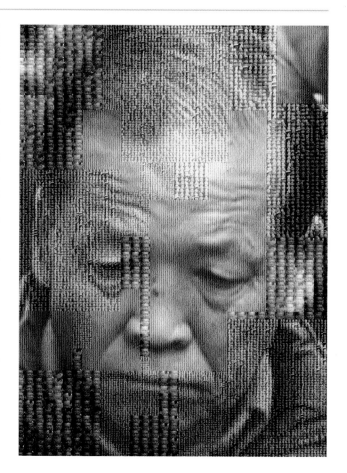

FL_md_Oldman1 Digital photography; 90 x 70 cm (2 ft. 11 in. x 2 ft. 3 in.); n.d.

particularly potent link between flesh and blood on the one hand and the pixels of electronic code on the other, something that transgresses the generally accepted boundaries of photography and portraiture. The final images are produced in a range of ways, including the relatively conventional form of printing on paper, and more recently on rainbow-coloured substrate, as well as on transparent sheet for mounting in light-boxes. In addition Kim has also explored, in *Track* and *The Second Tracking*, the technique of printing on lenticular plastic, in which dual images, each one created through his technique of combining many images together, are printed closely adjacent to each other on finely ribbed holographic sheet. The result is that the viewer moving in front of the work can see two or more successive images that appear to form and re-form within each other. The technique has been used in advertising products for some time, but by using it in conjunction with his well-developed approach to image-making the artist has developed an extension to his usual techniques that captures with success the intricacy of his vision of society.

ABOVE LEFT *FL_F10L_1CH* Digital print on rainbow sheet;
112.5 x 94 cm (3 ft. 8 in. x 3ft. 1 in.); n.d.
ABOVE *FLT_T67_U1* Digital print on light panel;
26.4 x 35.2 cm (10 x 13 in.); n.d.
LEFT *FL232* Digital print on paper; 140 x 187.6 cm (4 ft. 7 in. x 6 ft. 1 in.); n.d.

In his recent work *Flickering_md_Oldman1* the artist has combined micro-images in differing sizes, the resulting image apparently resembling weaving or beadwork. In all of his works, Kim's insight and his intuitive skill in the use of technology renders the anonymous people he captures in complex images that seize the imagination. In witnessing these images we can also, if we choose, witness our own place within world society.

3. Konstantin Khudyakov

Konstantin Khudyakov was born in Russia in 1954, in the Saratov region. He graduated from the Moscow Architecture Institute in 1971, and still lives and works in Moscow. The genesis of his digital work can be traced to his career in the former Soviet Union. During his final student year at the Institute he won a competition to design a new building for the Lenin Museum in Moscow with a design that subsequently led to his career as

chief artist at that museum. Khudyakov recalls that, 'According to the existing laws in the Soviet Union I had to go and work where I was assigned.' Working at this prestigious institution gave him access to the most advanced technology and facilities in the country and within 15 years he had led the reconstruction of the museum in Moscow as well as designed affiliated branches elsewhere in the USSR. However, during this time he also painted in his spare time and exhibited his work in what he describes as 'the half-legal exhibitions of the group "20 Moscow Artists" in their basement gallery ... the only place in Moscow where non-conformist art could be exhibited under the secret supervision of the KGB'. It was, he admits, an imitation of resistance in a society riddled with ambiguity and hypocrisy.

When the Soviet world crumbled in the last decade of the 20th century Khudyakov diverted his creative energies into pursuing an ambitious programme of digital art works, notably in two major series, *Hotel Russia* and *Ikonostasis XXI*, which collectively represent one of the most complex and extensive achievements in recent Russian art. The *Hotel Russia* project is a concept that the

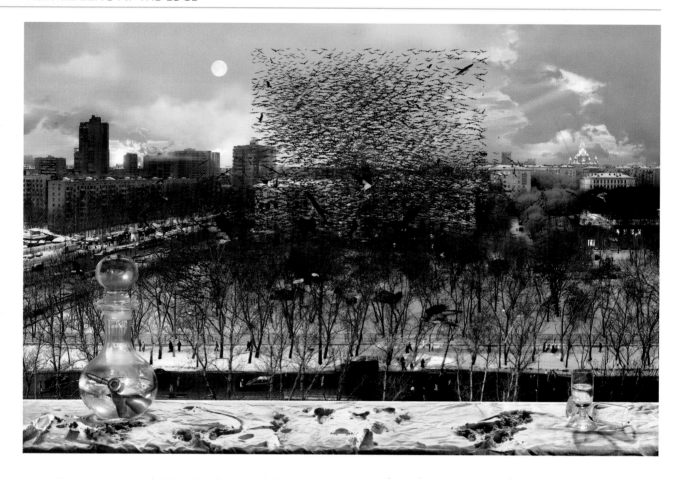

ABOVE *Moscow on March 20, 2003 (The Baghdad Square) (from: Hotel Russia)* Digital print on canvas; 110 x 160 cm (3 ft. 7 in. x 5 ft. 3 in.); 2003

artist has chosen 'not to limit in space and time, consisting of a boundless quantity of images'. Each work in the series is derived from a large number of high-resolution digital images combined together via computer programs to be output on different surfaces and in some cases finished with airbrushed oil paint. These figurative works include faces, objects, landscapes, buildings and elements of still life, each cloned from the artist's collection of extensive material evidence of past events, resulting in what he describes as 'precise digital analogues of real events'. He has defined the 'construction site' of *Hotel Russia* as being a virtual hyper-construction 1000 metres high and 729 metres squared in plan area, occupying a specific site in his home city. Khudyakov concludes, 'Absurdity, ambiguity, false pathos, powerlessness, metaphysical realism – all these intricate phenomena are transformed by me into a dimensionless unimaginable Digital Reflecting Cabinet of Curiosities where I am doomed to be reflected to my last day.'

Bio-Cross: Counter-infantry shell, Department of Cloning Animated Arms (from: Hotel Russia)
Digital print on canvas; 110 x 110 cm (3 ft. 7 in. x 3 ft. 7 in.); 2002

Ikonostasis XXI is Khudyakov's interpretation of the traditional Orthodox arrangement of the icons of saints. Arranged in three rows of images, the top row represents the Old Testament, the middle row the festivals, and the bottom row the New Testament. The faces in the top and bottom rows are built up from fragments of contemporary faces extracted from an archive of portraits made by the artist. The middle row represents fragments of human flesh and blood, symbolising 'the spiritual and moral sense of self-sacrifice in the name of saving mankind and the development of Christianity'. By combining such fragments Khudyakov strives to represent historical and biblical figures through the faces of contemporary Russians. The resulting work, measuring 4.8 x 14.3 m in total, is a very long way from the work the artist was assigned to do when he left the Moscow Architecture Institute, and is a measure of just how far his country has come in the past two decades.

It is clear that Khudyakov is thoroughly proficient in harnessing advanced digital technology to make manifest his idiosyncratic vision of that vast nation. He can be seen as a descendant of all those visionary creative minds that have over the centuries contributed to a collective understanding of a nation that covers much of the Northern hemisphere, and whose influence continues to be a potent ingredient in contemporary international politics. It is equally clear that much of the mystery of Russia – the old and the new – remains to be discovered, and the art of Konstantin Khudyakov offers one starting point for exploration.

ABOVE *Ascension (from: Ikonostasis XXI)* Digital print on canvas; 110 x 220 cm (3 ft. 7 in. x 7 ft. 2 in.); 2004 (Note by the artist: 'In the eye of the Christ we can see reflected the witnesses of His Ascension.')
BELOW *St George (from: Ikonostasis XXI)* Digital print on canvas; 160 x 110 cm (5 ft. 3 in. x 3 ft. 7 in.); 2004

4. Hanna Haska

Born and raised in Warsaw, Hanna Haska spent her childhood in a postwar city, 80 per cent of which had been destroyed by the time the Nazi army retreated. Recounting aspects of her childhood she has written, 'As a child I used to play in the ruins of old buildings in which several generations of families had lived and in which they had been viciously killed. I was overwhelmed by the strange energy they left behind.' She studied in Warsaw, and later at the Kansas City Art Institute and in Toronto, following which she lived and pursued her career in Canada and the United States. She has now returned to live and work in Warsaw. Haska's digital images have been exhibited in many countries; she has won numerous international awards, and was among the winners in the 2001 MacWorld Expo Digital Competition. Her work has been described as a 'computerised Apocalypse' and as being the contemporary equivalent of Bruegel or Bosch. There is a stronger link between her work and the paintings of the 19th-century English painter John Martin, whose apocalyptic visions of the end of the world have not diminished in popularity over the years. These descriptions go some way towards describing what she has achieved, but there is more than that to be found within her work.

Haska studied graphic design in the studio of the celebrated artist Henryk Tomaszewski, whose work had a major influence on the development of Polish poster art. On moving to North America she encountered early incarnations of the Mac hardware and software system and began to learn the potential of digital technology for creating original works as well as for modifying scanned images. As her work progressed in parallel with the rapid evolution of the technology she found that, rather than using that technology to imitate fine-art techniques, she could use its own unique possibilities to explore the creation of images more intrinsic to the medium.

As a part of her practice as an artist for many years she has been collecting a library of visual references and has found the technology of digital art to be the ideal means of utilising that archive to give expression to her vision of the world. Haska says of her working method:

Electronic and mathematical transformations create an illusion of space. That space has an amazing capacity to handle our overloaded culture. Into one space I can fit any real or abstract object. I can pick up any object from the information flood, dump it into my digital ocean and watch the space forming.

ABOVE *Sanctuary – Tree of Life* Digital print on paper; 100 x 200 cm (3 ft. 3 in. x 6 ft. 6 in.); 2004

BELOW LEFT *In Gold We Trust (call for re-evaluation)* Digital print on paper; 100 x 200 cm (3 ft. 3 in. x 6 ft. 6 in.); 2004

BELOW *The Wall* Digital print on paper; 100 x 200 cm (3 ft. 3 in. x 6 ft. 6 in.); 2004

It is clear that this working method has allowed her to develop an approach in which digital tools become a true medium, rather than one which attempts to replicate traditional mediums in a modified form. While her technical skill has developed to its present high standard of achievement, Haska has also refined her view of the world and its influence on both her spiritual and her humanist vision. She is acutely aware of the perils facing mankind, particularly in the urban world. Through the combination, repetition and transformation of a repertoire of elements she has developed a technique that enables her to create images of a world in crisis.

Many of the images relate to biblical, often Old Testament, themes. Some are metaphors for the seemingly insoluble problems of mankind, while others refer to the role of Polish culture in her life. Her work relates

4400 – The Great Hunter Digital print on paper; 100 x 200 cm (3 ft. 3 in. x 6 ft. 6 in.); 2004

to her childhood experiences and to her experience of living in cities on both sides of the Atlantic. Her work is driven by both her religious faith and her vision of the threats facing contemporary society. There is a sense of desperation about what the future may hold, but also, through a paradoxical faith in that future, a feeling that humankind has the power to survive. Haska does not produce religious art as such, but her work is nevertheless imbued with a tangible sense of what in Poland is referred to as the *sacrum* – a sense of spiritual awareness that stands in direct opposition to the *profanum*. The possibility of redemption is a strong element in her unique vision of the world.

6. CAVEAT EMPTOR

INTRODUCTION

'LET THE BUYER BEWARE' is good advice in the commercial world, where the making of a fast buck lies behind the lure of many 'unmissable' deals. It is an old principle that has long provided a get-out for the purveyors of shoddy goods. In recent decades, commerce has infiltrated every aspect of life in the developed world, and increasingly in the developing world too, and many artists during the last hundred years or so have signalled their concern about its insidious spread, abetted by a panoply of marketing and advertising offering the promise of a better tomorrow if only you buy this or that new, improved product to do the work, to entertain the children, to rejuvenate the face, to give you eternal life. The risks of being taken in are of course only too real, but the commercial world is wily and the writing of the get-out clause has become an art in itself. As the American singer-songwriter Tom Waits has written in 'Step Right Up' on the *Small Change* album, 'The large print giveth, the small print taketh away.'

In the 1960s the Pop Art movement celebrated the new world of brighter, better consumer goods following the austerity of the Second World War. It did so with a mixture of admiration and admonition, using all the high-gloss, slogan-heavy, new, improved tools of the marketing and advertising worlds. In so doing it produced art that, for the first time in the mass market, became a commodity in itself, as has been seen more recently in the resurgence of the style in exhibitions celebrating the 1960s, reflecting a post-postmodern nostalgia for that which has truly gone, to be supplanted by a more cynical, more knowing marketing world where success is measured in multinational terms. In this world of 'Coca-Colonisation' the icons of desire are the logos of the sportswear manufacturers and the sugar-loaded fizzy-drink makers, and the venerable trademarks of what was once apparel for the wealthy.

This is the piranha pool in which the contemporary artist has to swim. The artists represented in this section are exploring ways of criticising this world through mockery or subtlety, manifesting their concerns through many of the techniques that the world of commerce itself uses.

1. Maria Anna Parolin

Maria Anna Parolin is based in Vancouver and was educated in Canada and Italy. She set up Parolin Products, a fictitious company, to 'explore the commercial nature of Western society and specifically the realm of the art market'. Using the skills and techniques of marketing with a wry, ironic wit, this innovative artist offers through a thematically linked series of works an incisive critique of consumerism and at the same time the machinations of the art world. Rather than working in a conventional manner – framed prints, conventional gallery hanging and all that goes with this process – Parolin parodies the techniques of the commercial world by displaying her work in the shop units of shopping malls, or in specially created 'discount sales' areas within public arts institutions. However, she takes the whole process even further by setting the sales price for the items she produces at 'rock-bottom prices', thereby questioning the value system and marketing strategies of the art sales machine.

Each project embarks on a coolly considered study of one aspect of the world of commerce, accompanied by a series of carefully made and packaged products (with supporting sales material) that completes the process. People out shopping, or visitors to an art institution, can see the work displayed in typical point-of-sale format and, if they so wish, they can purchase an item at an affordable price, which is often as low as $4.99. Although the resulting works resemble mass-produced items, every part of each item is in fact individually handmade by the artist with considerable skill. One project, *Nature Series*, consisted of items collected from the natural world – leaves, pine cones, scraps of bark – all carefully categorised according to size and colour, with each piece encased in a blow-moulded plastic bubble attached to a printed showcard. It is recorded that one person bought a packaged pine cone for use in flower arranging, while another came to the realisation that she was in an art gallery and promptly lost interest. In a final twist the Alberta Foundation for the Arts bought up all the remaining stock at the end of the exhibition, thereby transforming these $19.99 carefully packaged fragments of nature into collectible 'objets d'art'.

Another project, the *Executive Series*, comprised four landscape images and four still-life images, each in an edition of five. By presenting essentially worthless materials in a methodically precise composition within an elegantly packaged portfolio complete with porcelain clasps, aimed

Conceptual (from: Parolin Products/Drawing Series)
Drawing, printed packaging, plastic bag; 2000

squarely at the high end of the commercial market, Parolin had produced highly desirable and collectable 'objects worthy of investment'. During a three-month visit to Japan, a country whose cultural traditions have long been a fascination for her, she explored the cultural tensions that exist between the traditional world of the rural craftsperson and the high-speed world of the contemporary city. The conflicts that she observed between these two disparate worlds gave rise to a project addressing the Japanese art of the 'benri' box, carefully created and presented using the traditional techniques and then displayed in a simulacrum of the high-fashion boutique.

In a project entitled *3 Months' Supply*, created in 2004 and based on an artist's residency she fulfilled in Newfoundland, Parolin offers a severe critique of the manner in which social dependency on prescription drugs has become a pervasive influence in many people's

ABOVE *Benri (from: Parolin Products for Busy People Series)* Antique silk fabric, paulownia-wood boxes, gampi silk tissue, paper string, CD-ROM instructional video; (as installed at Harcourt House Gallery, Edmonton, Alberta); 2003
LEFT *Medium Leaf, Light (from: Parolin Products/ Nature Series)* Natural leaf, digital print, vacuum-formed packaging; 1999

lives. Using powdered anti-depressant pills mixed with iridescent pigment she produced a series of stencil prints on paper made by hand with the fibres of invasive plants that are causing ecological imbalance in a Canadian national park. Thus she has drawn a direct and powerful parallel between the humankind's threatening behaviour in both the natural and social worlds.

Through her skill in printmaking and other techniques, Maria Anna Parolin has evolved a unique method for commenting on the lives that most of us in the developed urban world live. Her vision, sometimes subtle, at other times direct, offers a clear insight into the dilemmas our society will continue to face as the new century develops.

RIGHT *Knapweed Close-up (from Parolin Products/3 Months' Supply Series – July)* Stencil print using ground-up antidepressant pill with iridescent pigment, watercolour and gum arabic on handmade paper incorporating fibres from knapweed; 2004

2. Slop Art (Adriane Herman and Brian Reeves)

Few can resist leafing through those catalogues that arrive inside the Sunday newspapers, offering a world of wonders for the house or garden – all those things that you never knew existed and which someone now hopes you will find irresistible. Slop Art is a catalogue that offers consumers the opportunity to purchase real works of art by real, living artists working in a wide variety of mediums but predominantly in printed multiples. As of spring 2004 a total of 50,000 catalogues had been distributed in four American cities, with further supplies being available from a free street-corner dispenser in Madison, Wisconsin. Other copies were made available through the showroom franchises set up in galleries to promote the works represented in the catalogues, at which events some of the artists acted as sales assistants; in addition there is a comprehensive website. The whole enterprise is the brainchild of Adriane Herman and Brian Reeves, who developed it as a means of questioning the commodification of the contemporary art system and its creation of a value system based on exclusivity. Serious fun, then, but worked out to a fine degree of detail, in the process creating something of an art object in the form of the free catalogue itself.

The catalogues feature not only the work of the creators of Slop Art themselves but also other artists from the United States and from countries as far afield as Thailand and Ghana. Prices range from $3.99 up to $4,999.99, and a full range of consumer services, including sales by credit card, is available. The catalogue as a whole is a paean of praise to the American dream, in which any artist can offer their work to a wide public without the need for gallery representation, and any artist can make it to the big time through honest effort and good fortune. As Brian Reeves said in an interview with Melody Parker of the *Waterloo and Cedar Falls Courier* in northern Iowa:

> As artists, we want to place ourselves in the flow of society. People don't think of 'consuming' art, but music is art and people think nothing of paying $14.99 or $19.99 for a CD. Most artists create things and then wait for an art-gallery curator to discover them and give them recognition. Adriane and I had a desire to do it ourselves, to validate ourselves and the work we're doing.

It is a fine conceit, and one which works well on a number of planes, including that of ironic self-deprecation.

Adriane Herman's work offered through the Slop Art catalogue includes the *Gum Care Series* – blind-embossed pieces of bubble gum finished with corn starch, depicting the care of teeth, but also schoolchildren concealing their gum beneath their desks, or a teacher demanding, 'Spit it Out'. These multiples are offered at $299.99, a price that is claimed to be 'Anything but inflated'. She has also gained expertise in cake decorating, using a specialist ink-jet printer and food dyes to decorate cakes and cookies.

Brian Reeves, as well as collaborating with Charlie Reeves in the creation of a limited edition (four) of *Handmade Quilts* at $4,999.99 each, offers the *Thumbnail Sketches Pocket Portfolio*, a small plastic container containing a folded 8 x 1 inch print of five sketches of the artist's thumb, at the bargain price of $4.99. Among the other delights of the catalogue are photographs by John Baldessari, and lithographs created by Ellie and Marnie (elephants from Knoxville, Tennessee) assisted by Komar and Melamid. There are jigsaw puzzles of photos of hair by Kati Toivanen, and you can purchase coasters by Susan Kingsley bearing quotations from the wit and wisdom of George W. Bush, or even *Marshmallow Bathmats* by Lynn Matlock.

Slop Art is a serious enterprise aimed at demystifying the contemporary art world. Along the way, as well as presenting a serious critique of that world, a catalogue is produced in perfect detail that mimics the product-sales system that has become a pervasive part of the modern world. The products are, as the cover proclaims, 'Certifiable Masterworks' – in a world of increasing opportunities, a unique and irresistible claim.

LEFT Brian Reeves: *Thumbnail Sketches*
Ink on paper, plastic container; 20 x 2.5 cm
(8 x 1 in.) (print); 4 x 2.5/2.5 x 0.6 cm (1½ x
1/1 x ¼ in.) (container); n.d.

RIGHT Brian Reeves and Adriane Herman:
Slop Art Catalog #4 Commercially printed
catalogue; 26.6 x 26.6 cm (10½ x 10½ in.);
2004

BELOW Adriane Herman: *Shrink-wrapped
Gum (from: Gum Care Series)*
Blind-embossing on chicle, sugar, corn-syrup
and food-colouring base; dimensions variable;
n.d.

BELOW RIGHT Brian Reeves and Adrian
Herman: *Newspaper with Slop Art
Catalog #4* Printed material including
Waterloo and Cedar Falls Sunday Courier;
15th February 2004

3. Lisa Bulawsky

In September 2000 Lisa Bulawsky led a group of her students at the Washington University in St Louis (where she lives) in a project to make a public art work. This consisted of creating a massive printing plate, inking it, then using a city bus as a giant printing press to transfer the image onto vinyl, the resulting print being displayed on the side of the bus. This 'guerrilla' technique is indicative of this artist's approach to her own work and to her teaching. As a printmaker she describes herself as 'a generalist and a blasphemist ... interested in the populist tradition in printmaking, in reproducibility and its democratic potential'. She also freely admits to appropriating images of popular icons of contemporary culture, and of playing 'the straight man off the comic, the statement of fact next to the irony'. Integrating her personal printmaking with projects devised with student groups gives her work a raw edge, where aspects of the American soul can stand exposed. But her work is far from being ponderously didactic: indeed, its lightness of touch is illuminating.

In her use of traditional techniques such as woodcut and collagraph Bulawsky is as fluent as she is in her use of digital techniques, and the resulting images are just as likely to appear in an unconventional public setting as they are to be seen in a gallery exhibition. This eclectic approach carries with it risks of failure, and she herself would accept that not all of her projects succeed to the same extent. This is less important, however, than the fact of working through the process itself, a case of the journey being of equal (perhaps even greater) interest than the destination. Typical of her approach is the development of Blindspot Galleries, a unique form of mobile gallery which has been the vehicle (literally) for a number of shows by Bulawsky and other artists. The gallery consists of a white Ford minivan upon which art objects made using printmaking technology and magnetic vinyl are displayed, to be seen as she drives about the city or parks in various locations. The added twist is that the magnetic images are there to be taken and displayed on any other vehicle, or a fridge or other ferrous surface. Despite the images in one exhibition proclaiming 'Steal this', a curious reluctance has been noticed among the people of St Louis to even touch the images, let alone remove them.

Other projects by Lisa Bulawsky have included *O Joy!*, in which a series of woodcuts derived from 1950s portrait images were printed on Japanese paper and then displayed 'in serial format on the walls of abandoned buildings and on temporary construction fences, sites that were already being used as advertising space'. These prints simply advertised joy, exhibited in a way that would communicate directly with the public and yet at the same time would be gently subversive. In 2003 she devised a project to celebrate the 150th anniversary of the university, with the title, *Operation Pandemic Joy*. Conceived as a full-scale multimedia project involving the participation of a large group of students, the project used the methods and aesthetics of propaganda to promote

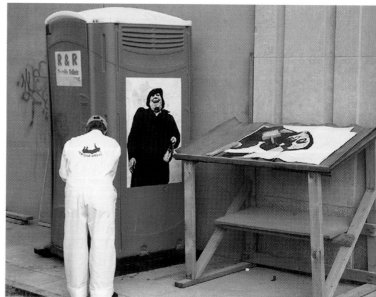

participation in the sesquicentennial celebrations. A banner drawn by a plane initiated the performance, followed by the launching from the rooftops of printed toy parachutes bearing a joyful image, the words 'O Joy!' and the celebration logo – these parachutes being intended as gifts to the public below. Leaflets were then handed out inviting the participants to make their way to the printing booth, where they could design and produce magnetic images to apply to their vehicles and so spread the joy of the celebration out into the community.

Through projects such as these, part of a continuing tradition which resonates through many other examples of American art produced outside the metropolitan art worlds, Lisa Bulawsky is producing a body of work that maintains the pioneering spirit. It would no doubt have been recognised with a smile and a song by Woody Guthrie had he encountered it as he passed by on his way to the 'Pastures of Plenty'.

ABOVE *Operation Pandemic Joy – Chute Drop*
(for sesquicentennial celebrations of Washington University, St Louis) Screen-printed fabric parachutes, cord, weights; 14th September 2003

FROM LEFT
Blindspot Galleries Prints (various mediums and sizes) on magnetic vinyl on minivan; 2003
O Joy! (location photograph, with portable toilet)
Woodcut on Japanese paper; 91.5 x 61 cm (36 x 24 in.); 2001
Award Wall (from: Love Stories 2 (Adjustable Couplings)) Etchings in plastic bags with ink-jet print labels on pegboard, drypoint-on-Plexiglas® awards, black velvet on wood shelf; 2003

4. Kestutis Vasiliunas

Many visitors to Lithuania remark on the elegance of the young people they meet on the streets of this small Baltic nation's cities, and some express surprise at the high levels of cultural output that they encounter in what was once a little-known and seemingly insignificant satellite state within the Soviet Union. These impressions, founded as they are on the vague memories of the twisted logic of the Cold War, are not reflective of the place that Lithuania occupies within the broad history of European culture, nor indeed of the present vitality and hospitality of the country. Lithuania, along with neighbouring Latvia and Estonia, in fact represents one of the remarkable jewels of Europe. These three small countries, despite having very distinct languages and cultures, are united in their mutual love of music and singing, and by their desire to maintain their individuality. Having escaped from the oppressive Soviet past to regain independence and now full membership of the European Union, the three Baltic States are proud and independent nations once more. They have also attained a remarkable level of achievement in the graphic arts, related to but distinct from those arts in other Eastern European countries. In particular Lithuania, with a love of folk culture and storytelling, combined with a strong element of Romuva – the traditional pagan faith of the Baltic region – offers both a clear insight into the old ways of Europe and at the same time a vibrant modern nation fully committed to the contemporary world.

It is in this context that Kestutis Vasiliunas works. Born in Vilnius, where he lives and works as a docent in the Vilnius Academy of Fine Arts, he is active in printmaking, graphic design, installation and performance, as well as exhibiting internationally and organising many exhibitions of book art. His personal work is a lively interpretation, and indeed a splendidly ironic view, of the idiosyncratic world of international fashion, with its glitz and glamour, its extremes of design and its reliance on the bodies of the models to present the exaggerated imaginings of the designers. For anyone even slightly familiar with the sights and sounds of the catwalk shows, or indeed with the coverage of such shows on the Fashion-TV channel, the work of Vasiliunas will bring a wry smile of recognition. His prints capture with economical skill and wit the essential eccentricity of that artificial universe, its pulsing music and flashing lights, the awkward

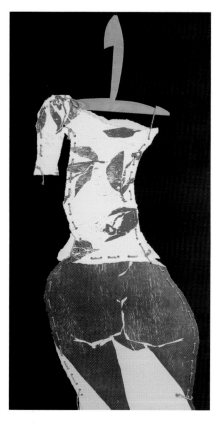
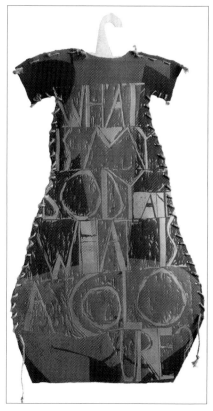
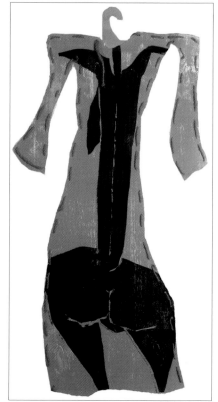

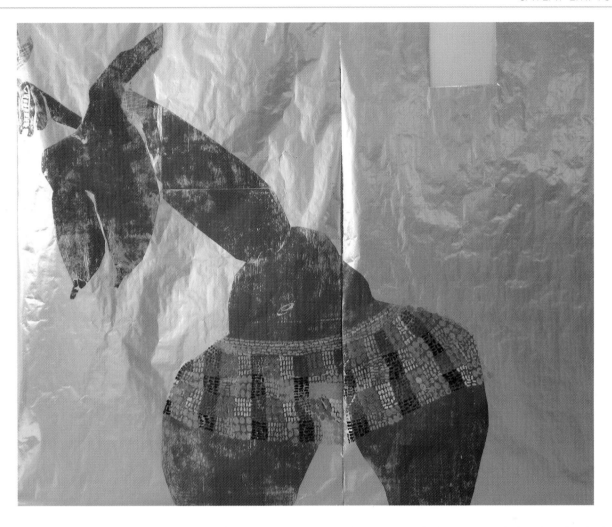

ABOVE *We Dress You* Coloured woodcut on paper, foil; 180 x 363 cm (5 ft. 11 in. x 11 ft. 11 in.); 2003

OPPOSITE, FROM LEFT
Dress No. 012-2, Woman's Jacket Coloured woodcut on paper, rope, wood; 69 x 45 cm (2 ft. 3¾ in. x 1 ft. 5¾ in.); 1999
Dress No. 14, Dress with Text Coloured woodcut on paper, rope, wood; 80 x 50 cm (2 ft. 7½ in. x 1 ft. 7¾ in.); 2001
Dress No. 002-2, Evening Dress Coloured woodcut on paper, rope, wood; 147 x 86 cm (4ft. 10 in. x 2 ft. 10 in.); 1999

rhythmic strutting – hips thrust forward and feet kicking out along an imaginary line – of the models, and the extreme angular poses that aim to show off the cut and fabric of the clothes, but which expose the bodies of the models as much as their make-up and hairstyling to achieve a carefully calculated impact. By presenting his images as double-sided prints, stitched roughly together and displayed on clothes-hangers that seem to have escaped from a cartoon film, he gains the upper hand on the fashion world. The bodies revealed within the clothes are scrawny, with pendulous breasts and exaggerated hips and thighs, and the figures are mostly shown headless, as if the personality and individual characteristics of the models count for little or nothing.

In choosing the vacuity of the fashion world for his leitmotif, Vasiliunas sympathetically points out the essential sadness of an ephemeral existence that is as far from the real needs of everyday women as it is possible to get. In another series of prints on metallic foil the models are further reduced to two-dimensional ciphers, accompanied by pricked-out diagrams and emblematic words such as 'totally sexy' and 'tomorrow'. Such a vision of the world of fashion is, ultimately, a commentary on the frailties of human desire and ambition. By presenting these images as objects hanging backstage at a fashion show Kestutis Vasiliunas offers the possibility of redemption through rejection of the shallow world that they represent. Outside, on the streets of Vilnius and in real life, the elegance continues.

7. TIME AND MEMORY

INTRODUCTION

THE NATURE OF MEMORY has been a major preoccupation for the human race for as long as we have walked on this planet. Mythologies and religions, and all other philosophies, are dependent on memory, through which the history of the tribe can be related and the moral imperatives established. It is widely believed that the earliest manifestations of the visual arts are the paintings and drawings that have been discovered on the walls of caves, and that these served a ritual purpose from which religion has evolved. It is therefore unsurprising that the power of memory lies at the root of much world art. Until the coming of photography the recording of memory in visual form (as opposed to its recording in written texts) was predicated largely on the ability of artists to find a symbolic language through which to delineate all aspects of human experience, not the least of which is memory. As a result, what has been recorded over aeons is as much a series of personal (and often very selective) interpretations as it is a truthful rendition of faces, places and events. The arrival of photography in the middle of the 19th century caused a revolution, in that for the first time the reality of faces, places and events could be captured in an instant, setting them in a kind of temporal aspic, through which they could be revealed to others in some distant future time. But, of course, as with other forms of visual art, photography always was, and increasingly is, open to manipulation and selectivity. It therefore still represents only a version of the reality of the moment, as captured and modified by the photographer. The radical developments in photographic technology – colour, Polaroid®, and most recently digital – have allowed the creation of all manner of alternative versions of reality, upon which much of our visual and social culture has become heavily dependent.

The artists in this section all use photographic means as a part of their work, and all explore the nature of memory and recollection. There is, understandably, a sense of nostalgia and melancholy in what they produce – such is the nature of memory in the recording of the passing of time. There is also something of the celebratory, as well as the 'recollection in tranquillity' that underlies the best of world poetry. Memory is, and always has been, at the edge of consciousness, sleep and the future.

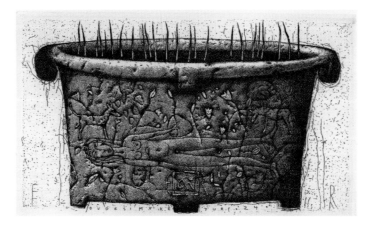

Egidijus Rudinskas *Twenty-Four* Etching; 13 x 22 cm (5 x 8½ in.); 2001

1. Ingrid Ledent

The nature of time is the central element in the work of Ingrid Ledent, and her manner of dealing with the conundrum it poses has led her to explore a wide range of technological mediums as well as maintaining a strong connection with the more traditional medium of lithography. Born in Belgium, she studied in Antwerp and in Prague, and has in subsequent years followed a number of courses in North America exploring differing techniques. She teaches lithography at the Royal Academy of Fine Arts in Brussels, and has in addition led printmaking workshops in many parts of the world, as well as having a substantial record of international exhibitions and awards. A crucial stage in her career was the time she spent in Prague in the 1970s, studying lithography with Rudolf Broulim. His approach, typical of the whole artistic milieu of Czechoslovakia, was at that time in direct contrast to the more traditionally based printmaking world in Belgium. The combination of an idiosyncratic form of surrealism that owed much to the Central European tradition of fairy tales and the socio-political climate that produced both Franz Kafka and Milan Kundera stood in direct contrast to the Flemish traditions in which Ledent had been educated.

Lithography is a technique that appeals to perfectionists, not only in the technical aspects of the preparation of the stone but also in the ways in which the transfer of the image from the stone to the receiving surface (paper or other material) can be controlled. That Ledent is a perfectionist is certain, but in addition she takes the whole process from the conception of the work to its final presentation very seriously. The outcome of her working methods may be something that at least initially resembles a traditional print, or it may be something else entirely, merging her conceptual approach with other mediums including video, digital art or sound. In every case one constant element is a powerful meditation on the nature of the human lifespan. Even in the case of works that approximate the results of traditional printmaking there are differences from the structured approach of that form, such as the combination within one work of lithography on wood or on Chinese paper together with a digital image on paper mounted on aluminium. By setting up the contrasts between these opposing forms and materials Ledent also draws attention to similarities that exist within the chosen images in a work. In addition she produces works in series, utilising the same approach throughout a body of work, thus bringing in the notion of time and the setting up of linear contrasts not just within individual works but also between the works in a series.

The initially stark impression that comes from an encounter with this artist's works changes into something altogether more human when the surfaces within the print are considered more closely. Through the underlying dark grid of a lithographic print a horizontal line of light emerges, continued across the work, formed from the creases in a digital photographic close-up of human skin, or the recognisable elements of mouth or eye – elements which are derived from photographs of the surfaces of the artist's body. In this manner the time taken to produce the lithographic

The Continuous Living of a Memory which Proceeds the Past into the Present I Computer print on Zerkall on aluminium (left and right sections), litho on Zerkall on aluminium (middle section); 64 x 220 cm (2 ft. 1 in. x 7 ft. 2½ in.); 2003

ABOVE *Linear Time II* Litho on Zerkall (2 sections); 65 x 198 cm (2 ft. 1½ in. x 6 ft. 6 in.); 2003

BELOW *The Continuous Living of a Memory which Proceeds the Past into the Present IX* Litho and computer print on Zerkall; 132 x 267 cm (4 ft. 4 in. x 8 ft. 9 in.); 2004

RIGHT *The Continuous Living of a Memory which Proceeds the Past into the Present V* Litho on Zerkall, mounted on aluminium (left section), computer print on Zerkall, mounted on aluminium (middle section), Litho on Wenzhou, mounted on wood (right section); 64 x 260 cm (2 ft. 1 in. x 8 ft. 6¼ in.); 2003

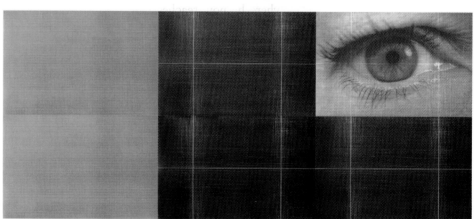

print is mirrored in the passage of time evident in the creases in the skin, so that the physical presence of Ledent, in a kind of intimate self-portrait, becomes one with the processes she has followed over a passage of time to produce the work as a whole. So it is that by following a process derived from, but not subjugated to, a revered traditional medium, and combining it with images derived from a technological medium that contrasts strongly with it, Ledent sets up tensions that reveal her as an artist producing innovative and challenging work. She is not so much concerned with the production of a print edition as a piece of work as she is with using a skilful combination of techniques to produce a new autonomous art form with both cerebral and visceral resonances. In this respect Ingrid Ledent belongs within the long tradition of Flemish art, producing work that is both derived from, and is about, our presence as human beings.

2. Grzegorz Banaszkiewicz

The long tradition of printmaking in Poland matured during the 20th century to become one of the strongest threads in the fabric of the visual arts of Eastern Europe, and as such it has had a profound effect on the graphic arts elsewhere. One of its main strengths relates to the tradition in Polish art academies whereby a student spends time towards the end of their course in the studio of a practising artist, something akin to the relationship between master and apprentice that obtained throughout most of the history of European art. It is commonplace for an artist to cite the name of the artist from whose studio he or she graduated, and through this means it is possible to trace a direct line of artists back through time.

Grzegorz Banaszkiewicz graduated from the studio of the late Mięczysław Wejman, a master in copper engraving and etching, whose prints fuse a very high level of technique with a powerful imagination to create a body of work that has influenced many artists in subsequent years. The tradition of the influence of memory is thus ingrained in the Polish contemporary graphic arts and the art of Banaszkiewicz demonstrates this with eloquence. Born in Częstochowa, where he now teaches, and living in Kraków, this artist benefits from the combined influence of these two cities, whose history is central to Polish culture, with the religious influence of the great Marian shrine at Jasna Gora in Częstochowa on the one hand and the great humanist traditions of Kraków on the other. His work demonstrates a high standard of figurative art, whether in traditional mediums or, as in his more recent works, using digital forms. He records the members of his family and their history, the history of the places in which he lives, and the details of those places through which he travels. By these means his work itself becomes a form of journal in which his memory and imagination are interwoven. At the same time there are themes within the work that have a wider resonance, including a haunting series of works derived from images of Kazimierz, the former Jewish town within the city of Kraków which featured prominently in the film Schindler's List. Those who view his work may wonder at the identity of the people depicted but may find themselves seeing a parallel with someone they know; those looking at images of places may sense a frisson of recognition, a feeling of having been there or seen it before. The power of such images to create links like these is one that Banaszkiewicz understands well and incorporates into his practice.

In the two series *Correspondences* and *Journeys*, the artist creates confrontations between images of objects coming from different places. The original photographic

Correspondence, Kraków – Nurnberg Digital print on paper; 39.7 x 80 cm (1 ft. 3½ in. x 2 ft. 7½ in.); 1999

ABOVE *Correspondence, Lyon – Częstochowa* Digital print on paper; 28.7 x 80 cm (11¼ in. x 2 ft. 7½ in.); 1999
RIGHT *7 Wzlotów (7 Ascents)* Digital print on paper; n.d.
BELOW *Correspondence, Częstochowa – Anvers* Digital print on paper; 29.4 x 80 cm (11½ in. x 2 ft. 7½ in.); 1998

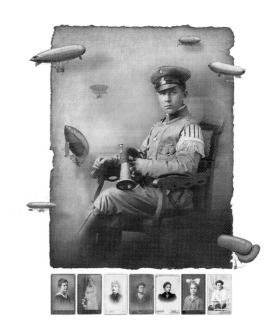

images, one square and one rectangular, are modified only slightly with imaging software, following the principle of minimal intervention. He strives to set up in these confrontations a deeper understanding of these objects' 'matter' in terms of perspective, composition and colour, and in so doing to provoke new associations between them. These paired images make use of images of objects that are both strange and at the same time familiar. By combining two objects, one taken from a horizontal surface and one from a vertical surface, the viewer is encouraged to consider how we relate to the urban environments in which we live. In the new series of digital images, *Patience of the Century*, Banaszkiewicz

proposes a game of cards in which the moves and combinations are limitless. The cards in this case are 19th-century cartes-de-visite, shown either face up or face down, and the objects that enter into the game are objects from the artist's daily life, shown at life-size. He describes the series as 'An imaginary game of Patience, in which the significance comes from the associations and imagination of a participant'.

In all these works Grzegorz Banaszkiewicz sets up opportunities for viewers to merge their individual memories and imaginations with those of the artist – to enter, albeit only briefly, into his world, and after leaving to have the opportunity of looking at their own familiar surroundings with fresh eyes.

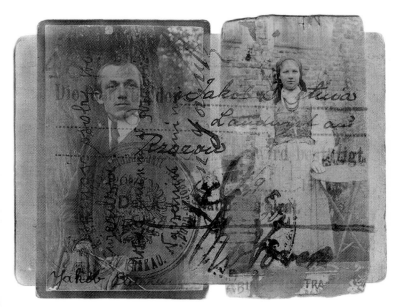

Monika Lozinska-Lee *Images of Memory #2* Digital print on paper; 1999

3. Monika Lozinska-Lee

Monika Lozinska-Lee's journey into the making of art has been a circuitous one, enmeshed with the history of Poland over the past decades. She remembers with clarity her early exposure to the art of photography in Kraków where she was born and educated. At the age of seven, she watched her father in his makeshift darkroom in the family apartment, producing print after print and laying them out to dry in the kitchen. The magic of the process intrigued her and remained with her during her university education in electrical engineering and in the following years when she worked as an engineer. Although she achieved considerable success in this field it did not bring her the satisfaction she sought and like so many Poles before her she seized the opportunity when it arose to emigrate from Poland to the United States. Arriving in New York with no knowledge of the English language she decided to follow her dreams and become an undergraduate once more, this time in the fine arts. She graduated in photography from the College of Arts and Architecture at Penn State University and now lives in Chicago, where she works as a commercial photographer.

Her experiences form the basis and the motive for her personal work, which explores and celebrates the relevance of her past, the history of her family and the changes that are coming about in the new Poland, as well as in her adopted country. She views these from the perspective of one who has made the transition from one country to another, so that the distance in both time and space accentuates the contrasts. Lozinska-Lee has achieved her own individual version of the American Dream, so familiar from the films and literature of the early 20th century. In her personal work she concentrates on the ideas of family, roots, home and the inherent sense of irrevocable change that accompanies emigration. Approached without caution these themes can provoke a very real sense of absence and loss, but she counters this risk by exploring her experience of a new life in a different country to give her the sense of establishing new roots, facing new challenges and building a new home. She writes:

> This is the experience of the foreigner, the stranger: to experience all things as present and yet as traces of something that cannot be made present. I do not want to uncover the sadness of loss. I am more interested in showing how such loss makes up who we are.

In documentary photography derived from her return visits to Poland, Lozinska-Lee casts a quietly observant eye on the changes that she sees through the faces of elderly people, or those of a new generation undergoing the rituals of their first communion or performing as altar boys in a country very different from the one in which she grew up. There is always a tension in returning to the environment of the past, because so much will have

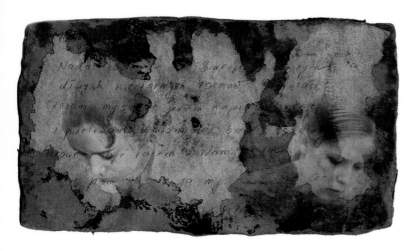

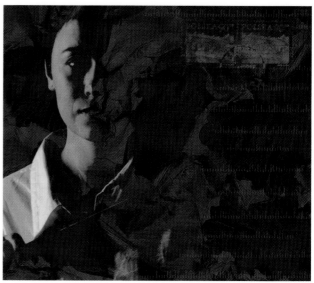

Monika Lozinska-Lee ABOVE *Images of Memory #5*
Digital print on paper; 2000
RIGHT *Images of Memory #6* Digital print on paper; 2000

changed. In exploring her new country she visits communities in rural Pennsylvania, photographing traditional bakers and farriers, as well as Mennonite children or boys with lizards. Seen with the eye of a stranger beginning to feel at home, her images are all the more familiar for their hints of strangeness. As with much documentary photography there is an element of acceptance that all things must change, traditional crafts dying out and childhood coming to an end.

But it is in her personal work in digital imaging that Lozinska-Lee touches the heart of the matter. Through layering digital images of fragments of her family past – letters, photographs, postcards, documents bearing Nazi stamps – and blending these together with delicate colour and textures she succeeds in capturing the past and reinterpreting it for the future. There is a sense of the elegiac, and, as she admits:

> Maybe all photography is self-portrait. In this sense my photography is always a kind of self-exploration. My digital collages construct images of myself, my family and my roots that I have not found looking through the camera. But if I can find myself in others, then others can certainly find themselves in my images.

4. Egidijus Rudinskas

In the 14th century Lithuania became the last country in Europe to convert to Christianity. Its geographical position at the edge of the Baltic Sea and on the fringe of the Great European Plain ensured that for much of its history this small country has been subjugated to larger and more powerful nations; following the end of the Second World War it all but disappeared into the Soviet Union. Yet, for all the accidents of history and geography Lithuanian identity and culture have survived. Indeed, the folk heritage that is lingering evidence of a culture that was once widespread in Europe remains a potent source of imagery and influence for many Lithuanian artists. Since regaining independence after the crumbling of the Communist system, subsequently joining the European Union in 2004, the country has reasserted itself as a unique contributor to the pattern of world culture. It can be said that in some ways Lithuania is a guardian of the cultural memory of the past, but equally that it has shown the ability to assert itself as a fully modern nation. This long cultural heritage is one of the mainstays of contemporary European culture.

Egidijus Rudinskas lives in Kaunas and teaches at that city's Art Institute, which has a good record for producing many of the new generation of artists in the country. Throughout the 1990s he continued to work on his etchings, but in recent years he has explored the potential of digital printmaking, with highly individual results. His

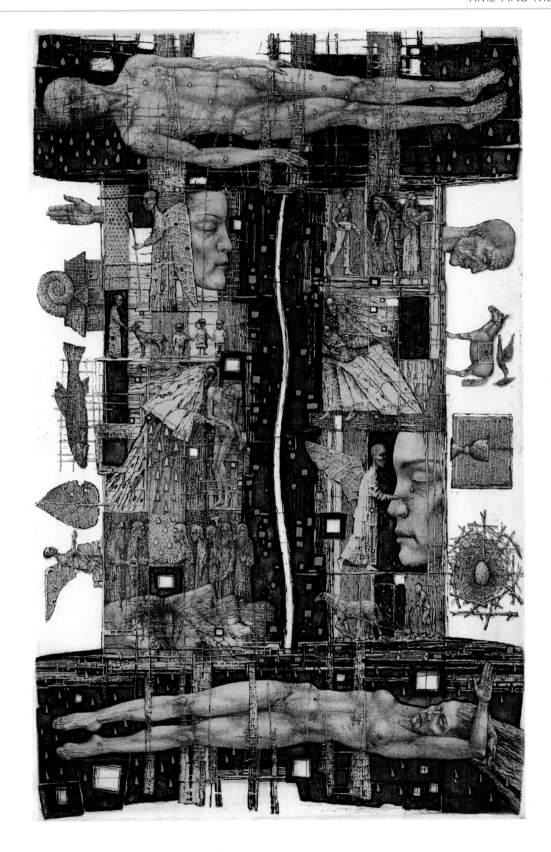

Egidijus Rudinskas *The River* Etching; 50 x 32 cm (1 ft. 7¾ in. x 12½ in.); 1997

ABOVE *Rider 2* Digital print on adhesive paper; 88 x 62 cm
(2 ft. 10¾ in. x 24½ in.); 2003
RIGHT *Hunt* Digital print on adhesive paper; 88 x 62 cm
(2 ft. 10¾ in. x 24½ in.); 2003

etchings are intricate and highly detailed, exploring with
great skill the delicate gradations that are available
through this medium. These prints are modest in scale
but contain within them references to a wide and eclectic
range of subjects. There are traces of the Nordic past – for
instance, rune-like lettering – together with fragments of
the natural world, masks, faces, figures, stones, fruit, ani-
mals and childish scribbles all meticulously composed
into finely wrought narratives full of densely coded allu-
sion. In their complexity they seem like crystallisations in
single images of the cabinets of curiosities of the 16th and
17th centuries, which held collections of all manner of
marvels and strange conjunctions. There is a solemn
poetry to these pieces, and a sense of otherness eluding
description that is evident in prints such as *Garden of
Memories*. In this work, the viewer is presented with an
open book that has leaves, twigs laden with berries, and
fern fronds inserted as bookmarks between the pages. On
the open pages there are botanical names and Latin texts,
including part of Chapter 5 of 'The Revelation of St John',
with its dire warning of disaster. There are also alchemi-
cal symbols and a magic square, drawings of faces and
figures, all perhaps the work of some unknown magus.
Apparently resting on the pages, there are a stone bearing
the letter A and a poppy seed head – the alpha and omega.

Rudinskas's exploration of digital printmaking has
led him towards a totally different outcome, but one
which has a strong relationship with his earlier work, and
indeed with the oldest traces of European art. Some of the

cave paintings and petroglyphs found in the caves of
Southern Europe, and indeed further afield in Africa and
Australia, have been dated at around 50,000 BCE, far ear-
lier than had previously been estimated. This long history
of graphic art is the only reliable link we have with our
distant ancestors. Working from this point Rudinskas
indulges in one of the primal forms of art, the making of
drawings in the sand. He chooses in some works to use
symbols and stylised figures that hark back to the earliest
art, carrying with them a childlike innocence. In others he
makes drawings of faces that resemble those of Cocteau,
but in every case the sand upon which he draws bears the
traces of passing people, bare footprints, imprints of
shoes, of dogs' paws and birds' feet – the beach is not a
tabula rasa. Having made the drawings he then photo-
graphs them, using imaging technology to alter colour
and heighten texture, to create digital prints. In this way
he fuses references to ancient art (which has survived for
millennia) with transitory drawings that will be washed
away with the tide, and with computer technology. It is a
potent encapsulation of time and memory.

8. BODY AND SOUL

INTRODUCTION

DEPICTIONS OF THE HUMAN BODY and the search for self-portraiture have been continuous threads throughout the long history of art. The reasons for this have been many, from the celebration of beauty to the recording of the passing of time and the effects of age, to creating a symbol for power and status, to highlighting social injustice, and many others. The cycles of self-portraits of Rembrandt and Van Gogh are well known and justly celebrated. Then, in the second half of the 20th century, portraiture, and the cult of celebrity that can accompany it, was taken in a new direction in the screen prints of Andy Warhol. And Roman Opałka, to accompany his cycle of paintings *1965/1 - ∞*, takes photographs of his face on a regular basis, but always in the same pose, with the same framing, and with each successive exposure recording the passage of time during which the paintings, listing numbers from 1 to ∞, are made.

The depiction of the nude female body, in particular, has been at the core of much work in painting, printmaking and, since the mid-19th century, photography as well. The relevant issues have been much discussed, and there is also now a substantial amount of work by contemporary women artists that is gradually bringing about a major reassessment of the genre. The continuing fascination of portraiture and the human figure for artists is unlikely to diminish, but the changes in emphasis are likely to lead it in different directions.

The artists in this section use the body and the nature of the soul that is presumed to lie within it as a starting point for their practice. Their approaches are very diverse, and it is significant that some depict their own bodies rather than those of others. In so doing, they question the nature of truth and reality, of our separate identities and our relationship to each other, and by extension the direction in which society as a whole is heading. Artists do not claim divine insight into these matters but, as it has throughout history, the artist's gaze can often uncover aspects of life that might otherwise remain hidden from view. Perhaps it can also direct our attention towards new possibilities for human development.

Beauvais Lyons *The Zooster: Proposal by the Jargon Society, University of Tennessee, Knoxville, October 18th 1894* Lithograph (Photograph by courtesy of the Hokes Archive, University of Tennessee, Knoxville)

1. Davida Kidd

Davida Kidd's work, using both traditional forms of printmaking and, more recently, digitally manipulated photography, has been exhibited widely in many countries and is critically acclaimed. She studied Fine Art and Music in Alberta and British Columbia, and now teaches and lives in Vancouver. In essence Kidd is a teller of tales, usually with a dark or sinister edge, which are inspired by many sources but invariably result in haunting images hovering somewhere between nightmare and fantastical dream. Among her influences she lists the Czech animator Jan Svankmajer, Paula Rego, Balthus, the artists of Graphix Comix, horror B-movies and the films of David Lynch. Much of her work is based on themes connected to the perverse and violent aspects of childhood play which, if not contained within the normal bounds of society, can spill over into adulthood with disastrous consequences. In her work can be seen all the impossible confusions of growing up, in which an innocent game can veer dangerously close to barbarity and where the evils depicted in William Golding's famous novel *The Lord of the Flies* are never very far from the surface, even in polite society. She writes:

Lessons concerning empathy, compassion, tolerance as well as general behavioural skills relentlessly follow us through life, from their beginnings at home, all the way through the intricate chicanery of the institutional bodies that govern our societies. Social ineptness can result in repeated interpersonal disasters, even among the brightest.

The dark imaginings in her work are interpreted through a highly skilful manipulation of materials and techniques with which Kidd controls every part of the process. She has an extensive collection of dolls, toys and ephemera that provides much of her inspiration and raw material. Choosing elements and constructing their settings with the aid of this collection, as well as using a wide range of media, she builds three-dimensional composites which are then captured photographically and digitally modified. The final stage in producing her unnerving large-scale images involves a close collaboration with a specialised print shop using archival materials.

This process leads to an uneasy alliance between the real and virtual worlds of objects and images. The accepted reality represented by the actual objects within

Web Cutter Light-jet print on archival photo paper; 101.6 x 162.6 cm (40 x 64 in.); 2004

her work is balanced against those aspects that owe their presence solely to the manipulation of fragments of digital information, a fragile zone between two frames of existence of which Davida Kidd is keenly aware. There is as a consequence a shifting ambiguity between the various constituent parts which is evident in reproductions of the images, but even more apparent when the full-scale works are seen in an exhibition or gallery setting. Kidd's work can act as a form of mnemonic for half-remembered traces of the viewer's past or echoes of dreams or imaginings. It is not surprising that she feels an affinity with the disjointed world of Outsider Art, which as its name suggests travels in an orbit very distant from the nucleus of the art establishment. Outsider Art is often the product of obsession, but it can also in its strangeness conspire with the everyday experience of viewers to create an instantaneous sense of recognition and familiarity.

The Navigator, awarded the prestigious Grand Prix at the 2003 International Print Triennale in Kraków, is deceptive in its apparent simplicity. The puzzle of why the face is on the baseball remains unresolved even after repeated viewings. It is as much there, or not there, as the smile of the Cheshire Cat in the alternative world of Alice. It hovers in an empty and silent space, eyes closed, seemingly at peace. There is no explanation within the

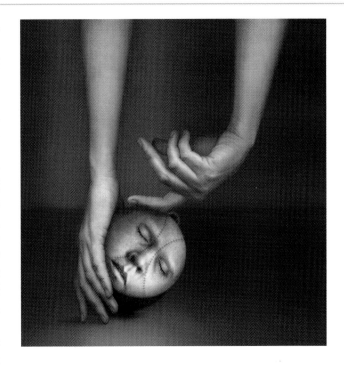

The Navigator Light-jet print on archival photo paper; 101.6 x 96.5 cm (40 x 38 in.); 2001

Guarding Eve Light-jet print on archival photo paper; 121.9 x 167.6 cm (48 x 66 in.); 2001

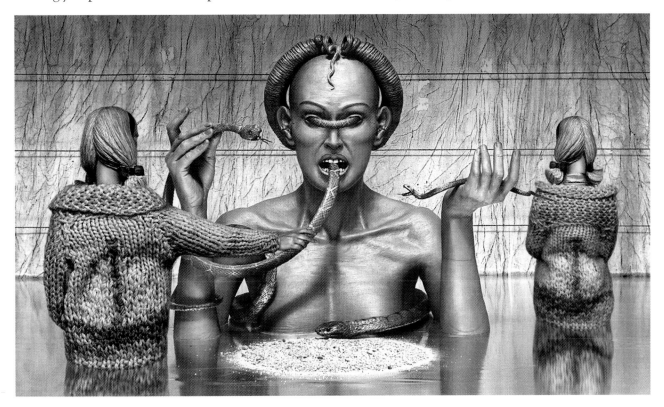

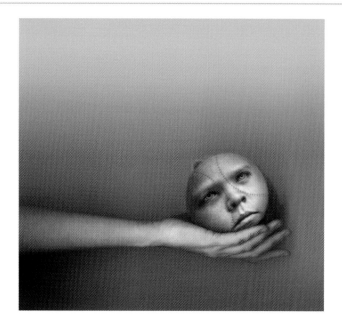

Deep Freeze Light-jet print on archival photo paper; 101.6 x 106.7 cm (40 x 42 in.); 2001

image of the purpose of the baseball or how it came to be present. The only apparently certain thing is that the object is being tenderly cradled, about to be caressed by a gentle finger. But even that apparent certainty is unreliable, because the baseball could be on the point of being curled into the hand and hurled into the space beyond. In Davida Kidd's highly accomplished work, exemplified in these selected images, there is an assured complexity in the way they are made combined with a tremulous uncertainty inspired by the ramifications of the world of imagination, where almost anything could happen.

2. Beauvais Lyons

Beauvais Lyons studied art in Arizona, Wisconsin and New York and is now Professor of Art at the University of Tennessee, Knoxville. He has exhibited his work widely and has wide experience of lecturing and leading workshops. He is Director of the Hokes Archive, founded by Everitt Ormsby Hokes in Britain in the mid-19th century and now housed at the University of Tennessee. More accurately, the archive was 'allegedly' founded by Hokes, because it is in fact an elaborate academic hoax created and maintained by Lyons, designed both to test the viewer's critical skills and to explore seriously the nature of truth. The Hokes Archive so far comprises the Spelvin Folk Art Collection, as well as a medical archive and archaeological collections of artefacts of the lost civilisations of the Aazud, the Apasht and the Arenot peoples. These are all the work of Beauvais Lyons, created in a wide range of mediums including ceramics, fresco and printmaking, and all thoroughly researched and recorded in a strictly academic form. The resulting works have been shown widely in the United States in museum-style exhibitions, accompanied by serious documentation, often with lectures given by Lyons on the subjects depicted or issues connected with the Hokes Archive. These lectures include, 'The Politics of Parody' and 'Olfactory Epistemology: To Smell the Truth'. Highly developed and worked through, these endeavours are neither overtly humorous nor satirical, but instead present convincing simulacrums of real objects made by otherwise unknown people, discovered in hitherto-unknown parts of America, and elsewhere in the world. Lyons states that the nature of his real art is, 'The accumulation of all of these different parts ... like a science fiction of the past'.

In an interview with Joel Davis of the *Daily Times* of Maryville, Tennessee, Lyons said of his work in creating the Hokes Archive:

It's not to say that truth doesn't exist, but it's really important not to believe a source of information simply based on the source, whether it's government, media or academic. Without critical attention to an authority, whether it's newspaper, TV or history books, we will not be able to discriminate between differing sources of authority.

In view of the date of the interview (October 2001) and subsequent world events it can be said that Lyons's comments were, and still are, timely. The same interview revealed that reaction to the exhibition of the Spelvin Collection at St Lawrence University in New York had been mixed, its ambiguous nature confusing some viewers. This serious work is part of a long history of parody in the arts, and it also holds up a mirror to some of the common practices among art museums. The manner in which such contemporary institutions deal with their collections is based in one direction – the academic – on careful research and high standards of recording and cataloguing the works. In the other direction, the commercial, museums ensure a substantial income stream

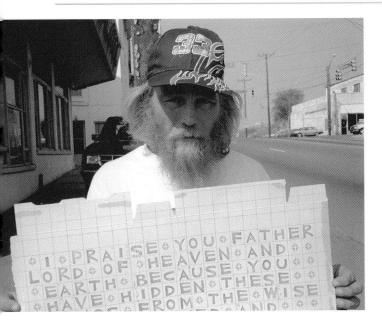

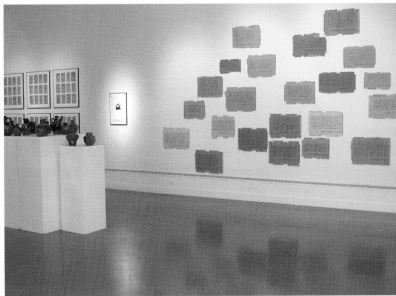

Max Pritchard, Corbin, Kentucky (Photograph by courtesy of the Hokes Archive, University of Tennessee, Knoxville)

Text Prints by Max Pritchard, The George and Helen Spelvin Folk Art Collection, exhibited at the University of Alabama, Birmingham, 2001 (Photograph by courtesy of the Hokes Archive, University of Tennessee, Knoxville)

The Philosophy of Leibniz, Page 175 Lithograph (Photograph by courtesy of the Hokes Archive, University of Tennessee, Knoxville)

through the sale of reproductions and gifts related to the collections. It is recorded that in 1985 the Metropolitan Museum of Art in New York grossed $34 million from the sale of reproductions and gifts, many produced using commercial forms of printmaking.

Seen in this context the work of Beauvais Lyons is both significant and relevant to the continuing debate on the nature, function and soul of art. The critical lens that he holds up allows for a reconsideration of many aspects of the art world that are often taken for granted, while at the same time providing the artist with some profound, self-imposed challenges and the viewer with an ambiguous experience that is both enlightening and entertaining. Referring to the nature of his work, Lyons has written that it can be seen as 'functioning at the edges of the discipline of printmaking'. He has also observed:

Printmaking is central to both my mock-academic methods and concepts. It serves a descriptive and reproducible function, drawing upon the rich museological and scholarly history. Both prints and museums often involve simulations, facsimiles, reproductions and various forms of copying. A faux museum which doesn't include the print would be a less than credible faux museum.

3. Barbara McGill Balfour

Printmaking is the primary component in the work of Barbara McGill Balfour, an interdisciplinary artist who studied in Massachusetts, Paris, Toronto and Montréal, and who teaches at York University, Toronto, where she is Head of Print Media. In addition she gained considerable experience as master printer to artists including Robert Indiana, Komar and Melamid, and Leon Golub. Her personal approach to the making of prints, as well as the other techniques that she uses in her complex and multilayered work, draws on extensive knowledge not only of the fine arts but also of science, psychology and literature. As a result her work, while having a strong initial visual appeal, reveals itself more fully after a consideration of the motivations and nuances of meaning that lie within it. Balfour writes of her work, 'In my art production I have come to consider abstraction as a form of self-portraiture. In the imaging of myself as a transmutable being I try to resist easy interpretations of self-portraiture: that it is necessarily narcissistic, self-indulgent, or even true.' This assertion seems even more valid when seen in the context of that part of her work that takes its inspiration from medicine, in which small elements of the surface of the human body come to represent the whole. This part of her work has a strongly autobiographical content in which she explores the meaningful interrelationship of abstraction and figuration.

BELOW *m melancholia and melanomata* (installation photograph); 90 lithographs, each panel 155.8 x 76.2 cm (5ft. 1½ in. x 2ft. 6 in.); 1996

BELOW RIGHT *m melancholia and melanomata* (detail)

In her printmaking installation *m melancholia & melanomata* (1994–96), Balfour investigated some aspects of the somatic and psychological effects of depression and skin cancer. The two words of the title are etymologically linked to a common ancient Greek root, *'melas'*, meaning 'black': melancholia, one of the four humours, once considered by doctors to be the result of the excess presence of black bile; and melanomata, skin lesions characterised by the malignant presence of melanin. The installation, accompanied by an eloquent artist's book, comprises 90 unique lithographs behind glass on panels that are laid out, raised 5 cm off the floor, on the floor of the gallery, with pathways creating routes through the groups of panels. The variations in the prints convey the shifting pathology of melanomata and melancholia, while the glass reflects those who walk through the installation and look down at the prints. In this manner the viewer becomes involved not only in their physical presence within the work but also in the nature of the journey through darkness implicit within the title of the project.

Another aspect of this artist's work from 2001 onwards involves the use of Silly Putty®. This synthetic material, originally developed in 1943 as a rubber substitute, was first marketed as a children's toy in 1950. Barbara Balfour remembers using it in her first experiences of printmaking, kneading it, flattening it on newspaper-comic images, and then rolling it back to reveal a reverse impression. This inherent capability of the material to reproduce images inspired her to create the *Offspring* project. Silly Putty® is a curious substance: as well as being marketed worldwide as a toy (some 3 million 'eggs' have been sold in the past 50 years) it is also used in medicine, as it has the same specific gravity as human flesh. It is therefore involved in the preparations for CAT scans and also has links with breast implants. It is the mutable nature of the substance – its

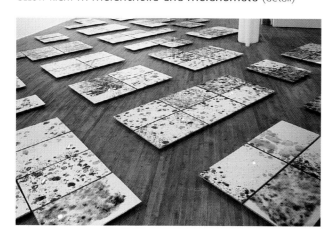

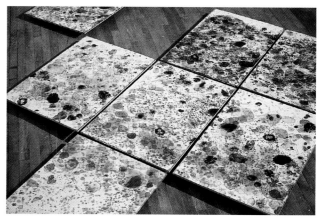

ability to act as a solid and yet to flow like a fluid – and its potential for use as artificial flesh that is central to the project. One part has slabs of the material printed with photolitho images connected with human reproduction, developed in Photoshop® and displayed on shelves; while a related set of prints explores the molecular structure of the material linked to facts about its development and history. *Bouncy*, a computer-generated 3D animation of a ball of Silly Putty® bouncing inside a white cube, adds a further dimension to the experience.

A related work, *Persistence* (2000), consisted of a life mask cast in photoluminescent Silly Putty® which emitted an apparently toxic yellow-green glow in darkness after being charged with ultraviolet light. With the allusions to absence that are inherent in life masks it is ironic that *Persistence* was stolen during its exhibition, a fact that the artist admits has left her somewhat bereft.

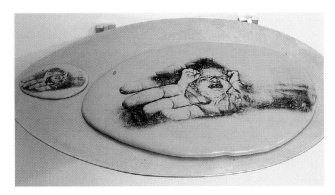

ABOVE *Two slabs of Silly Putty® (from: Offspring series)*
Photolitho print on Silly Putty®; dimensions variable on shelf
45.7 cm (18 in.) wide; 2001
BELOW *The Chemistry of Silly Putty® – detail of dimethylsiloxane, hydroxyl-terminated polymers with boric acid* (from: Offspring series); Silk-screen print on Japanese paper 68.6 x 104.1 cm (2 ft. 3 in. x 3 ft. 5 in.); 2001

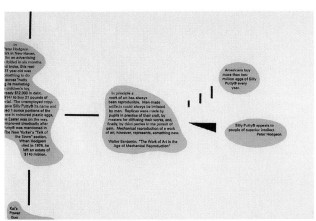

4. Iwona Juskowiak-Abrams

The academic approach to printmaking and art education in Poland, coupling a distinctive and honourable continuation of traditional techniques with an equivalent tradition of experimentation, has resulted in international recognition of the virtuosity in the work of a large number of artists. Iwona Juskowiak-Abrams was born in Kraków and has a master's degree from the Academy of Fine Art in that city. She continued her education with a Master's qualification from the Royal College of Art in London, where she now lives and works. She has exhibited widely and has received a number of awards, including a major award at the 2003 Kraków International Print Triennale. Her large-scale screen prints are derived from photographic images of her own body, and through them she seeks to comment on the nature of identity and mortality, themes of universal relevance. In both their subject matter and their scale these prints are intensely physical, produced using traditional techniques pushed to the extreme. Their powerful impact is clearly traceable to the artist's origins in the art world of Kraków.

In describing her work Abrams aligns it more with the visual arts in general than with just printmaking. She is concerned with exploring fundamental questions, such as the relationship between form and material. A quotation from Robert Smithson is important to her: 'There is no escape from matter. There is no escape from the physical nor is there any escape from the mind. The two are on a constant collision course. You might say that my work is like an artistic disaster. It is a quiet catastrophe of mind and matter.' Abrams stresses that she does not base her work on 'a priori' ideas or theoretical propositions, but that she sees it as a 'hybrid of controlled incidents in which works, to a large degree, make themselves', a statement that goes to the core of her working methods.

The human body, specifically her own nude body, is the starting point in Abrams's practice. In beginning with photographs she acknowledges the universality of the photographic image, which nowadays is essential to recognising the world around us. By working from photographs of her body she achieves her aim of being not only the author of the work, but also its subject and object, making a powerful link between her imagination and the process she has developed to articulate her creative vision. Having organised the setting and lighting,

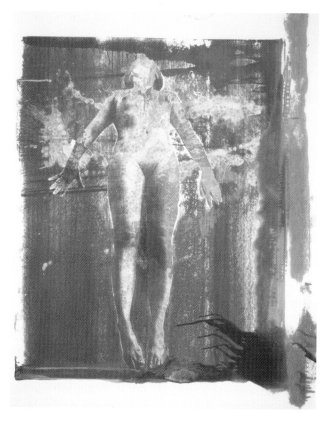

numerous photographs of variations on her chosen posture are taken for each cycle of works. The resulting images are then edited for use in the intended sequence of prints and are transferred to film for screen-printing. The images, often large-scale, are printed onto paper but are then modified by inks being painted into the image, and solvents being poured or splashed during the process, to enable the production of unique prints. In a statement concerning this process Abrams writes, 'My practice comprises an ongoing production of prints governed by their own laws. They do not pretend to be meticulously finished nor do they claim to be skilfully executed', and, 'the prints also become a form of memory, revealing part of the process of the labour of their making', and also, 'I intend to capture an urgency in the making rather than dramatise and romanticise the act.'

LEFT *Rebirth 6* Unique screen print on paper; 240 x 220 cm (7 ft. 10½ in. x 7 ft. 2½ in.); 2002
BELOW LEFT *Up and Down 11* Unique screen print on paper; 200 x 200 cm (6 ft. 6¾ in. x 6 ft. 6¾ in.); 2002/3
BELOW *Day 12* Unique screen print on paper; 90 x 64 cm (2 ft. 11½ in. x 2ft. 1¼ in.); 1999

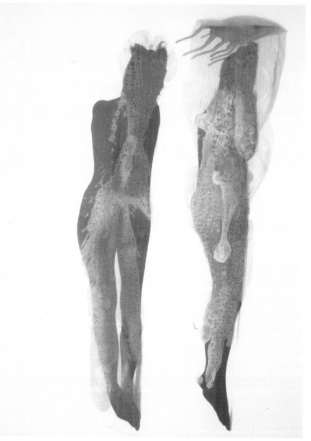

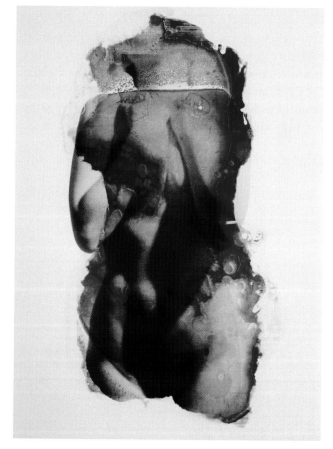

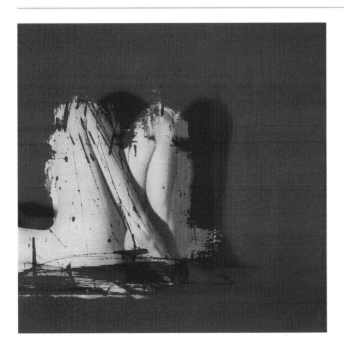

Thirty and One Nights Starting from the Fourth – Book 13
Unique screen print on paper; 44 x 44 cm (1 ft. 5¼ in. x 1 ft. 5¼ in.); 1998

The way Abrams works is therefore a process for transmuting the artist's body by photography, and through her physical effort, into a two-dimensional image that combines printmaking and painting techniques. These powerful images are also an example of how contemporary printmaking can be taken to limits at which it becomes almost a new medium. The results are sensuous, meditative and questioning, challenging (in the artist's words) 'the stereotype of passivity of the feminine'. They are also markers for the passage of time, a trace of memory, a record of inevitable change and, because the paper prints contain the seeds of their own eventual deterioration and loss, fundamentally connected to the essential mutability of human life.

5. Patricia Villalobos Echeverría

Transculturation – the phenomenon whereby 'the human body is transformed by place while at the same transforming its site and geography' – is central to the work of Patricia Villalobos Echeverría. From her interest in transcultural and post-human issues and the way in which alternative political identities have been created in the Western world in recent decades, she has become concerned with redefining the body. The 20th century, more than any other, has seen massive translocations of people brought about either through choice or by force, as well as genocide, war and destruction on an unprecedented scale. At the same time the rise of biotechnology, genetic engineering and the imminence of cloning have engendered not only widespread fears but also a growth in the movie mythology of the cyborg. These issues and the relationships between them lie at the heart of what Echeverría strives to present within her work.

Born in Memphis, Tennessee she moved afterwards with her Salvadorian family to Nicaragua, where her childhood was shaped in part by the Managua earthquake and the civil war. She returned to the USA following her father's death in 1978, and subsequently received her university education in

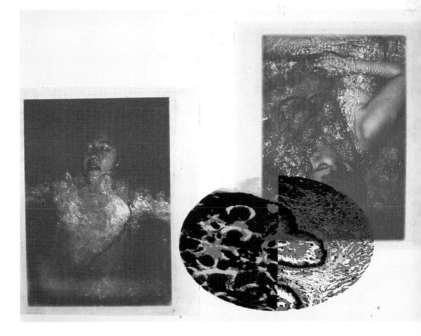

RIGHT *Patricia Villalobos Echeverría, Host 3* Photopolymer intaglio and 4-colour serigraph; 132.1 x 95.9 cm (4 ft. 4 in. x 3ft. 1¾ in.); 2002

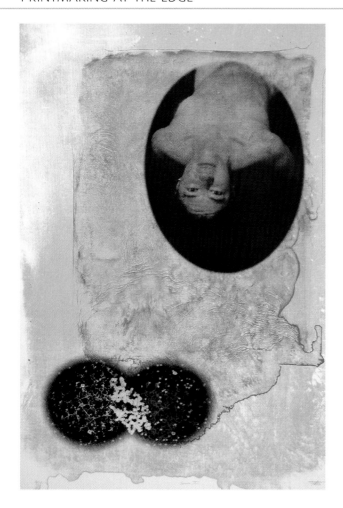

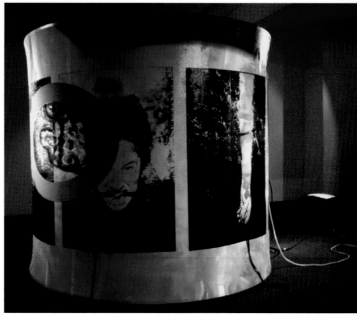

ABOVE *Viro* Acrylic ink and serigraphs on canvas, medical tubing, 2 DVDs, audiovisual equipment; drum measures 213 x 244 cm (7 ft. x 8ft.) (height x diameter); (as installed at Lima Biennial, Casa Rimac, Lima, Peru, 2000)

LEFT *Soma II* Lithograph, photopolymer intaglio and 4-colour serigraph on Rives BFK

Louisiana and West Virginia. Since then she has taught at various American institutions, including the Indiana University of Pennsylvania, where she is now Associate Professor of Art. She has exhibited and lectured widely in the Americas and in Europe, receiving a number of awards.

Echeverría's use of images of her own body is of central importance to her work, though she does not consider it necessarily to be biographical. Instead it is emblematic of the constant process of presence and erasure, memory and amnesia, in the human experience. She writes, 'using oneself in work I think gives one the ability to recognise the "distance" inherent in the contemporary body, and this is in some way what I am trying to, if not document, capture'. The human being is an intruder in water, in which survival of the unprotected body is constantly threatened; snow, despite its pristine beauty, presents even greater danger. To this artist water and snow are of particular importance since they are 'transformative and malleable (much like I think of the body) and at the same time in some states

(snow) [is] alien to this body and provides it [with] the ability to "hover" or "float" in its own un/consciousness'. Echeverría is also closely aware of the complexities of history in her Central American roots, of the collision of cultures among the highly structured societies of the native races, the imperialist intentions and religious intolerance of the European Catholic invaders, and the African influences that are a legacy of the slave trade. This cultural blend is inseparable from the genetic blend of different races that has resulted in a large number of people in the region having what the artist refers to as, 'chaotic family histories and personal identities'.

In attempting to bring order to this chaos and to address her many aims and concerns Echeverría uses not only printmaking but also photography, sound and video, and installation. Through this multimedia approach she feels she is able to articulate these concerns more deeply than would be possible through flat prints alone. A viewer moving among the various elements of one of Echeverría's installations experiences a constant change of emphasis, which has much to with

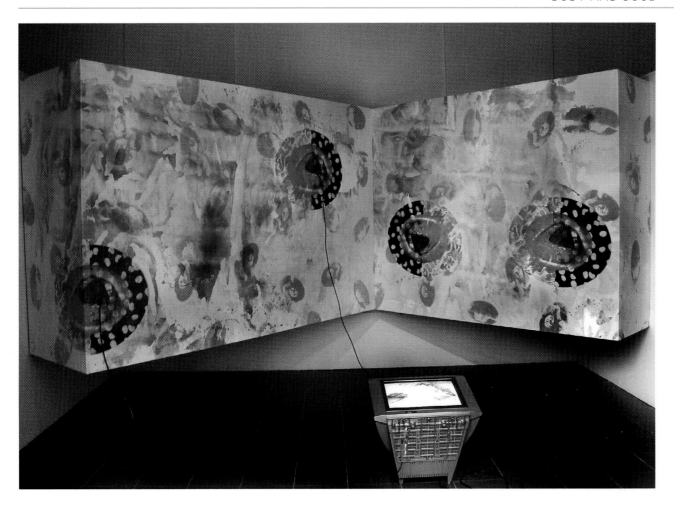

Rastreo/Trackings Installation view DVD, 20-in monitor, electric wire; approx. 457 x 183 cm (15 ft. x 6 ft.) (width x depth) (as installed at Central American Biennial, Managua, Nicaragua, 2000)

the large scale of these images and also the use of sound and video. In her desire to provoke the viewers of her work into deeper reflections on its content, the artist has developed a visual language that is rich and complex. In her recent work she has gone further, provoking consideration of the prevalence of viruses in world society, both as diseases and as used in biotechnology. By continuing to place herself within her images she is constantly reminding the viewer of the relevance of such global problems to individual lives. Like her, we cannot separate either our bodies or indeed our understanding from the complex system of relationships on which the beneficent evolution of society must ultimately depend.

6. Alicia Candiani

Alicia Candiani has played an important part in the recent reassessment of the portrayal of women in art history. Born in Buenos Aires, where she still lives and works, she has degrees in Fine Art and Architecture from the University of Córdoba, Argentina, and has also studied in the United States. Her record of international exhibitions is extensive, as is her academic work in many countries, and she has gained many important awards. She is the founder and current Director of Proyecto <A-Ce>, an international art centre focused on printmaking and new media, in Buenos Aires.

The new technologies that became available during the 20th century for the accumulation and communication of information, particularly digital technologies and the Internet, have hastened the dissemination of our cultural knowledge. We can now take a very different view of who we are and of the means by which the cultures that portray

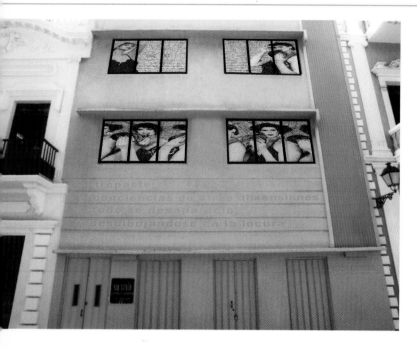

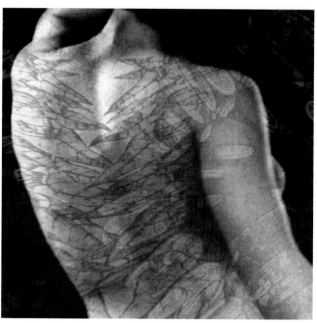

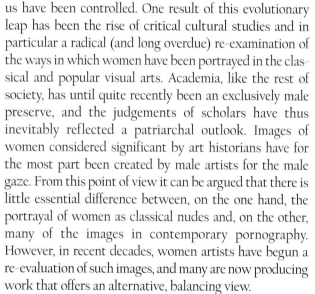

Public Spaces, Private Images (Façade of Sin Título, a contemporary art gallery in San Juan, Puerto Rico) Digital print using oil-based ink on micro-perforated self-adhesive film, mounted on glass; 210 x 130 cm (6ft. 10¾ in. x 4 ft. 3 in.) (each window); 2002–3

As Thorns (from In the Land of her Soul series) Digital print on Arches paper with relief processes; 70 x 70 cm (2 ft. 3½ in. x 2 ft. 3½ in.); 2002–3

us have been controlled. One result of this evolutionary leap has been the rise of critical cultural studies and in particular a radical (and long overdue) re-examination of the ways in which women have been portrayed in the classical and popular visual arts. Academia, like the rest of society, has until quite recently been an exclusively male preserve, and the judgements of scholars have thus inevitably reflected a patriarchal outlook. Images of women considered significant by art historians have for the most part been created by male artists for the male gaze. From this point of view it can be argued that there is little essential difference between, on the one hand, the portrayal of women as classical nudes and, on the other, many of the images in contemporary pornography. However, in recent decades, women artists have begun a re-evaluation of such images, and many are now producing work that offers an alternative, balancing view.

Candiani states that her work 'explores female identity and issues of gender while investigating political and social issues in Latin America'. She uses imagery derived from 19th-century Argentinian painting, national symbols, early pornographic photographs and architectural drawings. Her focus is on exploring the manner in which the female body has been reduced, displayed, glorified and,

finally, conquered through male art, and how this reflects the dominance of patriarchal European imperialism in past centuries. By liberating images of the past from their previous confines and reinterpreting them in her work Candiani is also addressing the liberation of women. While she is keenly aware of Argentina's dark history of oppression and violence, she can also work from the particular to the general, giving her printmaking a relevance that extends well beyond the borders of her country.

In her catalogue essay for the XIII San Juan Print Biennial (2001) Candiani wrote about technique being an unavoidable dimension of printmaking. In historical terms the work of printmakers was seen as being subservient to the work of painters, but this situation has now changed, as have the methods by which prints are produced. She writes:

Today, more than ever before, the technology we use acts at once as determining factor, and filter, of significant elements and experiences. Undoubtedly, we must rethink the relationship between art and technique and the situation of the printed image within these new contexts, which will lead us first to radically revise the concepts of multiple and original.

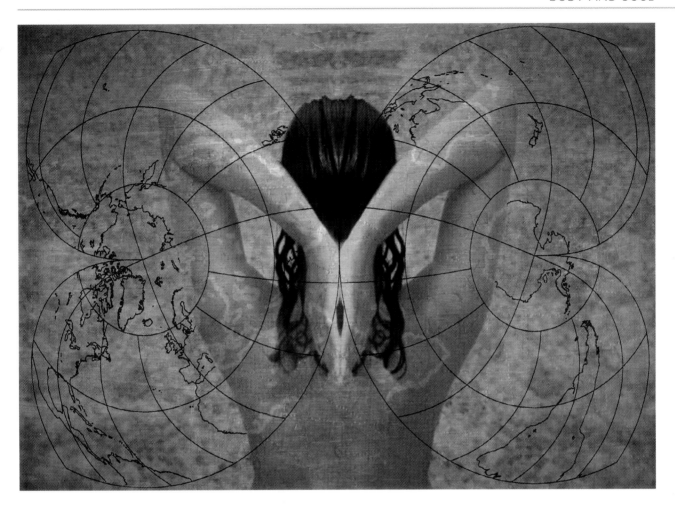

Humankind (from Continent series) Digitally printed film mounted with 1-in gap in front of a background of water-based woodcut on Bhutan paper; 70 x 100 cm (2 ft. 3½ in. x 3 ft. 3¾ in.); 2004

In effect, printmaking becomes just another medium through which artists can communicate their work, an evolution that Candiani no doubt welcomes. In addition, what was previously regarded as an unbridgeable gulf between traditional, edition-based techniques and digital (either unique or unlimited) techniques has indeed been bridged, and with seemingly remarkable ease, by Candiani and many other artists. For example, in the *Continent* series exhibited in November 2004, she combines water-based woodcut with digital print on wood – two techniques that have their origins some five centuries apart. The outcome is reliant on the medium only as a vehicle, not as an end in itself.

The manner in which Candiani approaches her work combines a profound understanding of art and social history with a skilful control of techniques and a record of exhibiting that work in less-than-conventional settings. The confidence of Candiani's art and her continuing focus on realigning the place of women within the full context of society suggests considerable reason for optimism about the future.

9. ISSUES

INTRODUCTION

PRINTMAKING HAS LONG PROVIDED a platform for presenting arguments against the Establishment and for highlighting the effects of social injustice. In 18th-century Britain satirists such as Gilray, Rowlandson and Hogarth used the printmaking technologies of their day to point out, often viciously, the manners, foibles and errors of the ruling class. Gustave Doré did likewise in the 19th century in his prints of the Dickensian stews of Victorian London. In the 20th century the celebrated poster artists of the Communist period in Poland used their graphic art to satirise, and indeed to protest against, the dangers and injustices of the totalitarian system. There are many contemporary examples of artists using cartoons, graphic novels and caricatures to mock politicians and celebrities, as well as to make serious comments about the society in which we live. It would be a sadder and a poorer world if politics was not subject to such criticism, as there is certainly enough evidence to show that satire can help to bring despotism and bad government to its knees.

Many contemporary artists, including those in this section of the portfolio, use printmaking techniques as part of their work, for much the same reasons as artists in the past. The production of multiple images is relatively straightforward and economic, so transmitting a message to the wider public is a relatively easy business. The nature of the completed images, being akin to the familiar advertisements seen in the daily townscape, makes them accessible – unlike paintings, which have an otherness that removes them from daily experience. Even in cases where the printed image becomes part of a more complex installation within an art gallery, the immediacy and familiarity of printmaking techniques are helpful to an artist needing to communicate often complex ideas. Extending the everyday experience of the printed environment into an art gallery has the two-way benefit of increasing accessibility and offering the chance to reassess the outside world in different terms. The added possibilities of digital print techniques will only serve to encourage further developments in this field.

1. Barbara Zeigler

Vancouver, a city between the Rocky Mountains and the Pacific Ocean, is close to some of the most celebrated wilderness landscapes in the world. The city also has a vibrant and innovative community of print artists. Barbara Zeigler, who studied in Illinois and Munich, lives and works in this city, where she is an Associate Professor at the University of British Columbia, and leads the highly regarded Printmedia Research Centre. Her personal printmaking work is firmly based on her growing understanding of the relationship between evolving culture and the ecosphere, an issue which has been central to her concerns for over 30 years. In both her personal work and her teaching in printmaking she has followed closely the developing technology of digital imaging, while her grounding in painting, drawing and traditional printmaking has provided her with a strong basis for understanding how digital techniques can been used to create new forms of print. She writes:

By-Catch, Steveston, BC Giclee print; 43.2 x 94 cm (17 x 37 in.); 2003

I think it is a very exciting time for those working in print media, because it is as if the past, present and future are suddenly within grasp to study and critique in ways that have not been possible until now. It is as if a time portal has been opened allowing those involved in print to access an amazing range of techniques, with each technique having specific expressive qualities and a specific history.

Barbara Zeigler's deep concerns about the ecological threats to the planet, particularly in the region where she lives, centre mainly on the problems of industrial fish-farming and pollution. While the outstandingly beautiful Pacific Coast of Canada offers a wealth of opportunities for leisure pursuits, it also holds growing evidence of the damage that can be caused by industrial technology. This dichotomy has provided Zeigler with much of the impetus for her personal work, but also for work that she has carried out in the community. She has recently worked with a group of students on the collaborative group design of a 13 x 40 ft. mural at an inner-city elementary community school, and prior to this she created a collaborative art project with a school and members of the public in Richmond, BC, resulting in a large ceramic mural, *The South Arm Millennium Mural:*

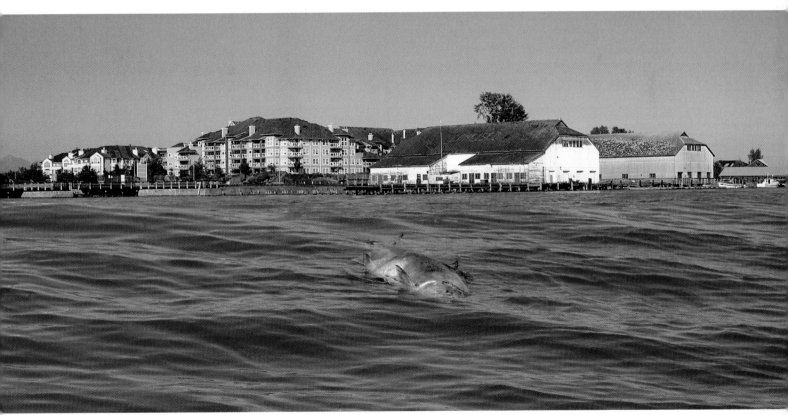

ABOVE *Under Siege* Giclee print, archival ink; 91.4 x 96.5 cm (36 x 38 in.); 2004

LEFT *Parking Lot, Vancouver, British Columbia* Giclee print, archival ink; 89 x 97.1 cm (2 ft. 11 in. x 3 ft. 2¼ in.); 2003

BELOW *The Chip Barge: North Arm of the Fraser River as viewed from Iona Island, Richmond, BC* Giclee print; 40.6 x 87.6 cm (1 ft. 4 in. x 2 ft. 10½ in.); 2004

Tribute to the Ecosphere. This commitment to interdisciplinary working has also enabled Zeigler to develop ideas for her personal images in collaboration with scientists and researchers in the field of aquatic ecology.

Her images are derived from photographs, which are combined and modified via Photoshop® using techniques that she compares to those of burnishing in intaglio printmaking or erasing into graphic works on paper. While it is possible to work very quickly through the use of digital software, Zeigler prefers to work over a longer period of time, allowing her images to evolve in a manner similar to the way a traditional print is made. However, being deeply concerned about the environment, she is keenly aware of how digital technologies use hardware that is potentially a serious source of future pollution; but she compares this with the toxic materials used in traditional printmaking and the high consumption of those materials, all of which she forgoes by working in digital. It's a trade-off that informs her work.

Her images likewise deal with dilemmas and paradoxes. In *Parking Lot* she contrasts a clear running stream with hard tarmac, a dead fish with a line of parked automobiles. *By-Catch* shows suburban apartment blocks mimicking the architectural style of the traditional fish-treatment sheds that they overshadow, with a dead fish alluding to the loss of the former industry. In *Under Siege* burning wood is merged with swimming fish to create a disconcerting conflict of messages – referring to deforestation and toxic run-off, growth and destruction, and, again, the dead fish. *The Chip Barge* is from a photograph taken on Iona Island close to the UBC campus. Zeigler comments that if the viewer shifts the line of sight from north-east – where this image is taken – to the north, then the view, without the evidence of timber extraction, looks more like paradise. Conflict and paradox emerge from these at first seemingly innocuous images, which constantly question the ways in which 21st-century humankind is treating the fragile ecology of the planet.

RIGHT **Chila Kumari Burman** *Sky Fits Heaven* Ink-jet print and collage; 42.2 x 59.4 cm (1 ft. 4½ in. x 1 ft. 11¼ in.); 2003

2. Chila Kumari Burman

Chila Kumari Burman, born in Bootle, close to Liverpool in the North-East of England, grew up in a Punjabi family and showed an early aptitude for the visual arts. The cultural mix of her childhood remains an important element in her life and her approach to the making of art, not only giving her access to an extremely eclectic range of sources but also a clear understanding of the conflicts and compromises that a such a collision of cultures can provoke. Over the past 25 years she has participated in a large number of group and solo exhibitions in many countries, and has taught art in higher education. She lists the concepts, ideas and themes that drive her as follows:

> Challenging stereotypical assumptions of Asian women, my work is informed by popular culture, Bollywood, fashion, found objects, the politics of femininity, the celebration of femininity; self-portraiture exploring the production of my own sexuality and dynamism; the relationship between popular culture and high art; gender and identity politics.

In addition she is, and always has been, a collector and hoarder of what she happily refers to as 'girlie junk' – dress accessories, cheap jewellery, beads and bindis, make-up, scraps of images and packaging – things that are of little intrinsic worth but that prove a rich resource for her art. Through collecting and sorting these ephemera and then recycling them in her work she

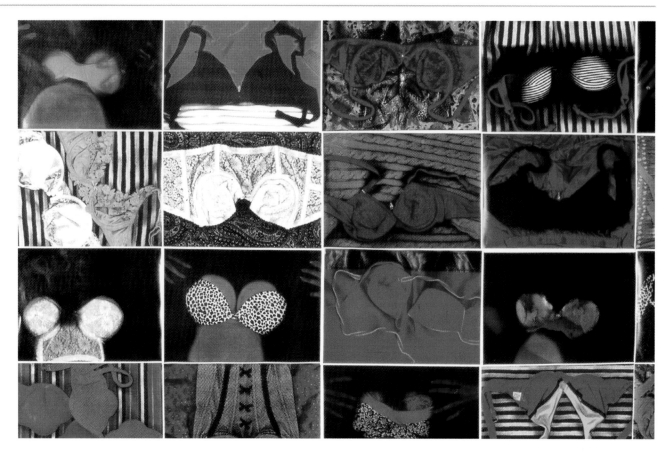

ABOVE *Hello Girls III (detail)* Cibachrome print of mixed-media collage; (whole work) 240 x 1200 cm (7 ft. 10½ in. x 39 ft. 4½ in.); 2003

invests them with a new richness and value, while at the same time creating work that both celebrates and criticises the themes that power her imagination.

Beneath the surface of Burman's work lies a range of influences that add richness to her basic cultural mix, ranging from Hindu philosophy and Bollywood culture, through Indian comics and urban street culture, to international film and world music, taking in Dada, surrealism and Arte Povera along the way. In short, she aligns herself with a complex range of influences emblematic of 21st-century metropolitan Britain. At the same time her work acts as a bridge between her Indian and British roots through a richly layered hybrid of the two cultures, achieving results that are most certainly more than the sum of their individual parts. Indian art (traditionally produced by male artists) has long been associated, among other aspects, with the celebration of female beauty, from temple carvings through miniature paintings to the iconic representations of female perfection in the tumultuous output of the Bombay (Mumbai) film industry. Burman employs this preoccupation as one of her motifs but subverts it with a feminist twist to comment on both the cultural and gender identities of Asian women in Britain, and indeed elsewhere. She incorporates drawings and prints of the body into the rich textures of her work, combining them with diverse ephemera from her collections. Latterly she has also used bras within her work, notably in a major work, *Hello Girls* – an allusion to the advertising campaign for the Wonderbra that achieved notoriety with the blatantly sexist 'Hello Boys' posters emblazoned on hoardings and the sides of buses in 1994. Burman takes this theme but reclaims it for women by combining colour prints made from a wide variety of bras in different fabrics, pressed against the glass of the photocopier, collaged with other fabrics, interleaved with flowers, jewellery, bindis and fashion accessories. The combination of the sacred, represented by the flowers, and the profane, represented by the bras, builds up a richly worked and highly coloured series of A3 prints which, when installed in a dense grid, create a fascinating reworking of the notion of the wonder wall.

OPPOSITE *Untitled* Ink-jet print, collage and bindis; 29.7 x 21.1 cm (11¾ in. x 8¼ in.); 2004

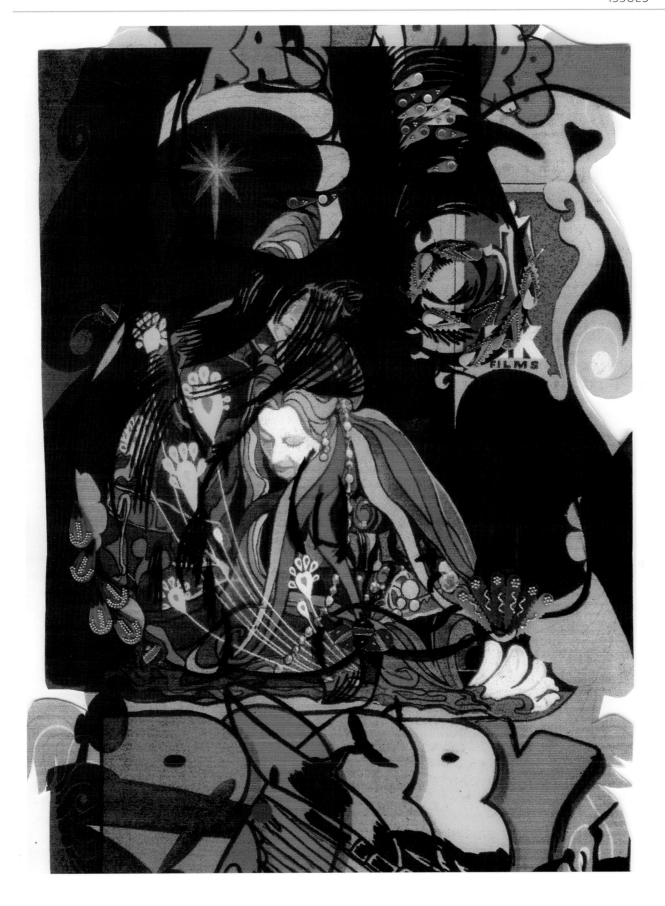

By combining such disparate elements of the imagery associated with contemporary femininity in this manner she appropriates the commercialised relationship between lingerie and the female body, and restores it to a position that echoes the equal place the female occupies within the duality of Hinduism. This she does with a seamless blend of serious intent and great good humour. At the same time in this work and other similar works with a similar theme, Chila Kumari Burman presents a joyful celebration of female desirability, albeit a celebration which contains implied criticism of the lingering remnants of outmoded male sexism – the spectre at the feast.

3. Daryl Vocat

Daryl Vocat lives and works as a printmaker in Toronto and has over the past few years been working on images – mostly screen prints but also digital photographs – that deal with the conflicts that arise within the need to establish identity within society. More specifically, they deal with the conflicts that come from a growing realisation of being gay. He considers his work to be an ongoing search for representational accuracy as well as being a search for the flaws and misunderstandings that exist within relationships and other social constructs. In choosing to conduct this search by recontextualising and manipulating already existing images he exposes an alternative point of view. By acknowledging and reaching beyond the relationships within society that define our identity and at the same time put constraints on us he strives to present another set of possible interpretations of everyday images. In so doing he provides an opportunity for us to reconsider our views, not only of ourselves, but also of others.

The process Vocat uses to create the images within his work can be seen as subversive, but in a manner that demonstrates a lightness of touch beneath the serious intent. There is almost a sense of familiarity in these images, and the recognition of half-remembered drawings and diagrams that might perhaps have been seen elsewhere and in a different context. By reclaiming such images and reinterpreting them he has found a way to share his perspective of growing up in a society where, despite an increasing openness, homosexuality is still seen by many as being 'abnormal'. Vocat's world view of the passage through childhood and adolescence into

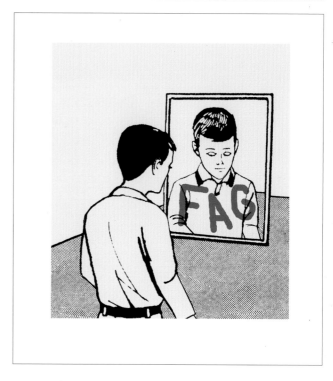

Personal Measurements Screen print; 38.5 x 34.5 cm (15 x 13½ in.); 2004

adulthood, and the self-knowledge gained in that journey, offers those who see his work the chance not only to come to a better understanding of an individual process of conflict and resolution but also to reach a fuller appreciation of the diversity of society. Of his earlier work he writes:

> My previous work has been an exploration of the wonder and awkwardness of growing up queer. These images were created using found photographs and manipulated illustrations from Scout manuals. Seen and unseen elements are depicted in overlapping images. Contrast reveals secrets, chronicling worlds forgotten or ignored.

An early series was entitled *Perfectly Normal*. One poignant image, *The Silent Spot*, shows a young boy in the foreground sitting at a table on which lies a pencil. The image is drawn in simple black line. In it the boy is holding a note. In the background there is a diagram from a manual on knots of how to form a noose. Behind this diagram and in red is a handwritten note, which reads like a suicide note. The evocation of the painful conflict in the boy's mind, at which we can only guess, is subtle but acute, and we are reminded of the fears and hypocrisies that impinge upon adolescence. From the same series another image,

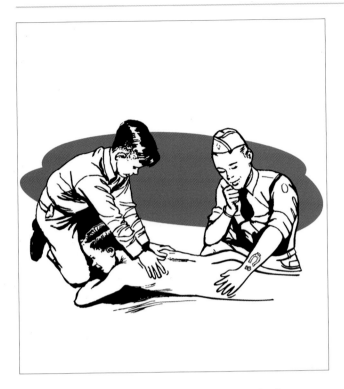

Massage Screen print; 38.5 x 34.5 cm (15 x 13½ in.); 2004

ABOVE *Tie* Screen print; 38.5 x 34.5 cm (15 x 13½ in.); 2004
BELOW *Leadership and You* Screen print; 38.5 x 34.5 cm (15 x 13½ in.); 2004

Leadership and You, combines an image of a Scout bird-watching through binoculars with an image of a naked man standing in a pond. Between the two images, in red, is an electric flex with plug, the flex having been cut through at one point to expose the live wires inside, the danger of electrocution being highlighted by the traditional lightning-flash signs. The ambiguity of this image creates a different set of responses to those engendered by *The Silent Spot*. The technique used to create those responses, however, is the same.

In a recent series, Daryl Vocat has further developed his theme of exploring the confusions and ambiguities in many everyday activities. The contrasts between the boys in Scout uniform and their activities are tinged with the deeper resonances of adult life. In *Gun*, for example, a Scout holds a revolver in one hand with his other hand in his pocket, while smiling out at the viewer. The sinister conjunction of the childhood game and the adult attraction to weapons of aggression is clearly indicated. In *Tie* two Scouts are roping their leader securely; the leader is gagged and unable to move. Is this practice in the art of knotting or a challenge to authority? Both are implied, neither is dominant. This skilful manipulation of complex ideas through relatively simple means runs through Daryl Vocat's work, provoking a full range of emotional responses in the viewer.

4. John Hitchcock

John Hitchcock had what he describes as 'an intercultural hybrid American upbringing', coming from mixed Kiowa/Comanche and German/Northern European stock. Born in the Wichita Mountains, he studied in Oklahoma and Texas, and now teaches printmaking and installation at the University of Wisconsin-Madison. His work has been exhibited widely, both in the United States and internationally, and he has also been involved in numerous public-art projects and national printmaking events. His childhood experiences of living close to the US Army base at Fort Sill and of being close to the wildlife refuges in the mountains remain powerful sources of inspiration for his work. He has memories from the early 1970s of the tanks rolling past his home at night, of helicopters overhead and military exercises in the woods, and of how he thought the television images of the Vietnam War were coming from outside his window across Highway 49. 'It was,' he admits, 'somewhat confusing.'

ABOVE *Crusade, Wanted* Screen prints/digital prints; 2002 (installed as part of the 'Terminal' exhibition of work by John Hitchcock at Joseph Gross Gallery, University of Arizona, August–October 2004)
INSET *Wanted* Screen print/digital print; 111.8 x 76.2 cm (3 ft. 8 in. x 2 ft. 6 in.); 2002
Crusade Screen print/digital print; 111.8 x 76.2 cm (3 ft. 8 in. x 2 ft. 6 in.); 2002

The issues with which Hitchcock deals in his work emerge from this background and from his close engagement with the politics of contemporary America. He is profoundly aware of his tribal inheritance and the manner in which the nature of armed aggression against native peoples in the past is reflected in current international conflicts. It is his belief that 'The foundation of the

United States was built on assimilation, relocation and genocide', and that 'We need to look at American history and ask serious questions now. We need to question the notion of progress, including the influence of technology on society.' In both his individual prints and in his exhibitions, which use a full range of media in their installations, he deals with the problem of consumption as well as 'the proliferation of images in popular culture and mass electronic media that inundate our lives daily', using these as starting points for a broader questioning of political and social systems. In his manipulation of images and devices in the installations he presents to the public, Hitchcock is sharply aware of how ideas and concepts become inherently political, particularly when they deal with issues of consumption that have a direct bearing on everybody in society. He believes that 'It's highly important for citizens to speak up about social, political and personal concerns. We need as many perspectives as possible to operate as a democracy.'

More than a Thousand (installation of screen prints as part of the 'Exit Strategies' exhibition at Macalester College Art Gallery, St Paul, Minnesota, November/December 2004)

In *Ritual Device* (1999/2000, at various venues), an example of his exhibited installations, John Hitchcock presents the viewers with an interactive game. A wall is covered with a cut-out bright-yellow wooden chicken, derived from the logo on commodity food items distributed by the US Department of Agriculture to welfare programmes and indigenous peoples, and there are buckets of balls, a video projection on a wall of white balloons with darts, a military blanket covered with prints, bottles and hoops and giveaway bags containing small prints. The intention is for the balls to be thrown at the chicken, the darts to be thrown at the balloons, the hoops to be thrown over the bottles and the giveaway bags to be taken home by the viewers-cum-participants in this Ritual Device. The references are to carnivals and tribal ceremonies involving the giving of gifts, as well as to the giveaway culture of mass marketing. Underlying the installation and its constituent parts there are the political and social implications of the imagery of the commodities on which society increasingly depends for its survival, a deeper, subversive message which is shared with those who choose to take part of the installation away with them.

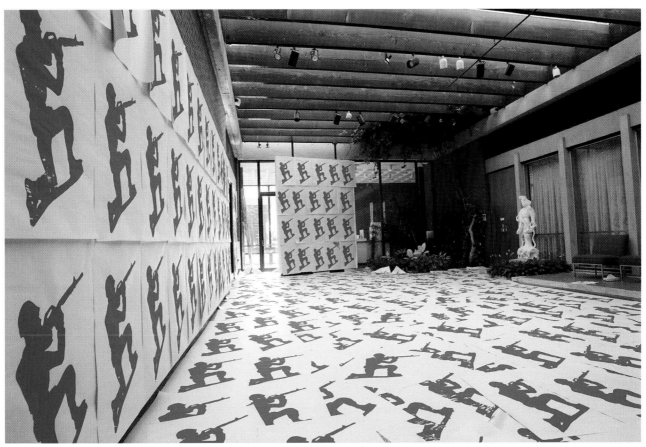

In the 2004 series of prints for the exhibition 'Frenzy Feeds Addiction', Hitchcock uses images derived from plastic toy cowboys, soldiers and Native Americans, combined with targets and word labels. The implications of each pair of prints in 'Crusade' and 'Wanted' are multi-levelled. On the surface are simple references to the innocence (and its subsequent loss) implied by the plastic toys of childhood, and the equally simple and naïve assumptions about the goodies and baddies of childhood games. The deeper intentions and meanings are suggested in the carefully chosen words and their positioning on the prints. In all John Hitchcock's work the viewer is compelled to consider the wider meanings of such apparently innocent depictions.

5. Redas Diržys

Born in Alytus, a small city west of Vilnius, Redas Diržys occupies a prominent and controversial place in the contemporary art world of Lithuania. He graduated in metal crafts from the Tallinn Art Academy and is currently the Principal of the Alytus Art School. His artistic activities cover many forms including printmaking, installation, performance and writing, and his work has been exhibited widely throughout Europe and in the USA. The activities he pursues follow his aim of 'establishing an independent artistic strategy of how to act in society (that is very close to the concept of the "construction of situation")'. In recent years he has developed a method of working that is based on his 'Drilling Manifesto' – the act of getting beneath a surface to allow an image to emerge. Diržys's original approach to printmaking is utterly consistent with his highly idiosyncratic attitude to the role of art in contemporary society. His work in recent years has followed two interlinked themes, both of which reuse the familiar element of the newspaper photograph. One theme is based on notorious leaders such as Pol Pot and Alexander Lukashenko (the current President of Belarus); the other on a friend who works in television. In the first case he seeks to 'humanise' those who, for most people, exist only in terms of a mass-media image; and in the second case to promote an ordinary person to the status of celebrity. In both cases, by transforming an image from a newspaper photograph into an art work he 'extends its evolution'. His working method for producing prints is to take a newsprint image and enlarge it greatly using a photocopier, thereby exaggerating the screen dots. The paper matrix is then fixed to a wooden panel, and holes are drilled by using drill bits of different sizes to match the white dots in the

BELOW, LEFT TO RIGHT *Pol Pot #16 (Ireland)* Woodcut from drilled woodblock; n.d.
Ryskus #13 Woodcut from drilled woodblock; n.d.
Post Pol Pot #6 (Lithuania) Woodcut from drilled woodblock; n.d. (studio photograph)

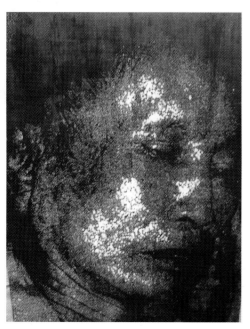 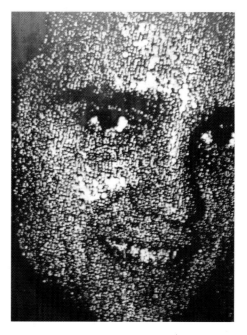 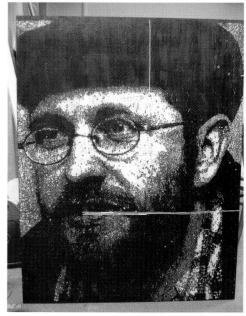

image. The woodblock thus created is inked to produce prints on paper, with the artist sometimes using his own body as a roller.

His *Pol Pot* series was taken from photographs published in European newspapers shortly after the death of the former Cambodian despot. A series of performances accompanied exhibitions in Europe of these images; some of these involved the artist taking on the role of the dictator in his coffin, which in turn resulted in photographs of this event appearing in local newspapers. Diržys has pointed out that Pol Pot received an education in France; it is said that he was a favoured student of Jean-Paul Sartre. Whether he was or not, the circularity of history is borne out in this work. The *Lukashenko* series is produced in a similar way but with different resonances: the featured individual is the President of Belarus, Lithuania's neighbour to the south, a country that is said by some visitors to most resemble the Soviet Union under Stalin. In this case the tension lies much closer to home.

By contrast the *Linas Ryskus* project was produced by the same method but from a different perspective. In this case Diržys first used photographs taken in 1998 when his friend was making his way up the lower rungs of the Lithuanian television hierarchy; he has since become General Director of Vilnius TV. The artist considers this ongoing series to represent, 'successful image-building in the press during the active creation of a career'. In all cases, and with similar prints of other individuals, he directs an acute eye on the nature of notoriety (or celebrity) and the way it manifests itself in the media, achieving results very different from those of conventional portraiture.

Diržys has taken his 'Manifesto' aim a step further in recent years by drilling the holes matching the white dots in the enlarged images directly into the walls, floors or ceilings of art institutions. This activity has included the creation of a life-size portrait of George Maciunas, the Lithuanian-born progenitor of the Fluxus movement, on a wall of the Contemporary Arts Centre in Vilnius, which houses a substantial part of the Maciunas archive in the form of the *Fluxus Cabinet*. Diržys notes, with wry amusement, that his name has been removed from this piece, something he has in common with the artists of parts of the *Fluxus Cabinet*.

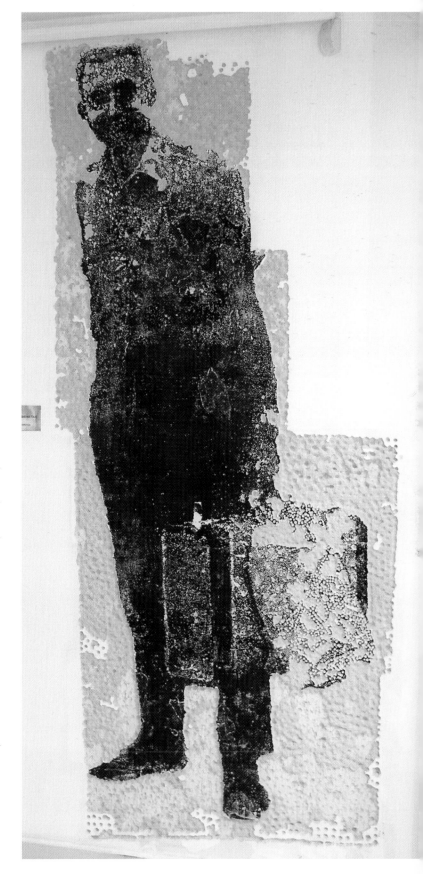

George Maciunas Wall Drilling, CAC Gallery, Vilnius; n.d.

6. Scott Betz

The recent work of Scott Betz is reflective of the conflict many people with young families feel between the structure of their immediate lives and political events in the wider world that are beyond their control. He lists the recent influences on his work as being the adventures of parenthood, foreign travel with a young family and new experiences in technological media. In addition he has a clear view of the wider scale of international events and their repercussions on American life. Betz spent a year in Paris after studying in Indiana and Tennessee, before his return to the USA to follow a career in teaching (in Mississippi, Utah and, currently, North Carolina). He has exhibited widely and is actively involved in academic and professional conferences.

During his European travels Betz has developed an affinity with Venice and in particular with the way in which the city and its depiction in art have been entwined over the centuries. His professional interest in drawing has led him to study David Hockney's theories on the subject, which in turn has taken him to Canaletto's paintings of the canals and palazzos of Venice and then to the etchings of these paintings made by Visentini. These etchings have become the basis of a cycle of work in which Betz introduces his own wood-

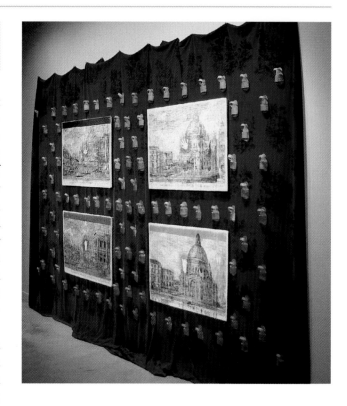

Red Toile (Baby Girl) Paint, woodcut prints, silk-screen prints on velvet, paper; 244 x 305 cm (8 x 10 ft) (overall); 2004

cuts based on the Visentini etchings into a large-scale, wall-based work incorporating drawing and printmaking. For example, *Marriage* (2004) consists of framed, paired woodcut views of the Rialto Bridge mounted on a printed bridal runner, which is in turn mounted on a 40 x 10 ft chalk drawing from Canaletto's painting of

Marriage Printed bridal runner, 10 framed paired woodcut prints, chalk drawing; 1220 x 305 cm (40 x 10 ft.) (overall); 2004

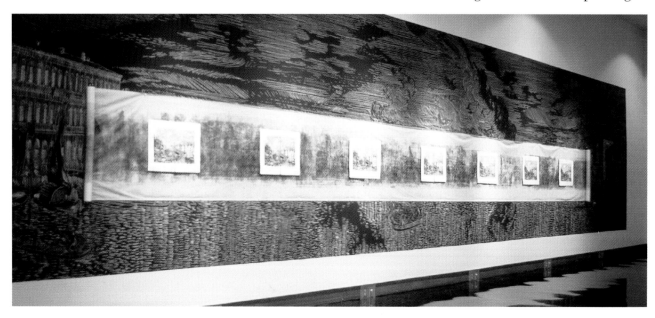

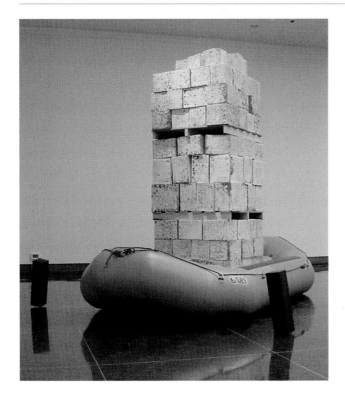

Here Comes the Son (DETAIL, RIGHT) Installation, silk-screen-printed cartons, life raft, wood, string; 2004

the entrance to Cannaregio. In this way he creates a dialogue between himself and the artists of his Venetian inspiration, as well as between the mediums involved. He also hints at the distance of time not only in the relationship established between three artists separated by almost three centuries, but also that required for a viewer to walk the length of this major work. Further images of Venice appear in two works made to celebrate his son and daughter. In *Blue Toile (Baby Boy)* and *Red Toile (Baby Girl)* Betz combines woodcuts derived from toner transfers of Visentini's copies of Canaletto's paintings of the Salute, the Palazzo Ducale and other celebrated sites. The presence of the children is announced in their hand- and footprints, which appear in the centre of the woodcuts, and in their faces (together with those of the family pets), which are drawn into the velvet toile on which the prints are mounted, as well as in the 100 hand-painted paper shoes (for his daughter) and the 100 ceramic pop beads (for his son).

Here Comes the Son (2003) addresses a very different set of concerns in an installation that draws attention to the disastrous misunderstandings that some Americans have developed in recent years towards the Muslim and Arab communities. The terrorist bombing of the USS *Cole* in Yemen and the cataclysmic horror of 9/11, leading to the 2004 invasion of Iraq, have had a major impact on the American psyche. This installation seeks to redress

the balance and to offer a different interpretation of Muslim culture. An inflatable raft, as used in the Yemen attack but also commonly as a life raft, is laden with timber pallets on which are stacked cardboard boxes silk-screened with traditional Islamic geometric patterns. The boxes previously held containers of oil, as is clear from the lettering and logos still visible in part beneath the patterns. The boxes are barely constrained by a black thread that runs between two black posts. Betz explains:

> It would appear potentially to pull the posts over if the raft continued forward. It was delicate and almost invisible at first glance. It seemed to me another reference to the Muslim community, as I am told, "It is time for the first prayer call of the day when a black thread stretched in front of the face is visible against the early morning sky".

The ambiguity within the work remains unresolved and therefore perched on an uneasy edge. However, while art alone cannot bring about a reconciliation of opposing ideologies, it can at least suggest an alternative view.

10. BEYOND THE FRAME

INTRODUCTION

IT WAS ONCE THE CUSTOM for fine-art prints – etchings, engravings, woodcuts or lithographs – to be displayed and mounted in frames and behind glass, clear evidence of the man of taste or his travels on the Grand Tour. Alternatively, they were collected and kept carefully in cabinets or folders, to be taken out for study or to be shown to others. As a consequence there is a rich heritage of such prints in private and public collections in many parts of the world. The rise of mass-printing methods, particularly in the 19th century, meant that commercial prints could be made readily available to those on lower incomes and displayed by being pinned to walls. Toulouse-Lautrec designed posters for the cabarets of Paris, and these appeared pasted on kiosks and the outside walls of buildings, together with advertisements for sundry products of the age. Print had already emerged from the confines of the study or gallery, and would from then on be unstoppable in its spread.

For most artists, however, using print as a medium continued to mean exhibiting the results framed, and it is in this form that much contemporary output is still displayed. The 1960s saw the rise of Pop Art, with artists such as Peter Blake and Andy Warhol using print techniques on less conventional surfaces such as enamelled metal plate or stretched canvas, making tentative moves towards bridging the gap between painting and print. The consequent spread of new techniques in the fine arts since then has led to conceptual art and installation, and artists using print have followed those directions. For some artists exploration of the third dimension in print became inevitable, these new works being either wall-hung or free-standing or suspended within a gallery space. In this manner the transition from fine-art print as a discrete subset of art practice to print being just one of a range of techniques available to artists is almost complete. The final steps are already being taken, with artists using print as one element in time-based works using video and DVD, and as part of presentations on the Internet. Traditionally framed prints will doubtless continue to be available, but the extra dimensions available to contemporary artists will continue to add energy to an already lively scene.

1. Aine Scannell

Aine Scannell is Irish and was educated in Belgium, Ireland, Spain and the United Kingdom. She now lives permanently in London, where she pursues her own work, teaches to Master's level and also works as a community artist. Like many artists Scannell came to printmaking via other disciplines, in her case painting and drawing. Having explored monoprint as a technique she came into more direct contact with other print techniques while studying to advanced level in Barcelona. She has found the experience she received at that time to be very liberating in terms of the materials and strategies she now uses to communicate her artistic vision. A broadly based, pragmatic approach to the use of printmaking and other techniques allows her to approach each work with a fresh mind: the outcome is the objective, and the technique (or techniques) found appropriate during the making is simply the means to that end.

The dynamics of researching and realising her ideas within the studio context are important to Scannell. The process by which she works allows her to arrive at

Conditional Love Tense Pigmented digital print and intaglio on Bockingford 190 gsm; 18 x 22 cm (7 x 8¾ in.) (flat form); 2004 (dispatched flat and built by gallery staff for 'Errata and Contradiction' exhibition, Harvard University, 2004)

fresh connections or meanings within her work – a process of discovery that extends to the manner in which she exhibits the results, whereby the viewer can be equally involved in the same process. She writes:

> I explore a range of personal, sociological and psychological contexts ... It is work that is very much concerned with our symbolic and metaphorical selves and our relationships. Political potency on an individual and institutional basis recurs as a particular concern in my work. I am very interested in exploring how we relate to ourselves as well as to our environment and to one another.

The projects illustrated demonstrate the approach that Aine Scannell adopts in her work. *Conditional Love Tense* was shown in an exhibition of visual poetry and letter-inspired art. She has long been interested in printmaking that goes beyond the frame, enabling the viewer to appreciate more fully the qualities of the object, in terms of paper surface, texture and the colour mediums used. Her concern that art should communicate as its primary objective makes the presence of the object without the intervention of glass and frame an important consideration. Her work for this project also gives ample rein to her fascination with the written word, which appears in the incantation of participles of the verb 'to love' across the surface of a houselike form, upon which are symbolic humanoid forms. The flimsy nature of the paper, readily

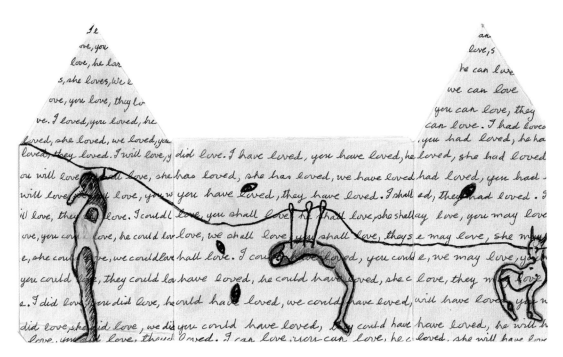

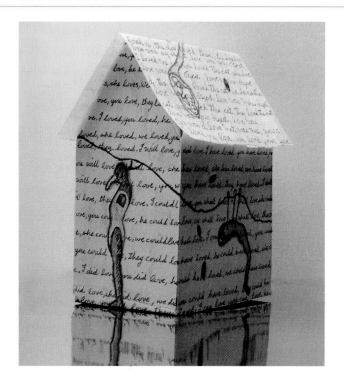

Conditional Love Tense Pigmented digital print and intaglio on Bockingford 190 gsm; 18 x 22 x 12 cm (7 x 8¾ x 4¾ in.) (built form); 2004

apparent to the viewer, is coherent with the fragility of human relationships suggested by the incantation, conditional love being the factor, in the artist's opinion, that often breaks up relationships.

House Angel is a major installation that has been exhibited in London and Galicia. The title is concerned with the fate of children born into situations where impossible conditions are imposed on them. Whether homeless or refugee, traumatised by war, abuse or domestic disruption, such children are the victims of the cruelty of others or of circumstances beyond their understanding. The installation aims to engage viewers of all ages in considering the plight of the children, to which end elements are placed to coincide with a number of different eye levels.

BELOW *House Angel* Digital print on acetate, sgraffito on metallic card, electric lights, glass, doll, feathers, mirror, papier mâché; 250 x 700 cm (8 ft. 2½ in. x 23 ft. 1½ in.); 2002 (as installed at Ourense Municipal Gallery, Spain, August 2002)
INSET *House Angel* (detail, individual house); 16 x 19 x 12 cm (6¼ x 7½ x 4¾ in.); 2002

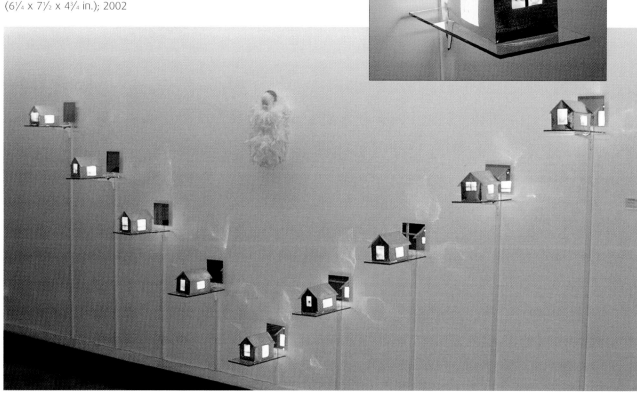

Each element consists of a house form constructed from foil and placed on a glass shelf with a mirror behind. The house form is illuminated from within, revealing a printed image of a child, either from a contemporary photograph or an historical document. The house form has no door, indicating that the child is trapped. The base of each form has a cut-out of a child with outstretched arms. The foil exteriors bear a scribed handwritten text of tales that might have been told by the children, had they been given the chance. In the centre of the installation is a life-size infant doll, masked with tissue paper to indicate anonymity and also society's failure to recognise many of the problems of such children, and covered with white feathers to indicate innocence. This important installation is dedicated to the children whose images are contained within it, and in its form alludes to their pain and suffering but also to the light of hope.

2. Koichi Kiyono

Born in Tokyo and now living and working in Kawasaki, Koichi Kiyono originally qualified in marketing, and worked in that industry for 12 years before realising that his ambitions lay elsewhere. He made the transition to printmaking via two years he spent studying after work, becoming a full-time artist in 1992. Since then he has exhibited widely in Japan and internationally, and has become closely involved with the Japanese printmaking world, as well as spending time as a research artist and lecturer in Canada. His somewhat unconventional path into printmaking affords him an idiosyncratic view of this art form within contemporary Japanese society. In a statement about his work as an artist he writes of the Japanese proverb that translates roughly as, 'The nail that sticks out must be hammered down', expressing social disapproval of any activity that emphasises the role of a single person, and the need to conform. His experience as a 'businessman' gives him a particular insight into the system, but as an artist, while he has worked within the conventions of the art world in his country, he has also followed a very individual process of development. Kiyono allies himself closely to the traditional Japanese respect for the natural environment, and much of his work has developed with a close regard to the organic world. In recent years, as his experience

and ideas have broadened, he has moved away from the large-scale prints of his early career into work that is three-dimensional or which moves off the wall.

A review of his work since 1992 reveals its evolution through a number of stages in an organic manner that mirrors his growing concern for the environment. At the same time he has broadened the range of techniques he employs, moving away from formal etching and aquatint to collagraph, collage and mixed techniques on non-traditional supports. He explains that his initial investigation of collagraph using readily available materials was provoked largely by a period of financial difficulty in his life. The enforced change had a liberating effect on his approach to printmaking and on the results obtained.

Tidal Planet/CD-ROM (2002) is a series that seeks to emphasise the place of the Earth as just one of many planets, and also the cellular interconnectedness of all living things. Part of the series is an installation of a selection of the copper discs used in producing the final prints, located in a CD cabinet or framed on the wall. The resulting discs ,printed in a combination of etching, wood relief and collage, are scattered on the floor. They are also available singly in CD cases. Kiyono seeks in this work to emphasise the connections between process and result and also between the universe, the Earth, the individual and the cell. In 2003 he lived in Calgary, Alberta, Canada, finding the opportunity to experience a culture very different to

Tidal Planet/CD-ROM 32c Etching and wood relief on CD-ROM; 12 cm (4¾ in.) (diameter) (unique edition); 2002

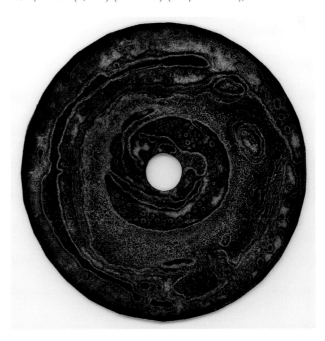

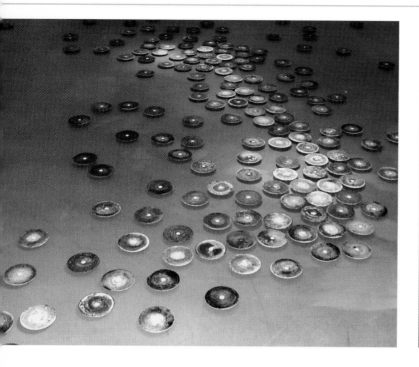

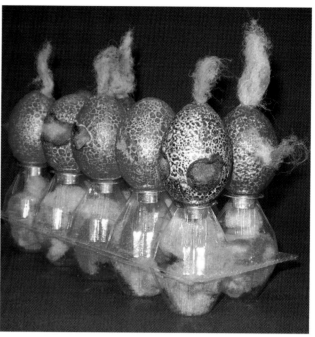

Tidal Planet Etching and wood relief on CD-ROMs; 2002 (as installed at Little Gallery, University of Calgary, 2003)

Breathing Egg-Cells D Etching, wood relief, collage on eggshell, egg carton, cotton; (objects) 5 x 6 cm (2 x 2½ in.); (carton) 11 x 25 x 7 cm (4½ x 9¾ x 2¾ in.) (unique edition); 2004

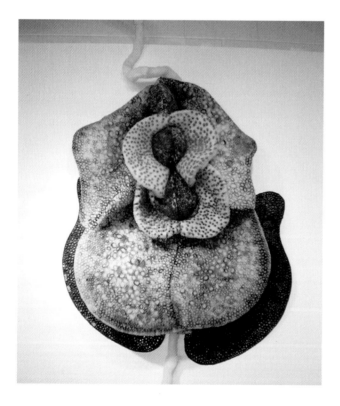

Breathing Chloroplast 3 Collagraph on quilt batting, original plate, string, wire; 120 x 100 x 25 cm (3 ft. 11¼ in. x 3 ft. 3¼ in x 9¾ in.) (unique edition); 2004

his own most invigorating. The work he produced during that year reflects that change of experience but also his growing awareness of the problems of the planet and the need to live in harmony with the natural world. In a major sequence of works entitled *Breathing Chloroplast*, he pursued his interest in cellular structures by using collagraph on quilt batting, subsequently stitched to create complex curved forms.

Kiyono found his return to Japan difficult at first, feeling something of an alien in his own country. The cultural openness he had experience in Canada contrasted greatly with the more structured society in Japan, but at the same time served to emphasise his ecological concerns. A series of works from summer 2004, *Breathing Egg-Cells*, originated in the disastrous infection of chicken flocks in Asian countries by bird flu. The deaths of many birds from this disease and many others as a result of attempts to stem the epidemic brought to mind the problems of agribusiness and biotechnology. The universal symbolism of the egg provided the context for a number of works in which textures are applied to empty eggshells by a mixture of etching, wood relief and collage, with the results, some containing coloured cotton, exhibited in egg cartons. There is no doubt that Kiyono's work is now well beyond the frame.

3. John Graham

Following an education in Environmental Studies and in Architecture John Graham pursued a Master's course in Fine Arts in Montréal and Oregon, and now teaches at the University of Guelph in Ontario. He has exhibited widely in North America and Europe, being the recipient of a number of awards. Graham's approach to printmaking is, by his own admission, that of 'a shameless but reverent pluralist', and he states that he 'would not say that his work is a reaction to or rebuttal of 'formalist art strategies'. While print suits his present expressive needs because of what he considers to be their archaic quality that comes from a long and rich history, he does not restrict himself to this medium, and has a developing interest in installation work. However, his work does use the full range of traditionally based techniques, is predominantly figurative in nature and largely derived from formal drawing.

His interests extend across a broad spectrum of spirituality, symbolic space and architecture, which come together in his mixed-media installations. There are distinct threads of literature and mythology in his work, and a desire to provoke feelings of empathy in the viewer through allusion or by engaging their sense of recognition. It is not surprising that he is also a poet and a maker of artist's books, in which he can explore his fascination with metaphorical and lyrical expression. He is a storyteller pursuing a wide range of approaches, which blend traditional techniques with a sensitive articulation of mythical and psychological references. He has written, 'The alchemy between the circuit of our own thoughts, mythical-imagery representations and dream information [is] one of the most fulfilling ways in which we can enrich a multiplicity of perceptions of the world.' Through this approach he hopes that, 'voices speak out from my work to the mystical realm that inhabits each of our own individuated subconscious spaces'.

In his first installation work, *Anima Mundi* ('soul of the world'), from 1999, Graham alluded to a broad range of metaphorical references that included the overarching

Anima Mundi Mixed-media print installation; 5000 x 3200 x 3000 cm (165 x 105 x 98 ft.); 1999

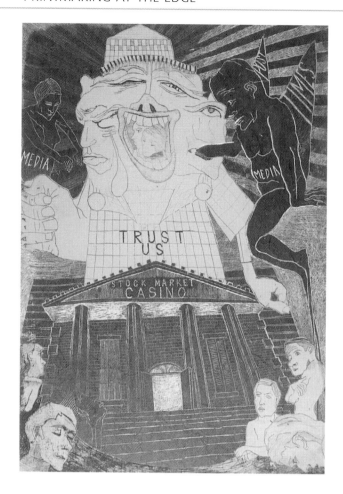

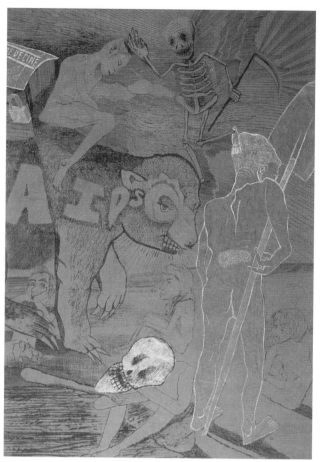

Gambling Institution Etching; 61 x 46 cm (24 x 18 in.); 2003

Unaided Etching; 61 x 46 cm (24 x 18 in.); 2003

image of the interior of a symbolic whale. Instead of following the conventional approach, whereby a series of works, framed and arranged on a gallery wall, would explore aspects of the chosen subject matter, Graham chose instead to construct a blue-paper building that was intended to function as a portable shrine in which were exhibited a collection of his personal interpretations of various world views, created using a variety of print media. The installation was lit to reveal the images within, but was in turn placed within a darkened gallery, with two suspended paper sculptures acting as guardians at the entrance. The effect on visitors to the exhibition can be imagined: entering an enclosed, lit space within a larger dark room would carry with it a frisson of recognition from the subconscious, perhaps a prehistoric memory of a shamanic ceremony in the depths of a cave. Creating an interior space in this way presents the opportunity for fragments of memory or echoes of psychological empathy to form in a viewer's mind in a far more powerful way than in a conventional exhibition.

In exploring the extended realm of printmaking Graham is placing his working methods at a challenging edge. He intends to explore the possibilities further, incorporating sound as an element. As part of this process he developed a project for his intaglio students in conjunction with a colleague in the music faculty at Guelph. Small groups of students from the two faculties were matched and given the task of cooperating to explore issues such as texture, tone, form and composition. Through this process of working together a set of 20 prints was produced in conjunction with a piece of music. The joint project was presented in a performance in a darkened theatre with the prints, linked together as a quilt, being revealed and illuminated as the music developed – a visual music to accompany a sonic art, each medium enlivening the other. Graham writes of his desire to communicate the importance of the spirituality of relationships: 'In the very least, my work may be appreciated as a small homage to humanity's elusive vulnerability to the forces of the imaginary.'

4. Rebecca Beardmore

The work of Rebecca Beardmore is situated at the boundaries of perception, having a fugitive presence that is almost an absence, in which the viewer is partially reflected, setting up a provocative and shifting relationship between the artist, the work, its meaning and the viewer. It comes from a profound consideration of the nature of reality in a world becoming so measured and recorded that, as the French social theorist Jean Baudrillard writes, 'reality has become eclipsed by its own representation'. The relentless expansion of global television and the Internet makes an overwhelming volume of information and images available to an ever-growing audience, so that we are close to having access to the total sum of human knowledge. The state of all-knowing power dreamt of in the science-fiction comics of the 1950s and '60s has become a reality in ways that could not have been foreseen half a century ago. Despite this it also seems that the certainties that surround us are diminishing, that we run the risk of knowing less and less about ourselves, the society we live in and the world around us.

While Beardmore's work engages the viewer through the subtle manipulation of space and light, and the opportunity for physical as well as cerebral reflection, it also provokes a sense of anxiety by denying the satisfaction of absolute certainty. She describes her work as using three languages – the informative/textual layer, the photographic image and the material itself – each one presented with such fragility that they cannot be collectively discerned. To engage fully with one involves relinquishing another. It is an unreliable experience in which no single language can be relied on to create coherence, and one which 'highlights the uneasy balance between experience and understanding; a fragile relationship in the body of knowledge currently being transformed by the pure possibility of access'.

Beardmore was born in Canada and received her art education in Alberta and Sydney, where she currently lives, working as a college lecturer in printmaking. She has exhibited her work internationally and received a number of awards; in 2001 she undertook an artist's residency in Tokyo, which had a significant impact on her work. She works with a variety of print techniques on surfaces such as acrylic and aluminium, and also with digital print on canvas. The works may be hung or leant against a wall or suspended from the ceiling. In each case the clear intention is for the viewer to move past the work (or even among a single piece's different components – see *Borrowed Scenery* on p.93), observing the effects of light and reflection. Beardmore acknowledges that the works and the way they are displayed 'rely on the subtle nuances set up by the pace of the viewer to create visual intrigue'. The text for three of her major

The Materiality of Truth Offset litho on zinc, silk screen, blind embossing; 35.5 x 28 cm (14 x 11 in.) (each); 2001

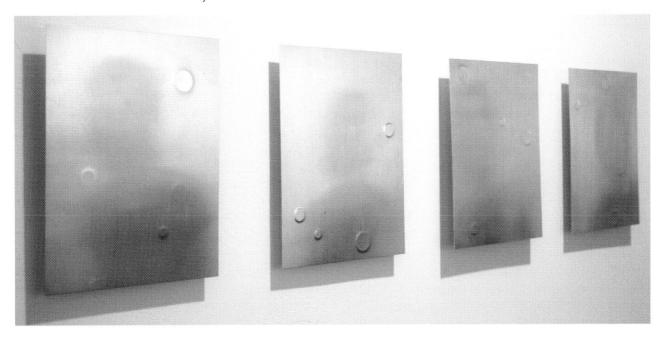

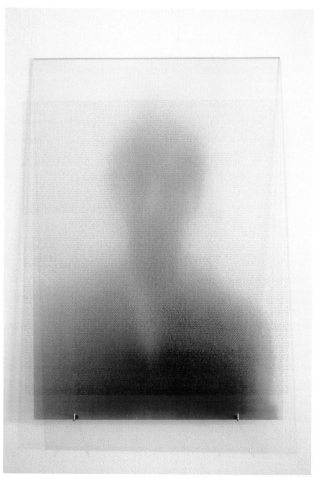

The Materiality of Truth (detail)

In the Mirror Offset litho on acrylic; 85.7 x 66 cm (2 ft. 9¾ in. 2 ft. 2 in.); 2001

OPPOSITE *Borrowed Scenery* Silk screen, semi-translucent mirror film, sandblasted acrylic; 408 x 208 cm (13 ft. 5 in. x 6 ft. 10 in.) (x 5 pieces); 2001

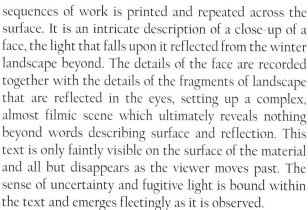

sequences of work is printed and repeated across the surface. It is an intricate description of a close-up of a face, the light that falls upon it reflected from the winter landscape beyond. The details of the face are recorded together with the details of the fragments of landscape that are reflected in the eyes, setting up a complex, almost filmic scene which ultimately reveals nothing beyond words describing surface and reflection. This text is only faintly visible on the surface of the material and all but disappears as the viewer moves past. The sense of uncertainty and fugitive light is bound within the text and emerges fleetingly as it is observed.

In *Borrowed Scenery* (2001) five large sheets of sand-blasted acrylic with silk screen and semi-translucent film are hung from the ceiling in the centre of the gallery space so that viewers may walk between them. The effect of the artificial light and the shifting daylight that falls on the works creates a multilayered series of surfaces that partially reflect the image of the viewer. The impossibility of fully resolving what is seen creates a dislocating experience of phantom images, akin to but more complex than the images seen fleetingly in distorting mirrors in a carnival. The figures that appear in other works give some help towards locating the viewer within the imagined scene, but in the end everything shifts again. In making these works Beardmore sets up, 'a relentless pursuit to find some absolute within the shifting margins of reality'.

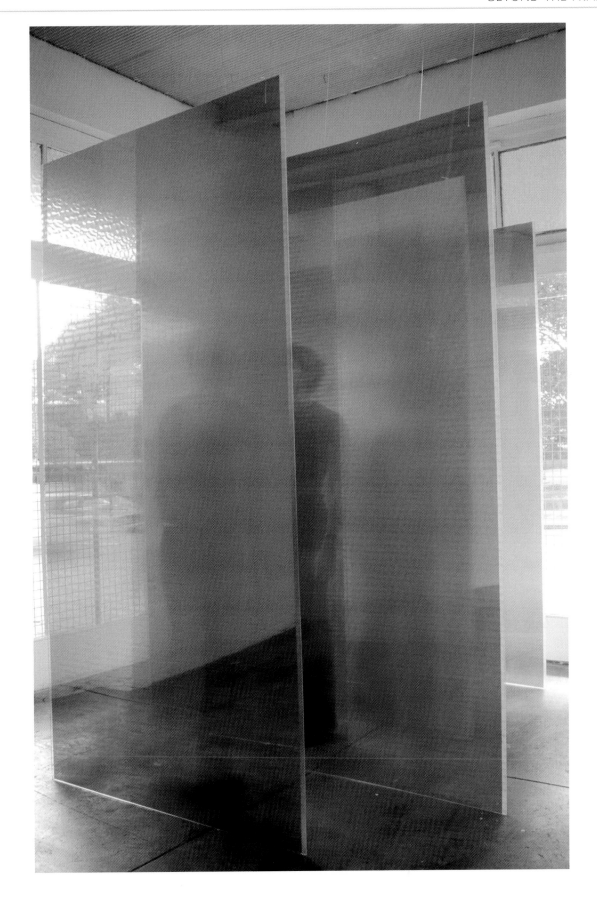

5. Valgerður Hauksdóttir

Valgerður Hauksdóttir was born in Reykjavik, where she lives and is an active faculty member of the Icelandic Art Academy. She was trained in Music in Iceland, and subsequently in Fine Art in New Mexico and Illinois. Her academic experience is considerable, both in Iceland and internationally, including her role as founder and coordinator of Printmaking Art and Research. PA&R is a European mobility postgraduate programme run jointly by art institutions in Iceland, France, Spain, Germany and England, offering accomplished printmakers a unique programme of study up to master's level with experience of different aspects of European culture and printmaking traditions. Hauksdóttir has a considerable record of international solo and joint exhibitions, as well as having participated in many biennials and triennials. While her roots remain firmly in her native country she has also established an active and innovative approach to working internationally that has influenced her work to a considerable degree.

OPPOSITE *Euphony* Installation with intaglio and photolithographic prints, collage, Japanese paper and sound (composed by Richard Cornell); Dimensions variable; 2003 (as exhibited at 808 Gallery, Boston, February–April 2003)
BELOW *Euphony (detail)*

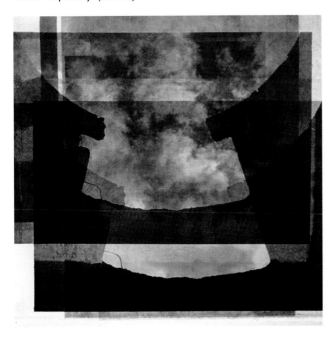

The nature of the landscape and history of Iceland is at the heart of Hauksdóttir's work, giving it a core of profound environmental awareness. This remote North Atlantic island has a still-evolving geological structure and large areas of pristine wilderness bearing only sparse vegetation. Its historical roots are Viking and Norse, and its culture is founded on a rich resource of myths and sagas. At the same time it is a country with a vibrant urban life and culture. It is within this broad context that her work is placed. Over the past 20 years the themes within her work have become progressively more integrated so that the subject matter is influenced by her interpretation of the environment in which she lives and the laws of nature that govern its ecology – both natural and human. She compares her work to a window, through which one can look both inwards and outwards in an attempt to reach an understanding of the origin of oneself and others. The focus she brings to the task of asking questions could be compared to that of a natural philosopher contemplating the properties of matter, cause and effect, and the limitations to comprehending our surroundings, as well as concepts of time and the cyclical character of the natural world.

It is not surprising that, given this agenda, Hauksdóttir's work and the manner in which she exhibits it have become innovative, seldom relying on conventional framing and wall display. Her mixed-media works, utilising etching, lithograph, collage and hand-coloured Japanese paper, are often printed on both sides of the paper to take advantage of the variations in light and transparency in her installations. The photographic element in her work originates with photographs taken either with traditional film or digital cameras, which are then digitally processed to provide the film for lithographic printing. Often appropriating images from one piece for another, Hauksdóttir is always seeking to expand her personal and symbolic vocabulary of travel and experience, into which may be read a multiplicity of evolving meanings.

In *Euphony* (2003) she combined intaglio, lithography, chine collé, handmade paper and sound (composed by Richard Cornell), creating an installation in which viewers could experience an interplay of light, shadows and images from many directions, participating in the changing relationships between the images and the background noise of environmental sounds and whispers in six languages. The random patterns within the sound composition provided the accompaniment to the equally random manner in which viewers experienced

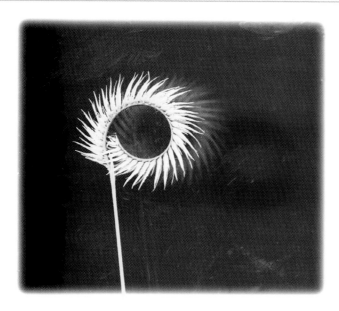

Beginnings I Digital photograph; 100 x 110 cm (3ft. 3¼ in. x 3 ft. 7¼ in.); 2002 (from a joint exhibition with Kate Leonard, Colorado and Iceland 2002/3)

6. Joris Martens

Joris Martens lives and works in Antwerp and has exhibited his work widely in Europe. His output deals with deconstruction, the dismantling of preconceptions about the nature of images, and in this vein he works with techniques that are diametrically opposed to the traditional forms of printmaking and to conventional ways of exhibiting art. His work challenges the idea of what is normal, and also assumptions about the relationships between social structures and the visual images that are all-pervasive in contemporary urban society, which are so often taken for granted. In his publication *structuren* (March 2004), there are a number of texts in Dutch and English which act as pointers to his intentions. One reads, 'We are about to lose capacity to deal with the visual – the non-language – in a conscious way. Therefore we will not be able to see new outcomes. In doing so we'll lose reality, we'll lose our connection with real life, we'll lose our fragmentary impetuses by it. Real discussion will stop.'

the installation, the four parts of which created a cycle from beginning through evolution to completion and the end, before returning to the beginning. It is of importance to the artist that the process of exploration she herself has followed during the long process of its creation is mirrored in the personal journey undertaken by each viewer. In 'Dyr/Portal' (2002/3) Hauksdóttir worked in conjunction with Kate Leonard, a Colorado-based artist, to create a dialogue between Iceland and Colorado, two parts of the world that, although initially very different, in fact have frequent similarities in landscape and geology. Both places are situated at the junctures of tectonic plates, Colorado on a minor scale, Iceland on a major one. The dialogue became the exhibition of a journey, both physical and internal, in which the exchange and growth of environmental experiences were themselves akin to tectonic shifts.

Although Martens's work has been exhibited in galleries it also functions within the films he has made for distribution by DVD. These sound-and-image collages record aspects of his exhibitions but add layers of movement, sound and music. They also provide the artist with a 'syntax' for the work he produces, allowing him to control its potential meanings, enabling it to emerge in a programmed manner. Experiencing the work he has selected in this medium is very different from the experience of seeing it in a gallery. Whether it transcends the gallery exhibition or encapsulates it is a matter of judgement; but it certainly does offer an extreme extension to the possibilities of printmaking.

A short film (1 minute 46 seconds), *Zomaar* – which translates variously as baseless, groundless, idle, unfounded, unwarranted – begins with reflections of light on water, followed by paddling feet. The sound of a bell signals a transition to a rapid flashing collage of images accompanied by ambient sounds and music, pausing briefly at an image of a figure with chopped off hands, before segueing into a drawing of chairs beside water. The ambient sounds fade to leave baroque strings echoing as the visual background dims through blue to black. A final reprise of the light on water completes the film.

Dyr/Portal 15 Photograph; 2002; (from a joint exhibition with Kate Leonard, Colorado and Iceland 2002/3)

OPPOSITE *Zomaar (collage of images)* Film incorporating mixed-media prints and watercolours; n.d.

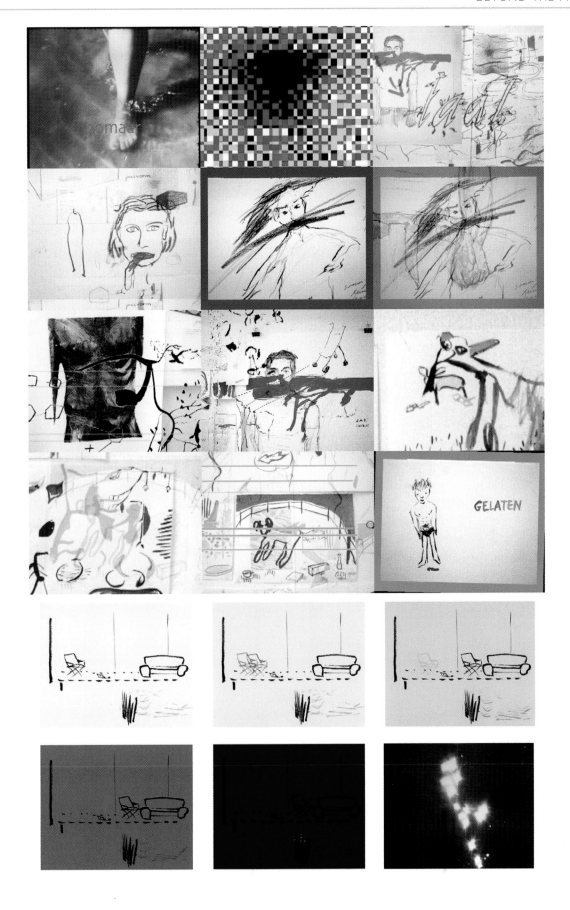

Ihmisonnen Osakkaita (Shareholders of Human Happiness) Installation with mixed-media prints, water-colours, light and sound; dimensions variable (Exhibited at Gallery Titanik, Turku, Finland and De Annex Sint-Niklaas, Belgium, August–November 2001)
BELOW *Drawing (from Ihmisonnen Osakkaita (Shareholders of Human Happiness))*

A longer film (8 minutes 42 seconds), *Ihmisonnen Osakkaita* (Shareholders of Human Happiness), is based on an exhibition that was staged in Finland and Belgium during 2001. A child's whisper is heard in darkness, fading into the titles, which is followed by a tracking shot of a young girl carrying papers running around the gallery seeming to chase a spotlight that circles the room. She drops the papers and pauses to pick them up before resuming her tour, looking at the images pinned to the walls. Sound and music accompanies sequences of images fading into each other, alternating with sequences of the remotely controlled spotlight passing round the room, pausing now and then on a wall or on the blocks on the floor. Scraps of words can be made out in some images: '*tous sont abîmés*' (all are ruined), 'I'm not sure', 'by voicing our opinion'. There is a space of darkness from which whispering voices of children can be heard, and then the sequence of images continues, ending with a further shot of the young girl dropping the papers. There is a close-up of the badge on her lapel: it reads '*Ihmisonnen Osakas*'. Children's whispers emerge from and fade back into the darkness that follows.

Joris Martens is investigating the fragmented territory left behind in the wake of Postmodernism. It is significant that he lives and works in the Flemish heartland of Northern Europe, in the city whence so many glorious works of the Northern Renaissance emerged. The context and relevance of contemporary Antwerp is greatly changed from the city's status in the 16th and 17th centuries. By the same token Martens's approach to the making of art is as different from that of his Flemish predecessors as could be imagined. This notwithstanding, his underlying concerns for the place of art in society are very much the same as those of his illustrious forebears, although the uncertainties of the 21st century represent a very different set of challenges.

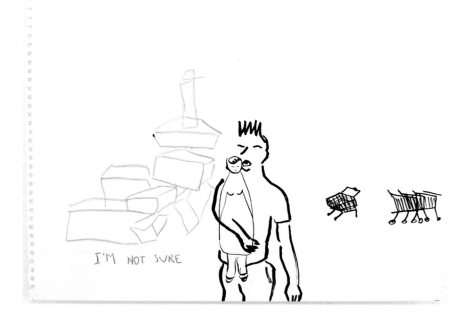

I'M NOT SURE

11. THE PUBLIC EYE

INTRODUCTION

PUBLIC ART CAN BE A RISKY BUSINESS. Artists naturally put themselves at some risk in any situation in which their work breaks away from the highly personal and private circumstances in which much of it is created. Showing work to visitors in a studio, or even more so in a public exhibition space, opens up a dialogue between the artist, the work and the viewer, which can bring adverse criticism, or high praise, or indeed any other reaction between these extremes. The art system has for many years been predicated mainly on this set of relationships. Taking the next step to make work in and for the public arena can be a daunting experience, whether that arena is in an outside location, or inside a public building the function and purpose of which is something other than the showing of art.

In the late 20th century and continuing into this century the presence of art in the public arena has greatly increased. Initiatives such as the 'Percent for Art', along with major public commissions, have brought into the everyday domain a great many large works, predominantly in the form of sculpture. Many plazas and atriums in new architectural landmark sites are adorned with sculpture on a massive scale. Antony Gormley's *Angel of the North*, the giant sculpture close to the A1 highway in the North-East of England, has attracted widespread acclaim from many, including the local community, which has adopted it as its own.

Printmaking on a major scale is a relatively recent phenomenon, but as the four artists in this section show there is tremendous potential for extending it into new areas. Two of the artists produce work specifically for outdoor spaces; two are working in spaces not usually dedicated to art with people whose relationship with the visual arts is very different from that of regular gallery-goers and art cognoscenti. But, given its accessibility and essentially democratic nature, there is no reason why printmaking in the public arena should not become far more widespread, even though the technical and material challenges are considerable, and in many cases as yet untried.

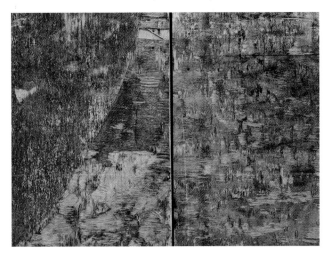

Pete Williams *Seven (detail)* Woodcut and woodblock print; 2002–4

1. Laura Berman

Laura Berman received her art education in New York State and New Orleans. She has pursued various further studies in other parts of the USA and has exhibited her work widely. She is currently Head of Printmaking at the celebrated Kansas City Art Institute. Kansas City, in which the artist also lives, is close to the geographical centre of the United States. Its history gives it a particular identity: first as a frontier town, then as a rail junction and, later, as the home of a notable jazz scene. The position of the city at the crossroads of cattle trails, pioneer wagon routes, the railroad and the Kansas and Missouri Rivers has given its lively cultural life a particular flavour for more than a century. Berman derives much of her inspiration from this distinctive cultural mix. At the same time

Tumbleweed Project Silk-screen print on felt on quilt batting; Dimensions variable, 15–122 cm (6–48 in.) diameter; 2003 (Installed at offices of BNIM in the historic Power and Light Building, Kansas City, filling 10 street-level windows, May–July 2003)

her work reflects an idiosyncratic view of Americana and its symbols, aspirations and attitudes. It contains elements of playfulness, humour and irony as well as the gentle interrogation of unspoken questions raised by both the work and the need to place it before the public gaze.

It is not surprising therefore that as well as gallery exhibitions she finds major public installations to be a stimulating outlet for her creative energies. The opportunity of creating an unmissable statement in a public location feeds her desire to exhibit her work in more mundane surroundings. For instance, in 2003 her *Tumbleweed Project* was installed in 10 street-level windows of an architecture practice in downtown Kansas City. Circular structures ranging in diameter from 6 in. to 4 ft., made from felt on quilt batting and silk-screened with images of tumbleweeds – those potent images of wild nature in movie westerns– were suspended almost motionless in the windows, to be viewed from the inside by the architects and from the outside by passing motorists and pedestrians. This led to Berman being commissioned to create a major installation as part of the annual 'Avenue of the Arts' exhibition, which features six artists making site-specific works along six blocks of the city's Central Avenue. Berman made works to be displayed on the façade

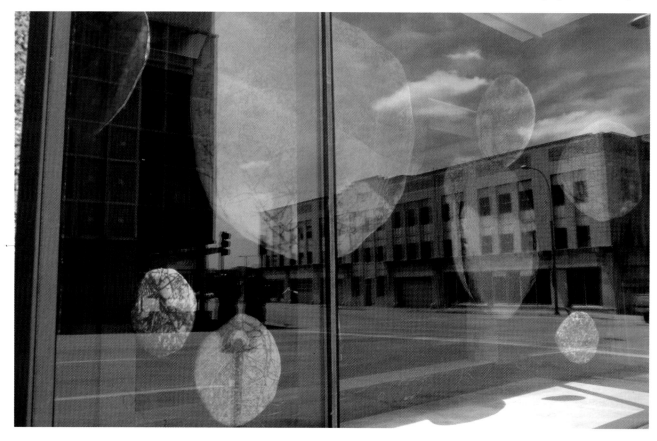

of a parking garage, basing them on digital photographs of children dressed as cowboys and Indians. The photographic images were reproduced by a local print shop to create figures measuring 10 x 8 ft., mounted on steel frames suspended from the building. The figures appeared to be holding objects, which were changed each month during the four-month display: apples and oranges, scissors and snails, locks and keys, love and money. These installations begged some interesting questions about what the relationship was between the building and the works, why they were there in the first place and how they should be viewed in such a setting. For one thing, to bring clichés about movie Westerns and childhood play into a close and oversized relationship with passers-by is to raise questions about the continuing relevance of American history.

Berman's work in gallery spaces often consists of printing directly onto the walls. In the summer of 2004

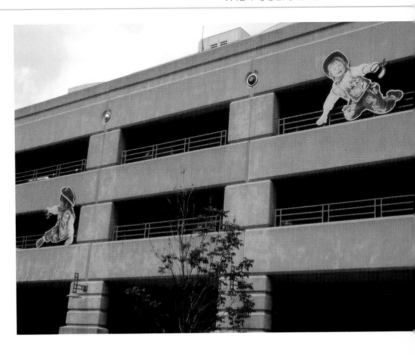

ABOVE *Cowboys and Indians* Digitally printed decals on outdoor-display substrate on steel skeleton; 244 x 305 cm (96 x 120 in.); 2004 (Exhibited on parking garage at 10th Street and Central Avenue as part of the 'Avenue of the Arts' Project, Kansas City, May–September 2004)

BELOW *I Can Make Food but I Can't Cook* Installation using silk-screen prints placed directly on walls; 458 x 916 cm (15 x 30 ft.); 2004

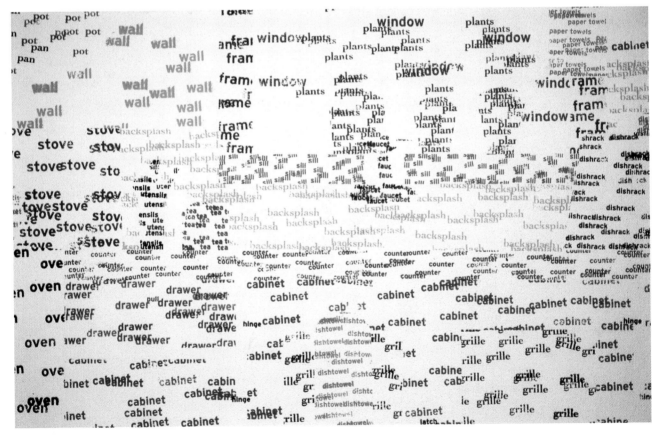

she made a typical installation of this type, *I Can Make Food but I Can't Cook*, which occupied the walls of a 15 x 30 ft. space. She writes of this work:

> The process of consuming food mimics engagement with art itself; a sensual experience is born from a seemingly simple and technical production. I live with the massive presence of ingredients for meals I will never cook along with a swarm of ideas I have yet to actualise. Both of these presences in my life comfort me.

The work is a larger-than-life replica of her kitchen, with the furniture and objects replicated in type – jumbled and brightly coloured – flattened onto the walls, a verbal parallel for the real kitchen in her own home. Dislocated and dimensionally altered, this installation is both wryly amusing and disturbing in a way that cannot quite be grasped, a bizarre replication of a recognisable reality that never quite seems to settle into place.

Philip Garrett *Shankly's Skies* Drypoint; 61 x 122 cm (24 x 48 in.); 2003

2. Philip Garrett

When Allen Ginsberg visited Liverpool in the mid-1960s, enticed by the music of The Beatles and the growing success of the Liverpool Poets, he described the city at that time as being 'the centre of the consciousness of the human universe'. There was certainly a vitality in many forms of popular culture that lasted for another decade or so, until the optimism of that time gave way to the pessimism of the Thatcher years. In more recent times, with large-scale urban regeneration and the coming of Tate Liverpool as a new focus for the contemporary visual arts, the city has taken a new lease on life. Liverpool has long had a unique identity among British cities, attaining an idiosyncratic personality with which its inhabitants identify proudly and which they defend fiercely. It has its own mythology and its own pantheon of heroes and villains which, combined with a heritage linked to the rise and fall of British imperial power, a unique sense of humour and a long history as a multi-cultural community, has provided a rich seed-bed from which many celebrated artists, writers, actors and musicians have grown.

Philip Garrett was born in Liverpool and graduated from Wolverhampton University in painting and printmaking. He subsequently qualified as a teacher and taught for four years in schools in North-West England.

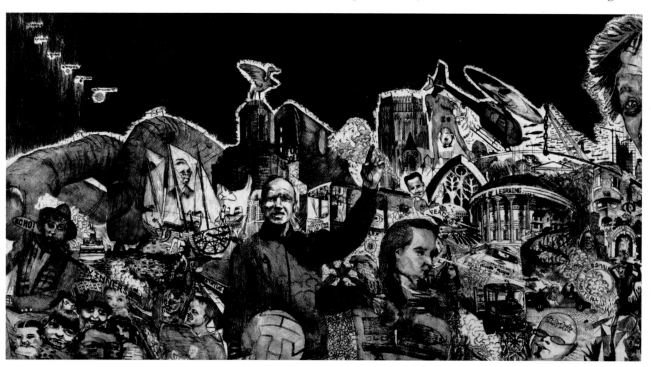

He spent the summer of 2003 editioning prints in the studio of Ana Bellido in Estepona, taking the opportunity to visit artists' studios and galleries. In 2004 he began a Master's course in printmaking at the Royal College of Art in London. During his time teaching art and design in secondary schools, which included working with disadvantaged groups, he carried out a number of commissions for murals in community centres and public spaces. He has also continued developing his own work, concentrating on the production of large-scale etchings and drypoint prints. Because of what he considers to be the lack of interest in print or indeed access to presses of sufficient size in the North-West of England, he has found it necessary to travel to various print workshops in Scotland to produce his editions using their superior facilities. His work, which he describes as figurative, is strongly influenced by drawing and encompassing social realism, black humour and an appreciation of nature, has been seen in numerous group and solo exhibitions. Garrett's background and education, as well as his involvement with community projects, and has given him a strong focus on the social dimension of art, which emerges clearly in his prints.

The Merseyside region, of which Liverpool is the centre, includes a rich variety of environments, from the crowded buildings of the industrial docklands and city centre to the wide avenues and parklands of the wealthier suburbs, and from the wild sand-dune-lined coast where the River Mersey meets the sea to the villages of the Wirral with the mountains of North Wales in the distance. These environments, and the people who inhabit them, provide Garrett with both his inspiration and his subject matter. In 2003 he produced *Liverpool Skyline*, a diptych engraving measuring 30 x 96 in. which depicts the people of Liverpool, its celebrities past and present, and selected images of the architecture for which the city is renowned – all are brought together in a dense celebration of the essence of Liverpool. The central figure of comedian Ken Dodd reaches out his arms to embrace, among others (from left to right): the actor Tom Baker, as 'Doctor Who'; Bill Shankly, the celebrated Manager of Liverpool FC; William Roscoe, who campaigned against slavery; the playwright Alan Bleasdale, and 'Yosser' Hughes, one of his famous characters; Wayne Rooney, the current footballing wunderkind; Dixie Dean, one of his legendary predecessors; Ricky Tomlinson, the much-loved actor; The Beatles; and Bessie Braddock, the firebrand Labour member of Parliament of the 1960s. The children of the city are there too, and the littered streets in which they live, all clustered among the architectural symbols of the Liver Building, the two Cathedrals, the William Brown Library, the Camel Laird shipyard, the Albert Dock and the Tower Restaurant. This is etching on an epic scale, a fitting celebration of a city with an epic history.

Dixie's Blues Drypoint; 61 x 122 cm (24 x 48 in.); 2003

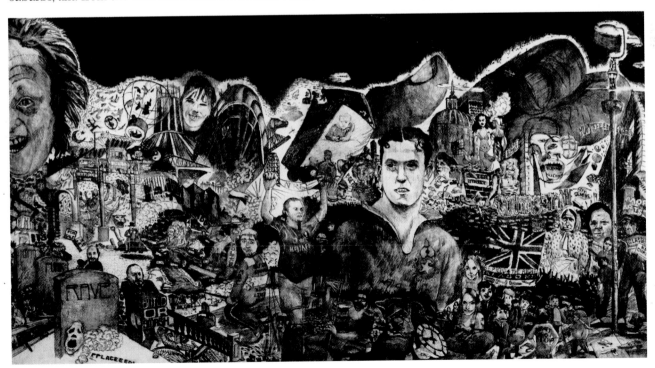

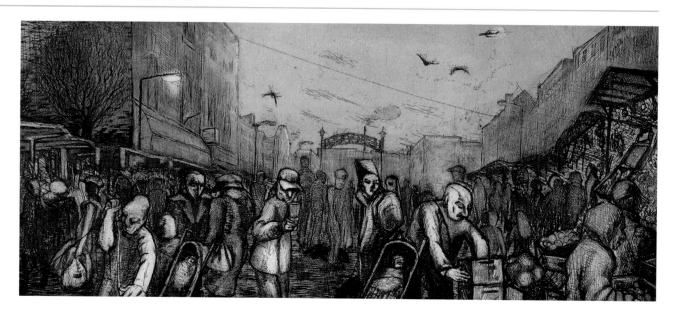

Philip Garrett *Winding Down on East Street*
Engraving and etching; 25.5 x 61 cm (10 x 24 in.); 2004

3. Pete Williams

Since Wales gained its own National Assembly in 1999 there has been something of a renaissance in the country, which, although part of the United Kingdom, has its own strongly independent character and a distinct language and culture. The cultural life of Wales has been given added zest by the changes in governance, and many new initiatives are breathing new life into the arts in the country. While Cardiff is far being from the geographical centre of the country, and the largely rural nature of the mountainous landscape makes getting into the city difficult and time-consuming, there is also new provision for the visual arts in towns throughout the country. However, in Cardiff itself, the multimillion-pound Wales Millennium Centre, which opened in 2004, promises to be a major European centre for music, dance and opera. This architectural landmark building, close to the controversial assembly building currently under construction, attracted a great deal of interest while it was being built, not least because of the innovative use of printmaking on the hoardings surrounding the site.

Pete Williams studied at Cheltenham School of Art and Design and has a postgraduate diploma in fine-art printmaking from Brighton University. As well as being a practising artist, he lectures in printmaking and since 1997 has been Director of the Print Market Workshop in Cardiff. In 2004 he became involved in establishing a series of exhibitions in the Cardiff Bay Arts Trust Gallery, including one that featured three prominent printmakers from Cuba. It is intended that this series and any future exhibitions will present innovative works in printmaking in a variety of formats, with the aim of establishing links with other workshops in Wales, England and further afield. The commission Williams received for the Millennium Centre, for whom he was already working on a project with groups of local school students, resulted in *Seven* (2002), which comprised an 8 x 60 ft. woodcut and print installation. Based on seven circles, the first stage was to cut directly into the plywood of the hoarding to produce three and a half circles of woodcut blocks. These were then inked in situ and used to produce prints on handmade paper, which were then taken back to the studio and completed with prints transferred from the worn parquet floor. The final prints, laminated to plywood, were then returned to the site and installed with the original woodcuts to complete the sequence.

Following this piece of work Williams received a commission for the headquarters of Cardiff's bid to be a European City of Culture in 2008. Although superficially similar to the works for the Millennium Centre, this

OPPOSITE TOP *Seven* Woodcut and woodblock print; 244 x 1832 cm (8 x 60 ft.); 2002–4 (Site-specific installation on hoardings surrounding the site of the Wales Millennium Centre, Cardiff)
BELOW *Seven (detail)* Woodcut and woodblock print; 2002–4

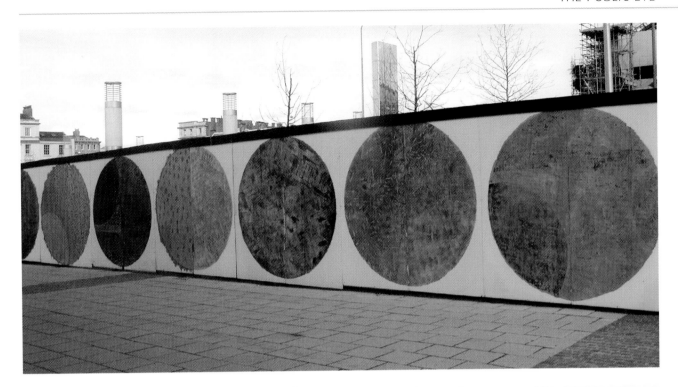

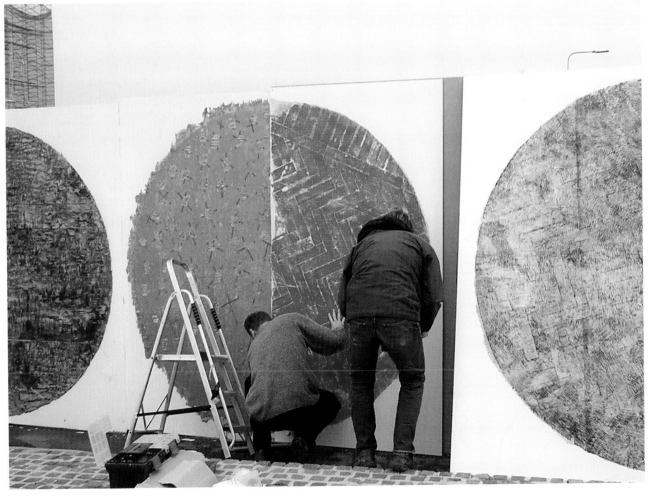

Untitled Framed assemblage with fragments of prints and blocks 2004 (Part of the 'Baggage and Boxes' exhibition, CBAT Gallery, Cardiff)

work covered two 12 x 30 ft. panels for the entrance to the offices. Williams worked with a team of writers funded by Academi, a grant-giving organisation for literature, to incorporate what was claimed to be the longest poem in Wales. Another project, for a sports stadium in Torfaen, comprised three large vertical banners for the entrance foyer and eight woodcuts each of 8 ft. in diameter for other parts of the building. In each case the work has been conceived for a very public space in which the prints can be viewed either from very close up or from a considerable distance. The challenge of working within this constraint, added to the need to ensure that the prints are durable, engages an artist in a discipline that is far from the relatively refined manner of working on fine-art prints intended to be framed behind glass.

Not that all Pete Williams's work is in large-scale: in 2004 he produced work for an exhibition at the CBAT Gallery named 'Baggage and Boxes', which recycled and redefined the remnants of his past work. By taking fragments of old woodblocks, etching plates and silk screens, and reassembling them in formal frames, he found it possible to shed himself of remnants of the past and to move

forward in a new direction. This approach gives food for thought, especially when seen in the context of the new Wales. That there will be further large-scale projects is certain, and with them will come new challenges to redefine printmaking in a public context.

4. Hugh Merrill

'Print is not an object, a technique, or a category, but it is a theoretical language of evolving ideas.' This quotation, from Hugh Merrill's essay 'Educating the Next Generation of Printmakers', can be seen as central to his work, both as a studio artist and as a community artist. He grew up in Washington DC during the 1950s and '60s, where his father worked in government, and was from an early age exposed to Democratic Party politics, meeting many of the major politicians of those decades. He studied art in Baltimore and at Yale before going into teaching, moving to the Kansas City Art Institute in 1976, where he is now Professor of Printmaking and Community Arts. His broad vision of what art, and printmaking in particular, can achieve is the product of a long career in the arts, beginning with the reductionist approach at Yale in the mid-1970s, which revered artists such as Rothko, Sol Lewitt and Ellsworth Kelly, and moving on continuously from that beautiful but sterile point. Of the need to consider the changes in the art scene and the wider relevance and a deeper sense of engagement he now considers essential Merrill writes, 'Deconstructing Modernism is asking art to take on new values and functions, asking for social content, communication and audience interaction.'

Merrill's work as an educator is not limited to the Art Institute, as he is also actively involved in community work, particularly in his close involvement with Chameleon, a multimedia arts project situated in a former factory in an industrial area of Kansas City. Chameleon is charged with a remarkable vitality and creativity, which can be felt across all artistic fields: dance, music and the visual arts. He maintains a base there because he believes profoundly that his personal studio work and community projects are symbiotic. His work as a community artist began with having the opportunity to work with Christian Boltanski on a project at the Kemper Art Museum, a short distance

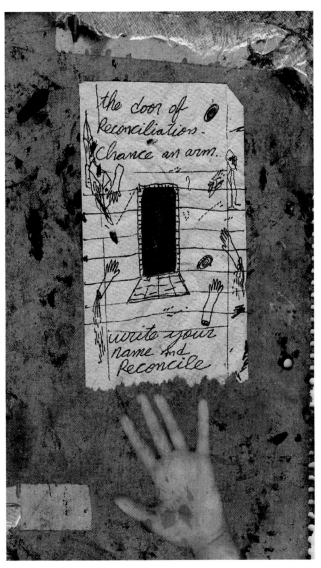

Reconcile Digital print; 183 x 122 cm (72 x 48 in.); 2003 (from Dublin, Kansas City, Community Arts Project, in conjunction with the National Academy of Art and Design)

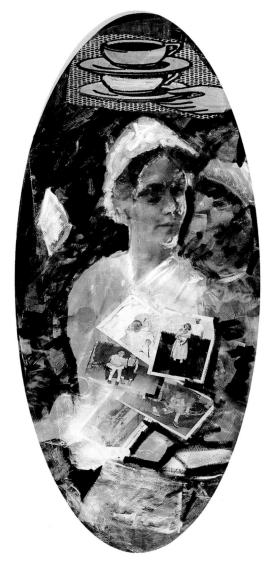

Columbia 12 Digital print and screen-printing; 244 x 122 cm (96 x 48 in.); 2004

from the Art Institute. This experience led to Merrill's 'Portrait of Self' project, in which community groups are helped to produce 'notebooks' that archive their recollections and experiences, so that they can be shared with and communicated to others. Through this approach, 'art is no longer an activity; it is a method for children to learn to think ... freely, creatively and critically about their world'. He considers that instruction and education have very different functions – instruction to enable the development of skills and education to allow a process of thinking that leads to discovery.

In his personal work Merrill adopts a complex, freewheeling approach to the production of what he calls his 'hybrid prints', which combine a wide variety of traditional and more modern techniques. A typical sequence of processes might include a drawing on a zinc etching plate to produce an image which is then scanned into a computer and modified as part of a Photoshop® collage. The collage is printed out on decal paper and adhered to a board. This is then altered, first by the addition of screen print and then again by the addition of further paper, allowing the image to be drawn and painted into. In the artist's view the work remains a print because his use of technology in the process allows

ABOVE *Double Chase* Digital print and silk screen; 122 x 152.5 cm (48 x 60 in.); 2004

BELOW *History of Empire* Digital print and silk screen; 122 x 152.5 cm (48 x 60 in.); 2004

him 'to slow, stop, multiply, transform, produce variations and recontextualise the image', techniques that are commonly used in printmaking. This process is used in the *Columbia* series, in which photographic images from different periods are layered together to produce something like a movie that freezes time, allowing an 'all-at-once-ness' experience of someone else's past, or like the fragments of fleeting landscape seen from a speeding train.

To come to a fuller appreciation of the dynamics within Hugh Merrill's personal work, or indeed his community work, requires an understanding of the importance he places on delay and variation, factors that are inherent in the printmaking process. Delay comes between those moments of spontaneity that come in stages during the making of a drawing, or from a change of medium. It also comes from the need for reflection, and this in turn provokes a desire for variation and progression in an enriching process of discovery.

12. EXTREME TECHNIQUES

INTRODUCTION

DEEP IN A CAVE IN THE ARDÈCHE in southern France there is a remarkable trace of a long-dead artist. Around 31,000 years ago an unknown person engaged in the creation of the series of rock paintings in La Grotte de Chauvet dipped his, or perhaps her, hand in pigment and pressed it to the rock wall. No one can be certain of the reasons that persuaded our forebears to face the terrors of the darkness deep inside the earth in order to make paintings by the feeble light of guttering fat lamps. It is thought that they may have done this as a form of sympathetic magic, to bring luck in the hunt or to ensure the fertility of the animals; it has also been suggested that such a risky business marked the beginnings of religious worship. Caves elsewhere bear hand marks made by spraying pigment from the mouth over a hand placed on the rock, leaving a negative imprint. Such traces of identity can be seen as the first efforts at printmaking, and they are certainly evidence of art at the edge. During the millennia that have since passed, the arts of printmaking have been refined and codified. The technologies harnessed, from the first faltering beginnings to the latest in digital imaging, have always started out being regarded as extreme. The innovations that have come about are all linked to those artists who have decided to push the boundaries a little further out. In so doing they have often broken the prevailing conventions to explore new ways of using mediums, or even new mediums, in search of forms that more clearly enable them to express their ideas.

The range of work submitted for any of the regular major exhibitions of international printmaking will contain pieces that push at the boundaries of the acceptable. Not many years ago digital images were considered too far off the acceptable track, but they are now commonplace. The 13th Tallinn Print Triennial in 2004 included works in digital video, traditional silver-based photography, computer-cut vinyl on glass, and etching on deerskin. It seems that the edges, like glaciers or tectonic plates, are constantly on the move. Without this willingness of some artists to embrace the unknown, the world of printmaking would be a much safer, but far less stimulating, place.

1. Cecilia Bakker

Cecilia Bakker studied printmaking at Kansas City Art Institute and spent one semester studying at the University of Western Sydney, Australia. Still at the beginning of her career, she has shown her work at a number of exhibitions in the USA. She currently works in Kansas City running her own letterpress workshop and is an assistant to Michael Sims, Master Printer at the Lawrence Lithography Workshop. Her approach to printmaking is idiosyncratic, even somewhat anarchic, but it allows her to make use of a range of techniques in the realisation of her ideas. She is able to shift fluidly between traditional printmaking forms, particularly woodcut, and newer techniques such as photography and computer manipulation, while at the same time exploring the ways in which mediums and materials can be combined, modified or pushed to their limits. Bakker does not set out to use one particular method but prefers to allow techniques to suggest themselves during the progression of the work. She agrees that this approach does contain within it a degree of risk, but maintains that an element of serendipity is also possible.

In welcoming processes that by their nature allow for an element of play in the making and presentation of an image, Bakker sometimes discovers hybrid print forms that in turn suggest further development. In this regard she cites her exploration of printing from a woodcut block onto latex sheets, or making acrylic transfers of digital prints, which enable the creation of a three-dimensional object, thus offering the chance to create a space within which the images can exist as an installation. These images can in turn generate new images for recording and exploration. An example of this approach can be seen in *Dancing Skins* (2000), an

Dancing Skins Bound twigs, woodcut on latex, hay, steel; Dimensions variable; 2000

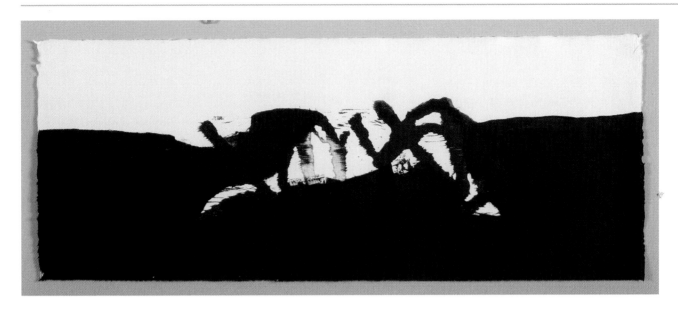

installation comprising woodcut prints on latex, bundles of twigs, hay and steel. The figures in the prints are positioned horizontally, to render them as 'lyrical, singing and swooping ... in a forest of burnt trees, still standing'. This work later led to *Survival* (2004), which began as a small life drawing of a male figure, was enlarged towards life-size by Xerox® print, then crumpled for exhibition. Bakker needed the third dimension to create a physical entrance for the piece, in which a vulnerable but active figure seeks a crevice through which to escape from an assailant, 'choosing survival rather than submission, regardless of his state'.

Script 4 Woodcut with drawing; 23 x 51 cm (9 x 20 in.); 2004

Bakker has long had a fascination with writing as a form of communication, believing that the personality of the writer is revealed in the detail as well as in the whole, an attitude that comes across clearly in two cycles of work that extract elements from writing in an extreme way. Beginning with found scraps of paper bearing the handwriting of anonymous people she has made high-magnification images of small sections, so that the results approach the abstract. In one cycle, *Scribble* (2002), she used Baltic birch to make woodcut

Scribble 4 Woodcut using Baltic birch; 33 x 53.5 cm (13 x 21 in.); 2002

Urban Landscape 3 Acrylic transfer; 13 x 13 cm (5 x 5 in.); 2002

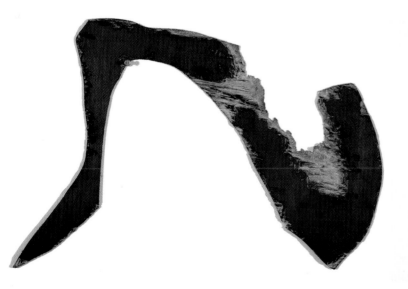

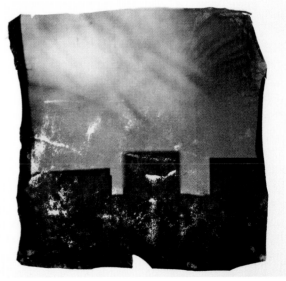

blocks from such images. Although she pulled prints from these blocks, she has since decided that the blocks themselves constitute a more effective response to her basic idea. They remain curious evidence of the hasty writing of an unknown person, revealed by a painstaking process of enlargement. In the second cycle, *Script* (2004), Bakker takes the same starting point, but concentrates in this case on highly magnified elements from the edges of found scraps of writing. These very enlarged images (created on a computer) are used to produce woodblocks, from which prints are made in the conventional manner and then subtly modified using drawing. For this artist it is appropriate to use wood, 'a live material with its age recorded in its grain. To carve a still image of motion or to carve gestural scribble marks makes that which was once moving and growing as still and forever recorded as grain is in wood and as memories are in the mind.'

The woodcut techniques used by Cecilia Bakker are predicated on a different interpretation of the purpose of communication from that of, say, Dürer or Hokusai. Her work is just as relevant to her own times as the works of those masters were to their own eras.

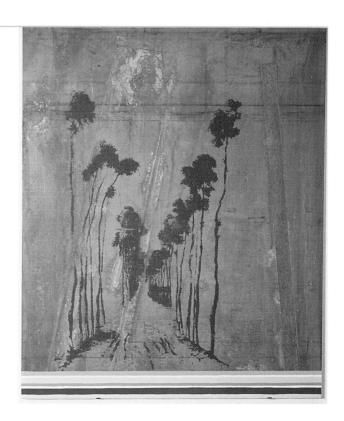

Square Horizon Steel, silk screen, carborundum, paint; 122 x 112 cm (48 x 40 in.); 2001

2. Marjan Eggermont

Born in the Netherlands, Marjan Eggermont emigrated to Canada in 1986, and graduated from the University of Calgary, firstly in Military History and then at Master's level in Printmaking. She now teaches at that university, splitting her time between the Art faculty and the Engineering faculty, in which she teaches drawing to first-year students. This unusual course was introduced to revive the students' awareness of the need to visualise using hand and eye rather than relying solely on the computer as a design tool. The interdisciplinary approach in her teaching is echoed in the way she approaches her personal work, which has been widely exhibited throughout Canada.

Eggermont became intrigued by the nature of human skin while producing a series of figure studies towards her Master's degree, and much of her work since then has been based on this interest. For her, human skin, and the structure of its cells, is what unites the estimated 6.3 billion human beings on this planet. Along with this

basic interest, Eggermont is also concerned with the broader phenomena of cloning and cosmetic surgery, as well as issues such as immigration, the environment and homelessness. With such an eclectic range of themes to ponder it is not surprising that she uses materials in less-than-conventional ways. During her graduate studies, as well as becoming interested in the surface of the body, she moved away from making conventional prints, beginning instead to work with techniques for printing directly onto steel plates. She has written of this side of work, 'Sometimes I think it was pure laziness. I was tired of editioning twenty prints at a time. I was always interested in sculpture and the plates because they have weight to them.'

The evolution of Eggermont's work has led her some distance away from conventional printmaking and into the territory more usually attributed to fine art. This blurring of both technique and attribution is to be welcomed, particularly when an artist is dealing directly or indirectly with the wider issues that affect society. In her work for an exhibition entitled 'Thick Skin' at Calgary's Herringer Kiss Gallery, she produced a body of work based on her ideas about skin that included silk-screened skin textures on ceramic stones, paintings, and

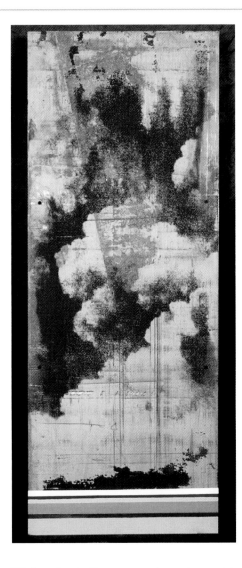

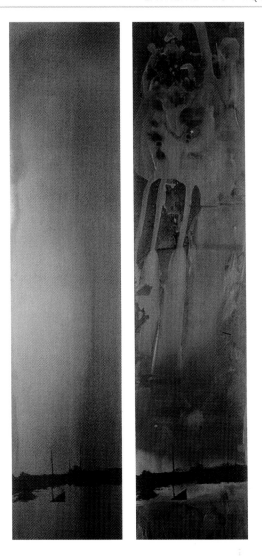

Holland Yellow Steel, silk screen, carborundum, paint; 122 x 46 cm (48 x 18 in.); 2001

REM/Recurring Dream/Dutch Landscape Steel, silk screen, patina; 244 x 51 cm (96 x 20 in.) (each part); 2003

prints on steel plates. One such work, *Elbow City*, comprised a three by three grid of nine square steel plates photo-stencilled with highly magnified images of skin from an elbow, the images being printed in a range of colours. *Palm* (2003) consists of highly enlarged fragments of a handprint etched into a steel plate, resembling the marks left by a giant hand, a trace of some mysterious passing.

Every other year since 2000, Eggermont has used the homelessness statistics for Calgary as the basis for an art work aimed at bringing the magnitude of the figures to life. In 2004 the work was presented using interactive computer technology at the Sun Centre of Excellence for Visual Genomics at the University of Calgary. This facility, normally reserved for modelling biological sys-

tems, including cellular structure, was in this instance used to create a virtual environment populated by 1,737 ghostly individuals – one for every homeless person in the city.

Marjan Eggermont's Dutch background also emerges in her work. In *REM/Recurring Dream/Dutch Landscape* (2003) images of landscape are silk-screen-printed onto patinated steel. The precarious position of the Netherlands, so close to sea level, is reflected in the inevitable degradation over time of the steel plate. What seems to be permanent is in fact, like life itself, subject to change and decay. Other work echoing the country of her birth includes *Square Horizon* (2001), a silk-screen print on steel with carborundum and paint, derived from Meindert Hobbema's iconic Dutch landscape

3. Jim Gislason

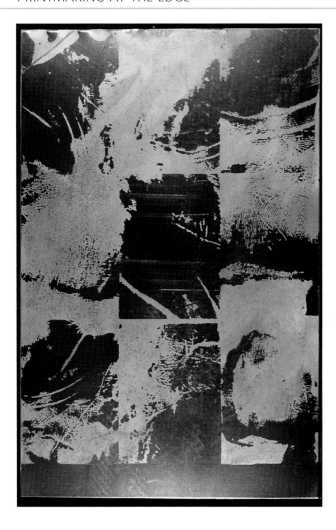

Palm Etched steel; 61 x 46 cm (24 x 18 in.); 2003

Avenue at Middelharnis (1689), the source of other work by Eggermont. As with her work based on human skin, similar concerns with mutability are indicated in this painting: her elegiac reinterpretation of the exaggerated slenderness of Hobbema's trees (which create a sharp perspective across the flat land in dull light) speaks for the fragility of the contemporary ecological balance, a quality that is echoed in the patches of rust that have already begun to degrade the surface of the work.

Born in Vancouver, where he still lives and where he studied painting and printmaking at the Emily Carr Institute of Art and Design, Jim Gislason is both an artist and a poet, and has exhibited his work in Montréal and Vancouver. His endeavours in the twin fields of art and literature seem to him separate but complementary; in each, while the grammars are complementary, the task is the same: to illuminate the chosen subject through form. Of his paintings he writes:

> These works are painted in 'flag' format and displayed not so much as contemporary art work, but more as relics (figuratively 'flags') to represent a given state at a given time. As we move through time these states necessarily change, and their flags become obsolete, relics. It may be that this consciousness of moving through time gives rise to a more metaphoric or poetic mode of thought, pushing the images towards religious tone and content. Ultimately we draw pictures of ourselves. The only questions are of quill and paper.'

Gislason's technique is a hybrid of silk-screen preparation and painting finish. The 'flags' are begun using conventional silk-screen techniques employing photo-emulsion, with a selection of images to be used as blocks – a face, figure, hands, pattern, text, etc. The screens are then exposed in the normal way to create the final composition. At this point the exposed image could be printed in the traditional way onto a secondary surface, creating an edition. Instead the artist applies oil paint in selected colours to the back of the screen and uses a squeegee to extrude the paint to the front, leaving a high-relief image that is allowed to dry. In some works he finishes the image using painterly techniques to manipulate the wet paint, adding further colour if desirable. It is not surprising, given Gislason's twin interests in the literary and visual arts, that many of the finished works incorporate text, usually in the form of one of his poems. By so doing he seeks to increase the potency of each medium by imbuing each with elements of the other. In this way the words are 'made of' paint and the painted image is 'made of' words.

This increases the density of each piece, combining the elements but diluting neither – rather they

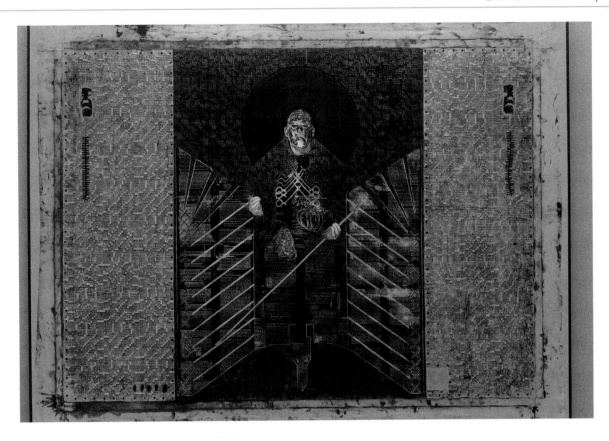

ABOVE *Hard Beast* Oil on silk-screen mesh; 134.5 x
180.5 cm (53 x 71 in.); 2003

BELOW *Hard Beast (detail)* Oil on silk-screen mesh;
134.5 x 180.5 cm (53 x 71 in.); 2003

ABOVE *Icarus* Oil on silk-screen mesh; 134.5 x 180.5 cm (53 x 71 in.); 2003

LEFT *Icarus (detail)* Oil on silk-screen mesh; 134.5 x 180.5 cm (53 x 71 in.); 2003

basis for jazz improvisation, and the many examples of poetry and jazz being combined. In each case the resulting synergy of seemingly disparate forms served to underline the universal quality of music as a language transcending time and culture, and in the case of poetry and jazz the ability of one form to riff with the other, blending musical improvisation and lyrical inspiration. The manner in which Gislason approaches his work – whether in word or image – in some ways resembles jazz, and his interest in music is clearly evident. Equally, his work reveals a strong interest in literature and myth.

In *Icarus* (2003) the doomed antihero of the Cretan myth is reduced to a cipher of lines symbolising a feather, with a photographed face that resembles the artist. The background is filled with extruded text; the sun is a circle of golden text. In the accompanying poem there are the lines, 'There is a wind for every Icarus/and an Icarus for every wind'.

In *Rising Sun Blues* (2003) a grand piano stands on a stage draped with mesh curtains and a backdrop covered

strengthen each other so that the whole is greater than the sum of its parts. The poems are often exhibited beside the print-paintings, enabling a more intimate access to the artist's intentions and thoughts. There is a close parallel in this unusual technique with the various ways that jazz has been combined with other mediums: for example, the fusion of Indian music with jazz in the Joe Harriott-John Mayer Double Quintet, the innovative work of Jacques Loussier that used Bach's music as the

Dorothy Simpson Krause *Plowed Field* Digital print transferred onto fresco, paint; 61 x 61 cm (24 x 24 in.) (each); 2004

with a music score. The accompanying poem, 'I Cover the Waterfront', which appears at the foot of one of the curtains, refers to a night in a bar. It contains the lines, 'We turned the coasters into eye patches though/that was pretty funny/ except the waitress hated us'. Gislason's poetic and visual imagination reveals aspects of a world half-seen, half-heard against the music.

4. Dorothy Simpson Krause

The experimental ways in which artists approach the making of art can open up new dialogues between concept and image, resulting in works that exceed the expectations of the artist and reveal new possibilities for the viewer. Throughout the history of art, the combination and manipulation of techniques have led in previously unconsidered directions, a process that has accelerated in the rapidly mutating technological world of the mid-20th century onwards. While some artists have abandoned traditional materials in favour of the new technology, others have approached the matter through lateral thinking, seeking new possibilities through a fusion of traditional and new. Krause is an artist of the latter kind, whose innovative approach is yielding fresh insights into the process by which art is made.

Krause is Emeritus Professor at the Massachusetts College of Art, and a member of the Digital Atelier® collaborative (with Bonny Lhotka and Karin Schminke), which has recently produced a book detailing the techniques for combining ink-jet printing with traditional art materials. She lives and works in rural Massachusetts, has exhibited widely and is a frequent speaker at conferences. Her contributions to the world of art have led to many awards. She describes herself as a painter by training and a collage-maker by nature. Her experimental work began with the use of reprographic machines and in the late 1960s, while working on her doctorate, she was introduced to computers. Since then her work has involved combining traditional and digital mediums, embedding 'archetypal symbols and fragments of image and text in multiple layers of texture and meaning'. By combining humble materials such as plaster, wax and graphite with hi-tech digital machines she is able to evoke the past and

Cliff Diptych Digital print transferred onto fresco, paint; 61 x 61 cm (24 x 24 in.) (each); 2004

BELOW *Ringed* Digital collage assemblage, printed on both sides of polycarbonate sheet, with white-painted metal ceiling tile behind; 61 x 61 cm (24 x 24 in.); 2002

look to the future. Her work confirms that the gap between traditional images and new technologies can be bridged with considerable success. It also invites subversive readings, and questions the implementation of power at the same time as it celebrates individual dignity and the strength of the spirit. She writes:

> By focussing on timeless personal and universal issues – hopes and fears, lies and dreams, immortality and transience – I challenge myself and the viewer to look beyond the surface to see what depths are hidden. I imbue my work with the quality of allegory, not to be factual but to be truthful in character.

Some of the techniques used by Krause are initially straightforward. For the two series *Sacred Spaces* (2003) and *Fragile Beauty* (2004), she combined digital images of oil paintings and photographs (taken by Donna Rossetti-Bailey and Viola Kaumlen), using Photoshop® to create the working image. The substrate in both cases is, however, more innovative; in *Sacred Spaces* she used spun-bonded polyester (used as interfacing in the garment industry),

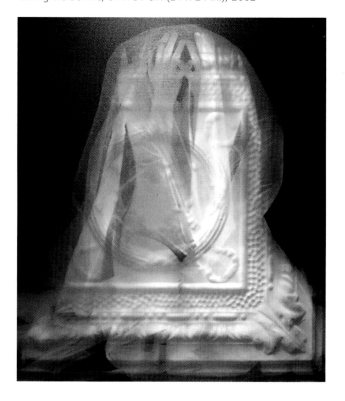

coated to receive high-durability inks on a flexible media printer. The printed images were reworked with traditional materials such as oils, pastels and encaustic; in some cases graphite powder was rubbed into selected areas of the print to give added sheen. In *Plowed Field* (2004), a painting and a photograph were combined digitally, then transferred to fresco, with additional working using traditional materials. In the case of both series the resulting images hover between painting and photograph, giving the elegiac impression of stillness tinged with a melancholy redolent of century-old photographs of a lost time.

The series *Body + Soul* (2002) contains several groupings of works, including two of Krause's artist's books. Much of the work was based on photographs that were digitally manipulated to create the image files from which the final prints were made. Spending some time with a specialist print shop in Illinois gave her the opportunity to experiment with the possibilities of the first flat-bed ink-jet printer in the USA. This machine can print images up to 84-in. wide on virtually any substrate up to 1.58 in. thick, at high resolution and using UV-cured inks. Krause experimented with images on galvanised steel, wrinkled tin sheet, and lead nailed to plywood. For the group including *Ringed* and *Bowed*, print images were made on both sides of a ¾-in. polycarbonate sheet, which was then sandwiched together with a white-painted metal ceiling tile, creating a dense final image.

Clutch Bag Bag designed by Kristina Briseno incorporating waterproofed letterpress prints by Hammerpress and magnetic clasp; n.d.

5. Hammerpress

To operate successfully with both traditional movable type and an Internet website requires an extreme jump in technologies, but this is what a number of print shops in the United States have accomplished. It is a phenomenon that has not yet occurred in the same way in Europe. Its success in the States perhaps owes something to the history of the American pioneers. During the second half of the 19th century, small printing businesses followed the settlers west, producing newspapers, announcements and those 'Wanted' posters that have featured in so many movie Westerns. While new technologies have overtaken most printing businesses those old presses, forms and type collections have survived – being made of far more durable materials than computers. Much of this equipment is now in the hands of young graduates from art institutes, who seek to continue the traditions, at the same time putting their own particular slant on what comes out of those old machines.

Hammerpress is one such print shop, which has grown in popularity and size since being started by Brady Best in 1994. Now situated in the Crossroads Arts District of Kansas City, it produces a wide range of commercial material, including invitations and announcement cards, business cards and events posters, and an idiosyncratic range of postcards and printed ephemera. The shop is a large, double-height space with a wooden floor, equipped with venerable presses, compositing tables, rack upon rack of paper and card stock, type collections, and numerous drawers of wood and metal decorative elements and borders. The noise of the presses and the smells of the inks complete an atmosphere that would have been instantly recognisable to the editors of the countless small journals that contained all the news 'fit to print' in the newly developing communities of the Old West. Those days have gone, of course, but Kansas City still has the lingering traces of

Robots Need Coffee Letterpress on card with metallic ink
10.7 x 15.6 cm (4¼ x 6¼ in.); n.d.

Wall Hangings I Computer-generated image showing large-scale letterpress prints in restaurant; n.d.

the atmosphere of a frontier town, which survives despite the metropolitan homogeneity of a burgeoning business district. The city's art world and the thriving music scene – successor to the celebrated jazz scene for which the city is famous – into which Hammerpress so neatly fits, provide much of their business, though businesses and individuals who want printed works that will stand out from everyday, mass-produced, computer-designed material constitute another important revenue stream.

With an in-house design service – it employs artists such as Michelle Dreher to produce hand-cut woodcut blocks and other details where appropriate – and using metal type in a wide variety of typefaces, Hammerpress prints mostly on heavyweight stock of predominantly neutral colour with a wide colour range of inks. The results are often complex, having been passed through the presses a number of times, with overlaid colours and textures providing a richly detailed surface that, combined with a design style tinged with humour, results in products that are very different from the results of high-speed lithography. There is a degree of comparison with the posters and cards produced for the famous Fillmore Auditorium concerts of the late 1960s, and it is not

surprising that Hammerpress products are now seen as collectable. Indeed, they are found in situations far removed from their original purpose: one local designer, a big Hammerpress fan, has set a collection of their work beneath the glass top of his dining table, providing not only an unusual showcase for the work but also a talking point for his guests. Another artist, Kristina Briseno, makes use of posters from the press to make clutch bags, waterproofed and fitted with magnetic clasps, which are themselves highly sought-after.

But Hammerpress is not stuck in some sort of technological time warp. It has a website, and looking forward – or as they put it, 'keeping the wheels spinning' – they are exploring through the medium of 3D-computer modelling the possibility of producing images for commercial-display purposes that could be up to 12 ft. (4 m) high. The combination of technologies needed to bring about such an enterprise would be challenging, but would also offer proof, if any were needed, that traditional forms of printing can find their place in the 21st century. All that is required is Hammerpress's high degree of skill in the old techniques combined with lateral thinking and innovation.

13. TRAVELLERS

INTRODUCTION

DURING THE MIDDLE AGES and the centuries that followed it was usual for scholars in Europe to travel from place to place in order to enhance their learning. The great universities gained repute through the content of the libraries they were building up as well as through the presence of renowned professors and tutors in their faculties. It was accepted practice therefore for scholars to spend a period in, say, Oxford studying with a celebrated philosopher and to follow this with further studies at one or more of the other great universities of Europe. At the same time the developments in particular styles and techniques in the burgeoning visual arts created a similar network through which young artists could develop their skills by working in the studios – in Italy, the Netherlands and elsewhere – of the various masters of the day. This instructional criss-crossing of the Continent helped to promote advances in other areas of cultural development, leading to a fertile environment for intellectual pursuit in which the prominent thinkers and artists of the Renaissance, and their successors, could flourish and prosper. However, this great web of learning was restricted to a privileged few, and the outcome of their labours had little immediate effect on the majority of the rest of the community.

The global society in which we now live offers wider opportunities. The spread of learning has greatly increased the possibilities. In addition the coming of the World Wide Web has opened up a vast resource of knowledge that is available to anyone with the means to gain access to it. But, as in the Middle Ages, there is no substitute for hands-on experience. For this reason it is common for print-makers – probably more so than practitioners in other areas of the visual arts – to travel from place to place in order to work and study in the workshops and studios that have developed in many parts of the world. It may be a relatively simple matter of needing access to a particular press or technical facility, or it may be that a specific workshop offers the chance to work with an artist developing a new conceptual, or perhaps practical, approach. Whatever the reasons, this extensive process of travelling, studying and working has fostered a truly democratic and vibrant international print community.

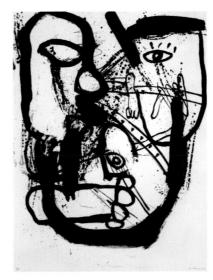

Modhir Ahmed *Nay Player II*
Planoprint; 108 x 78 cm (3 ft. 6½ in.
x 2 ft. 6¾ in.); 1997

1. Modhir Ahmed

Modhir Ahmed is currently Director of the Falun Print Workshop in Sweden. The long journey that has led him there from his birthplace in Iraq is an unusual one. He was born into a large family in Baghdad and became interested in art as a young child, having discovered an ability in drawing. He also recounts the pleasure he found – and still experiences – in playing the 'nay', a Middle Eastern flute. When Ahmed was 12 years old his father died, and the extra responsibility thrust upon him persuaded him of the need to take his own educational needs in hand. Encouraged by his high-school teachers he became a student at the Institute of Fine Arts in 1974, graduating in graphics. He was fortunate that one of his tutors happened to be Roman Artymowski, who made his first journey from Poland to Iraq in 1959. Artymowski himself achieved a high reputation as a graphic artist in Poland in the mid-20th

Square I Linocut; 78 x 108 cm (2 ft. 6¾ in. x 3 ft. 6½ in.); 1999

century, and was also an influential teacher. Ahmed made his first visit to Poland in 1977 as a tourist and, so impressed was he by what he had seen, particularly the poster art that thrived at the time, he decided he would return there to study as soon as he was able. Back in Iraq he travelled widely to learn about the rich cultural heritage of his country, on one occasion spending time with the nomads in the vast desert landscape of the south.

In 1980 he returned to Poland to study, first in Łódź and then in Warsaw. His time there coincided with the rise of Solidarność. Along with the many deprivations suffered by the Polish people in that period, Ahmed also experienced a shortage of art materials and was forced to improvise with whatever came to hand. Undaunted by the difficulties and stimulated by the rise in cultural consciousness at such a pivotal moment in Polish history, he also discovered an enduring interest in jazz and blues, sensing its relationship with Sufi dervish music and its aim to unite the soul with God. At the same time he was frustrated by how difficult it was to find a print workshop in which to develop his own work. Swedish friends at the Art Academy in Warsaw encouraged him to consider moving to Sweden; so in early 1988 he crossed the

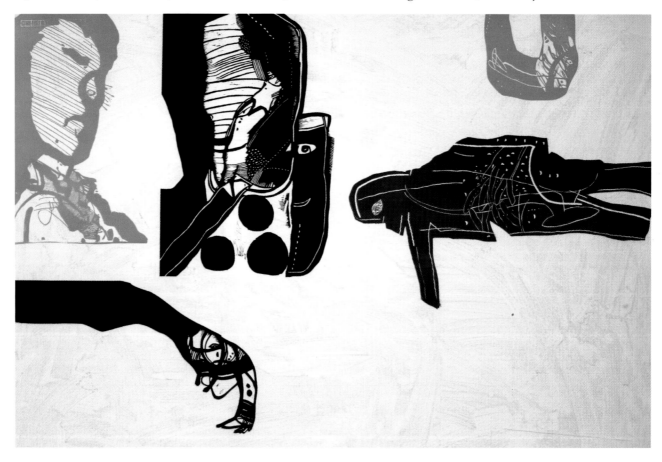

RIGHT, TOP *The Poet* Planoprint; 78 x 108 cm (2 ft. 6¾ in. x 3 ft. 6½ in.); 1999
BELOW *Without Title III* Mixed media; 122 x 86 cm (4 ft. x 2 ft. 10 in.); 2003

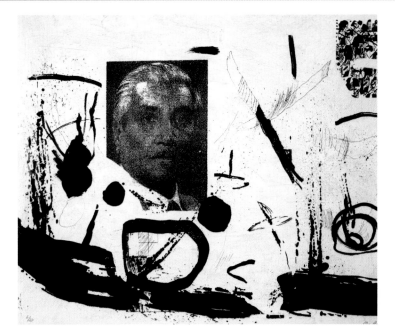

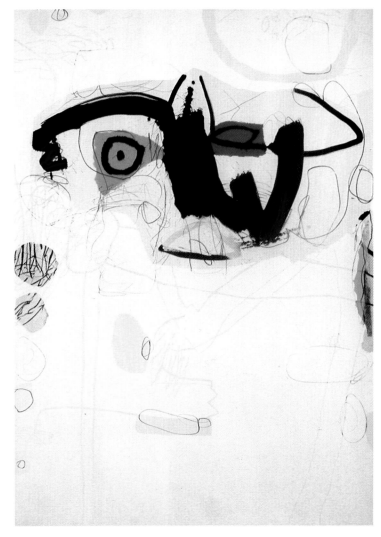

Baltic Sea, firstly seeking asylum with his Polish wife and child, and subsequently settling near Gothenburg. He began working in the print workshop at Borås, developing his technique of using old offset plates, first coating them with shellac and then, using colour as in the lithographic process, producing large planoprints on an intaglio press. In 1992 he was appointed Director of the Print Workshop in Falun. Under his guidance the workshop has expanded and, with the assistance of the municipality, hosts the Falun Biennial, which has developed a reputation for interesting and innovative exhibition programmes: for instance, the 2004 Biennial concentrated on printmaking from the Balkans.

Ahmed's personal work has developed radically during the years he has spent in Sweden, but it is apparent that he has neither forgotten nor abandoned his Iraqi roots. The broad gestural marks of his mid-1990s prints – for example, *Nay Player II* (1997) – recall the delicacy of Arabic calligraphy, but with elements of the rudimentary graphic marks of the Sumerian tablets that so fascinated him as a young man. At the same time there is a pictorial sense that is European, so that the fusion of these elements creates a unique blending of cultural influences stretching from the Middle East to Scandinavia. By 1999, as in *Square I*, there is a tighter control and the introduction of added colour, with imagery that is reminiscent of Viking art. The *Without Title* series of 2003 reveals a looser approach and paler washes of colour, and exhibits a lighter and more humorous touch.

Modhir Ahmed writes of the journey he is undertaking:

> In all the places I have visited in my life I witnessed both a shortage and a richness in every place. By this I mean that for example I wished that a Polish atmosphere of art existed in Sweden. On the other hand I wanted Swedish materials and possibilities to exist in Poland. At the same time I wanted to live in an environment like the Sahara.

2. Michael Schneider

Born in Innsbruck, Michael Schneider studied painting and printmaking in Vienna before spending four years in Japan, gaining a further Master's qualification in printmaking from Tokyo National University. His decision to go to Japan was based not only on his desire to gain technical experience but also to deepen his understanding of a culture that is very different to that of Austria. While in Vienna he had already obtained a considerable knowledge of and skill in woodcut printmaking, discovering a particular interest in the way the technique can be used to articulate the language of signs. Japan, with its cultural tradition of signs, was therefore an obvious choice for his further development. He stresses that he tried hard to avoid allowing the first strong impressions of Japan to bring about merely superficial changes in his work, to the point where it seemed to him that his work changed very

little for the first two years. Nevertheless, the cross-fertilisation of cultural approaches to the making of art has proved to be of pivotal importance in Schneider's work.

The depiction of signs and all the ambiguity that came with understanding their use, already deeply embedded in European art from prehistoric times onwards, reached a zenith in the Renaissance. In the rapidly developing world of the 13th–16th centuries, interpreting the complexity of religious symbolism in art became a highly evolved intellectual discipline. At a time in which access to the written or, later, printed word was still limited, the exploration of hidden levels of meaning in art – whereby each colour and object and the relationships between them could be given increasing weight through study and discussion – became an irresistible pursuit for the privileged minority.

By contrast Japan has a very different cultural tradition, together with religious and philosophical practices that are themselves more abstract than their European counterparts. The individual characters that make up

ABOVE *Rekonstrukt Lithographie I–III* Woodblock prints with polymer intaglio, black Indian ink and printing ink on Japanese paper; 84 x 51 cm (33 x 20 in.) (each); 2003
LEFT *Digitally Enhanced Reconstructions I–IV* Woodblock prints with polymer intaglio, black Indian ink and printing ink on Japanese paper; 85 x 27 cm (33½ x 10½ in.) (each); 2002
RIGHT *Digitally Enhanced Reconstruction IV* Woodblock print with polymer intaglio, black Indian ink and printing ink on Japanese paper; 85 x 27 cm (33½ x 10½ in.); 2002

the Japanese language serve to characterise several different things with one form, having multiple meanings that can only be fully understood and articulated within the context that contains them. In addition there are considerable subtleties inherent in the combinations of characters, which go beyond the nuances found, for example, in the English language.

While the invention of movable type shifted the balance away from the use of symbolic visual language in communication towards the concrete actuality of the written word, a shift that the diffusion of the Internet has accentuated in recent times, a fascination for the non-verbal language of sign and gesture remains a potent force in many forms of contemporary art.

In its traditional form the making of a woodblock requires that sharp cuts are made with knife or chisel to remove those areas of the drawing or design that are to remain unprinted, a straightforward separation into

black/colour and no black/colour. The subtleties of tone arise from the manner in which the pigment is applied and transferred to the paper, either by press or, as in Japanese woodblock, by baren. The delicacy of prints by, for example, Hiroshige, depends also on the fluency with which the cuts are made in the block.

While Schneider is highly competent in the traditional techniques, he has chosen instead to pursue an alternative method of producing blocks and prints. He uses stones to beat indentations into the wood so that sharp edges are avoided. The highly controlled technique that he uses results in graduated transitions from the worked to the unworked parts of the surface. Using traditional Japanese papers and pigments he then transfers the images by hand with a baren. This allows for considerable finesse, but it also means that by virtue of this process each print will be unique; in any case, Schneider normally limits the edition of each image to three. In his recent work, in addition to the woodblock images he has introduced elements created by using

highly modified digital photographs transferred onto polymer plates and printed by an intaglio process. In this way he fuses direct traditional and indirect technological methods of origination to produce innovative work that establishes a bridge between two cultures.

3. Wayne Eastcott

Wayne Eastcott, born in Trail, British Columbia, Canada had intended to study science and mathematics at university. Instead, after a major change in direction he graduated with double honours in painting and printmaking from Vancouver School of Art (now the Emily Carr Institute of Art and Design). However, despite four decades of international success in printmaking his work still contains connections with science and mathematics, and his interest in technology is unabated. Following work as a commercial artist, during which he not only expanded his knowledge of print techniques but also became fascinated with the developing technology of photocopying, he joined the art faculty at Capilano College in North Vancouver. In 1973 he established the printmaking department at the college, which has since gained an international reputation for excellence. His work with the early photocopying process – at that time involving the use of machines that occupied half a room – resulted not only in a Canada Council research grant but also the loan of equipment from the Xerox® Corporation, which enabled him to set up a studio to make full use of it. His experiments with the process led to a substantial body of work, and in turn, from 1979 onwards, to numerous visits to Japan.

While Eastcott's first Japanese trip was made to coincide with a one-person exhibition of his work based on the interface between fine art and technological processes, it also brought him into close contact with traditional Japanese culture. In particular it gave him a deeper insight into the essentially spiritual core of that tradition, and he found that the experience resonated with his own way of thinking. He describes this philosophy as 'Dialogues of Process', a method by which the connections and tensions between nature, humankind

LEFT **Wayne Eastcott** *Moodyville Notes 2* C-print on Kodak metallic paper; 51 x 41 cm (20 x 16 in.); 2000

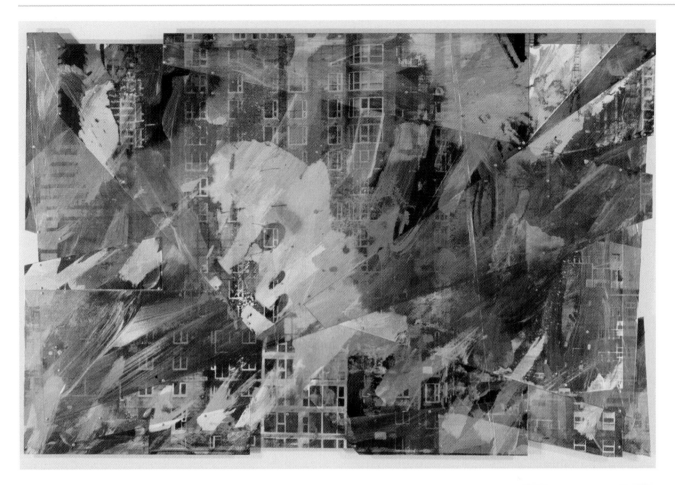

ABOVE *Bayshore 2* Enamel, acrylic and pigment (printed and painted) on riveted aluminium; 95 x 148 cm (3 ft. 1½ in. x 4 ft. 10¼ in.); 2002

RIGHT *Bayshore 2 (detail)* Enamel, acrylic and pigment (printed and painted) on riveted aluminium; 2002

and technology can be explored. At the core of his work are the dualities of organic/synthetic, order/chaos and intuition/logic. In addition natural laws, such as gravity or the formation of ripples on a pond, and the similarities between natural and man-made structures, continue to fascinate him. The connections between seasonal cycles, musical harmonies and mathematical sequences influence many of his thought processes, while the relativity of man, nature and technology, and the nature of humankind as organic, spiritual and emotional beings, are the themes that link all these concerns. In his experience the process by which works are made manifest – whether under his control or by some more organic development of ideas – can be a slow one, sometimes taking years to bear fruit. Notwithstanding this painstaking approach, and his restless exploration of

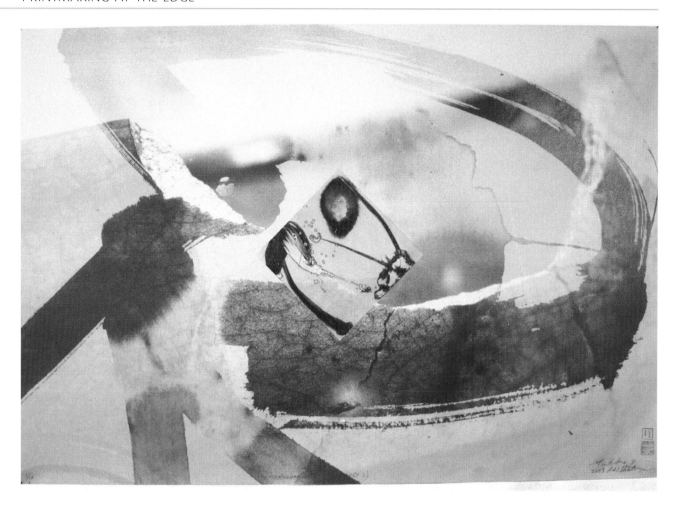

Interconnection 2 – Yobitsugi 2 Ink-jet print, toner etching, chine collé and silkscreen on paper; 78 x 114 cm (2ft. 6¾ in. x 3 ft. 9 in.); 2003 (produced in collaboration with Michiko Suzuki)

the right way to present his ideas, Eastcott has still managed to produce a large body of work that contains many innovations and hybrid techniques.

For example, the *Bayshore* series (2000 onwards) uses a wide range of printmaking techniques and approaches to create complex meditations on the connections between humankind and technological structures. The images of office buildings and high-rise condominiums are derived from the glittering wall of buildings that line the harbour in Vancouver. The geometry is strict and sets up a matrix in which the events of the works in the series can be placed. The straight lines are sometimes graphically derived and sometimes the result of cut and riveted metal sheets. The organic marks contain metallic pigments, echoing the use of such materials both in the electronics industry and in traditional Japanese lacquer painting. The many layers of colour glaze make

reference to the colours generated on heated or electrically charged surfaces; the apparently random brushwork is either painted through precisely cut stencils or otherwise silk-screened. *Interconnection* is a series of works made in conjunction with Michiko Suzuki (see next profile). Suzuki's residencies at Capilano College allowed the two artists time to explore the similarities between their approaches to printmaking and the materials they used in common. The series subtitle, *Yobitsugi*, refers to the Japanese technique for repairing a precious ceramic piece that has been broken, whereby any spaces between the reconnected fragments are filled with gold. The two artists considered this the appropriate term for the joining together of their two forms of printmaking. In any event the cooperative project has been mutually enriching and beneficial to both artists.

OPPOSITE Michiko Suzuki *Voyager (Suminagashi I)* Archival ink-jet print; 76 x 57 cm (2 ft. 6 in. x 1 ft. 10½ in.); 2003

4. Michiko Suzuki

Michiko Suzuki was born in Tokyo, where she still lives, graduating from Musashino Junior College of Art in 1974. At that time there were no major courses in printmaking at university level. However, Suzuki gained valuable further experience after graduation by working at Print House OM, where she trained and subsequently worked as a Master Printer. In the three decades since then she has developed a considerable body of work and has exhibited internationally, gaining a number of prestigious awards in Japan, Lithuania, Canada and Korea. In 1997, her work was selected for an exhibition of Japanese Prints in Edmonton, enabling her to visit Canada for the first time. In 1999, she met Wayne Eastcott at Musashino Art University during one of his visits to Japan, and she met up with him again in Vancouver following a three-month residency she had spent at the University of

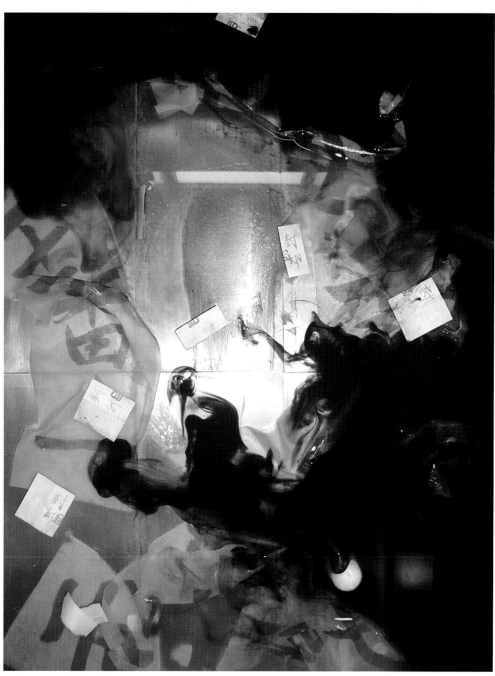

Edmonton in 2002. This resulted in a continuing collaboration between the two artists and a residency for Suzuki in the printmaking department at Capilano College, Vancouver in 2003, with a further visit in 2004.

The experience of her visits to Canada and the chance to cooperate with Eastcott has proved fruitful for her work, just as she feels a sense of connection to the work that Eastcott has made following his visits to Japan. Suzuki's own work is based on her perception of a world in which the sense of space and distance is shrinking, not only in the physical world but also in terms of the mental space that people tend to inhabit in a fast-paced urban society. She considers that the demands of contemporary life leave too little space for meditation, or the possibility of contemplating the present moment, resulting in human beings being out of balance. As a response to this condition Suzuki incorporates empty space within much of her recent work. Of this she writes:

> It confronts the viewer ... objects remain peripheral, and a perfect balance exists between nothingness and life forms. Japanese people call it 'Ku'. It literally means 'sky space', but there are a lot of other meanings, like 'substantial emptiness'. This concept is difficult for many Western people to comprehend since the idea of 'filled emptiness' seems contradictory and paradoxical.

Together with this philosophical element Suzuki emphasises also her need to observe the nature of the materials she uses: natural, traditional, paper or technological. Japanese paper, or 'washi', is produced from wood derived from trees that have been coppiced. Coppicing is a traditional technique practiced also in the West, whereby a young tree is cut down periodically, allowing new shoots to sprout from the stump. In the manufacture of washi, when the wood is made into paper the fibres are retained, thus adding to the finished paper's inherent beauty. Suzuki contrasts this method with the European technique for mass-producing paper, in which trees are felled to produce pulp, with the fibres more or less obliterated. She regards this as a metaphor for the difference in attitude between European and Japanese civilisations, whereby in Europe nature is seen

LEFT, TOP *Voyager (Suminagashi 3)* Archival ink-jet print; 76 x 57 cm (2 ft. 6 in. x 1 ft. 10½ in.); 2003
BELOW *Visibility 7* Archival ink-jet print; 99 x 71 cm (39 x 28 in.); 2004

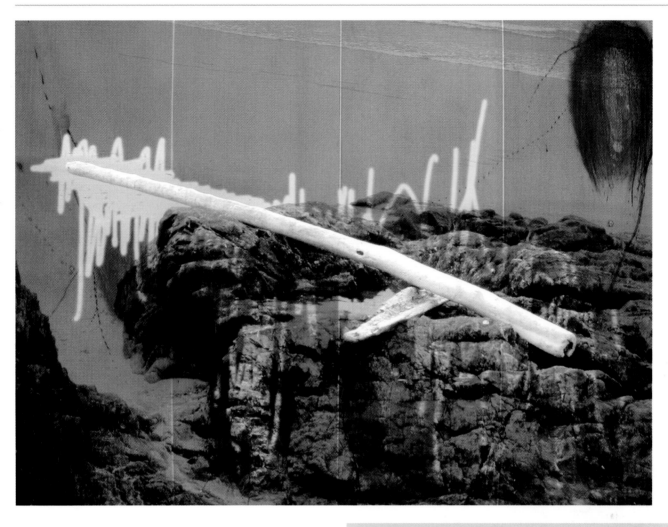

A Feeler (Driftwood 4) Archival ink-jet print; 74.1 x 100 cm
(2 ft. 5¼ in. x 3 ft. 3¼ in.); 2004

5. Arūnas Gelūnas

as an obstacle to conquer, while in Japan it is seen as a world with which to coexist.

The technique that she uses, both in her individual work and that produced in collaboration with Eastcott, is a combination of traditional copperplate relief and digital ink-jet, resulting in a hybrid form that transcends the limitations of each component. She has developed a further technique in tandem with copperplate relief, in which black photocopier toner is used as an anticorrosive on the surface of the plate. The toner is sprayed or is drawn with fingers, before being fused to the surface by heating. Once the plate has been made the resulting images are processed, the final image being delivered by a large-format ink-jet printer using archival inks on traditional papers. Suzuki believes that 'art is a balancer: I hope that people achieve a balance between a sense of time and a sense of space'.

Arūnas Gelūnas lives in Vilnius, where he is Vice-Rector of the Vilnius Academy of Fine Arts and Associate Professor in Printmaking and Calligraphy. He graduated with an MA in printmaking from the Academy, and was subsequently a research student for two years at the Tokyo National University of Fine Arts, studying Japanese language and painting, before completing his PhD in philosophy at the Vytautas Magnus University in Kaunas. His academic background therefore bridges many disciplines, as well as embodying a strong link between Lithuania and Japan. It may at first seem somewhat unusual that an artist from a small Baltic state should have taken a profound interest in the culture and language of Japan. Upon reflection, however, it can be seen that there are connections between the two countries that go some way towards explaining that interest.

As has been outlined elsewhere in this book, Lithuania has a culture rooted in the depths of the European past. The last European country to be converted to Christianity (in the 14th century), the ancient pagan religion – in this case, Romuva – is nearer the surface of the culture and thus more widely practised than in other countries in the region. The respect in Romuva for the forces of nature stems from an awareness of the natural world that also underlies much of Japanese culture. The forms of traditional art in the two countries are dissimilar, but at the same time there is a strong graphic element, which can easily be seen in both the wrought-iron crosses of Lithuanian folk art and in the strongly graphic forms of traditional Japanese buildings. The ancient languages have different roots, Lithuanian being one of only two surviving members of the Indo-European language family (the other being Latvian, from which it diverged in the 7th century), while Japanese can be traced far back into the East Asian past, despite having been a written language for only the past 1,500 years.

Wind In My Head, Dotted Line Identity Woodcut, ink painting, digital photography on Japanese hosokawa paper; 205 x 305 cm (6 ft. 8¾ in. x 10 ft.); 2003

In his teaching and academic writings Gelūnas has pursued his interests in the art and philosophy of both cultures, the relationship between them and the manner in which they continue to have an important value in education and society. He has exhibited with success in Europe and Japan, and has received a number of awards. His personal work relates strongly to the breadth of his interests, revealing a philosophical depth and an assured knowledge of the techniques of both European and Japanese art. In a colour etching from 2000, *The Fallen (Mechanical) Angel*, a shadowy winged figure tumbles through a dark sky towards a distant array of tall towers, while another winged figure lies crumpled in the foreground. The Icarus myth is updated to the uncertainty of a technological future, in which progress and humanity seldom coincide. A set of etchings entitled *Structure and Energy* (2000), combining precise mechanical structures and inscriptions of key dates in European history, with swirling lines and dynamic splashes of tone, encapsulates the essence of energy. One, based on a diagram of a speed governor, bears the inscription, 'AD 1812 Europa', a year of revolution during which Napoleon passed through Vilnius on his return from the siege of Moscow. There is a subtle warning here

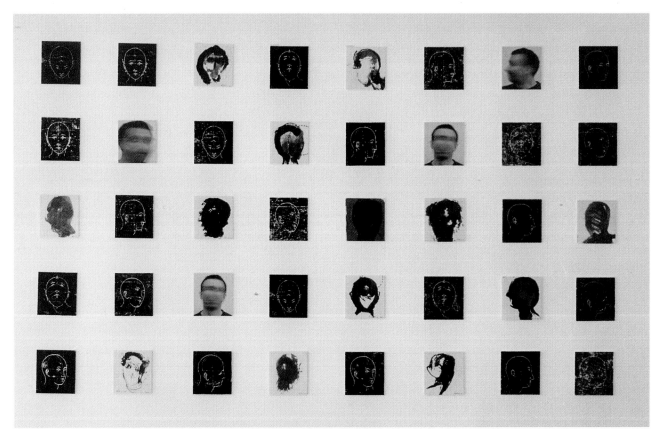

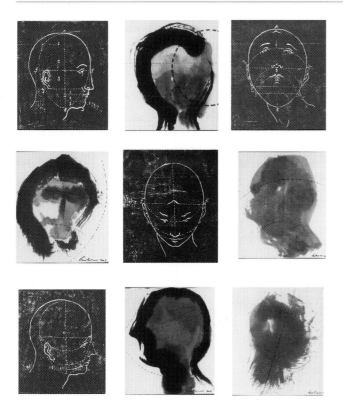

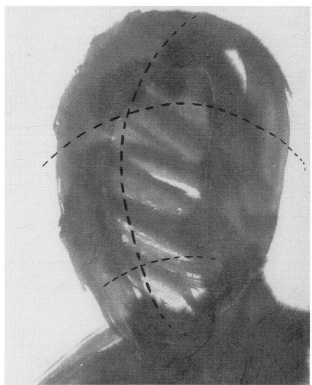

Wind in My Head, Dotted Line Identity (selected images)
Woodcut, ink painting, on Japanese hosokawa paper; 2003

Wind in My Head, Dotted Line Identity (single image)
Ink painting on Japanese hosokawa paper; 2003

of the need to learn the lessons of history lest we are doomed to repeat them.

In a major work exhibited in Kaunas and Vilnius in 2003, *Wind in My Head, Dotted Line Identity*, Gelūnas turned to the notion of identity and its depiction. A total of 40 prints form a grid of 5 lines of 8 images, with woodcuts, brush paintings and blurred digital prints iterated more or less symmetrically. The woodcuts have the precision of technical illustration, with diagrammatic faces from various viewpoints delineated in white on black, and dotted lines marking out proportions and geometrical relationships. The brush paintings are broad and ill-defined, gestural reminders of the uncertainty of the only answer to the question, 'Who do you think you are?'; while the digital prints, based on the most highly developed technological process of the three mediums, are blurred into anonymity. In his presentation of a tentative answer to the common conundrum of identity Arūnas Gelūnas has produced a work with philosophical depth and an assured control of the techniques he uses.

6. Naoji Ishiyama

Naoji Ishiyama was born in Niihama, Ehime, Japan and gained an MA in Fine Art from Aichi Prefectural University of Fine Arts in 1993. His work has been included in many Japanese and international exhibitions, from which he has received a number of awards, including the Mayor of the City of Katowice Prize at the International Print Triennale in Kraków in 2003. Following his visit to that exhibition he travelled to Jyväskylä in Finland, where he now lives and works. The change of culture and lifestyle brought about by moving from Japan to Finland has made a strong impression on him, and this is starting to manifest itself in his work. He is fully aware of the degree to which his work has evolved since he decided to submit prints to national and international competitions in the year following his graduation, and considers that this experience has been of great value. Like many young artists he finds it difficult to critically evaluate his own work. By submitting

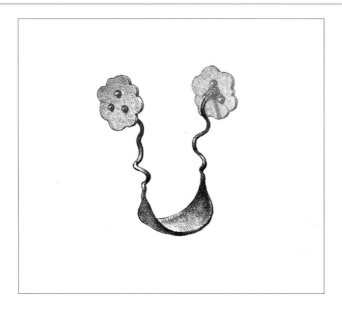

Kukka Etching; 19.5 x 14.5 cm (7¾ in. x 5¾ in.); 2004

his work for competition with that of other artists from the international print community, he has gained in confidence, and in his awareness of the varying criteria adopted by the juries of major competitions.

Like many visitors to major celebrations of the arts of printmaking, Ishiyama at first found the sheer variety of styles and approaches bewildering. The initial impression of there being no unifying factor caused him some confusion, particularly in trying to assess the worth of his own work against that of so many other artists. After some time, he writes, he noticed 'that there is a kind of ideal sense of values about art common to all artists, no matter what nationality they have'. He also saw that differences resulting from the artists' cultural and environmental backgrounds seem to be getting less pronounced, something he puts down to the progress of information technology. He considers that there is a need for common ideal values among contemporary artists, and that as artists strive towards this end the public will gain a growing ability to divine more fully the concepts and meanings of contemporary art.

Ishiyama writes that he had no desire to move from Japan before he started thinking about Finland, and that his friends asked him why he had not chosen the United States, France or England. His motivation was to work in a totally different cultural environment, and to this end he considers that his choice of Finland was propitious: he has found himself in a culture that feels

comfortable – although it is very different from that of Japan – and which inspires him to take his work in new directions. Jyväskylä, located north of Helsinki, has a vibrant cultural life, and an active centre for printmaking, connected to the town's art museum, that has been a strong influence in his work since 2003. Before then he had already developed a highly accomplished style, as is demonstrated in the etching with aquatint *Flowering Plant* of that year. This work, which led to the award in Kraków, is a good example of the work of this Japanese artist, who has transcended the usually expected stylistic boundaries of his country and achieved a result that is truly international, owing its creative values to the ideal sense that he has described.

One of the first prints Ishiyama produced in Finland was *Kukka* (early 2004). 'Kukka' means 'flower' in Finnish, and the image is derived from a children's swing in the playground beneath the balcony of his apartment. This simple image clearly marks the transition the artist has made in moving from one culture to another. His subsequent work has become more complex, as seen in *Splash* (2004), which combines the dynamic diagonal marks of the splash in the foreground with a delicately drawn head in profile in the background, in appearance somewhere between an ancient Japanese warrior and a Scandinavian chieftain, his hair flowing in the opposite diagonal to the splash. Other prints include *Ra-Shin-Ban* and *Kazami-Dori*, both of which incorporate the artist's accomplished portrait heads enclosed within structures that are reminiscent of Samurai armour and yet belong elsewhere.

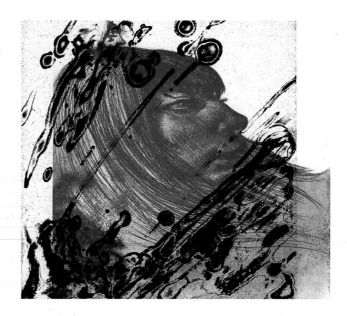

Splash Etching; 14.5 x 16.5 cm (5¾ in. x 6½ in.); 2004

RIGHT *Ra-Shin-Ban* Etching, aquatint; 56 x 90 cm (1 ft. 10 in. 2 ft. 11½ in.); 2004 (*Ra-Shin-Ban* = a mariner's compass)

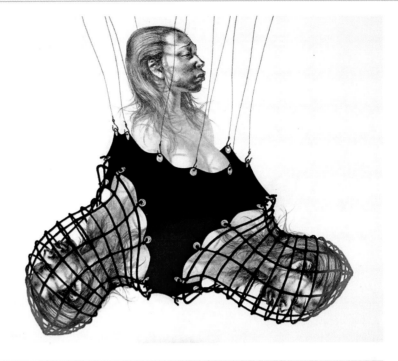

BELOW *Kazami-Dori* Etching, aquatint; 23 x 25 cm (9 x 10¾ in.); 2004 (*Kazami-Dori* = a weathercock)

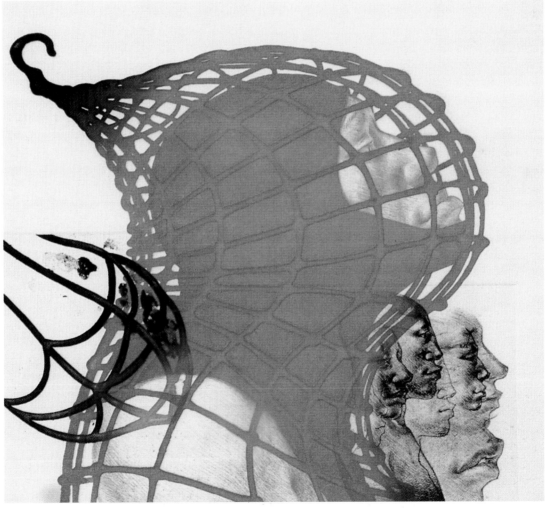

14. FURTHER

THE FUTURE WILL BE A DIFFERENT COUNTRY

FIFTY YEARS AGO a speculative vision of the future – at least in the way it was illustrated in the comic strip 'Dan Dare – Pilot of the Future' in *The Eagle* – included interplanetary travel, green humanoids from Venus and Digby, Dan Dare's batman from Wigan, a town of mixed repute in the North of England. Their adventures were peppered with dialogue that stemmed from the jovial jargon of the Royal Air Force during the Second World War, but the scientific advances portrayed had little more than a passing connection to the real emerging technology of the Cold War and the Space Race. The conflicts of the post-Second World War era have become increasingly technological: from the helicopter gunships of Vietnam some 30-odd years ago we have 'progressed' to being able to destroy Baghdad by remote control during the war on Iraq in 2003/4. By the time the first dawn of the new millennium fell on the islands of the mid-Pacific our visions of the future had become increasingly dystopian, as shown in films such as *Blade Runner* and the *Terminator* series, and in novels such as *The Handmaid's Tale* by Margaret Atwood.

There seems to be an increasing obsession among the public with what the future might hold, while at the same time it is becoming increasingly difficult, if not impossible, to predict with any accuracy the future shape of society. In the meantime world events, piped into our homes by a flickering barrage of 24-hour television, have become ever more extreme in their impact on our lives. Little wonder perhaps that, as a retreat from harsh reality, so much of the cultural output of the entertainment industry is derived from fantasy, as in *The Lord of the Rings* trilogy or the Harry Potter films; or the wild imagination and increasing sophistication of computer animation, such as can be seen in *Shrek* and *Belleville Rendezvous*; or in the extreme stylisations of Manga comics and graphic novels. Otherwise in its efforts to keep us amused the entertainment industry is turning to the increasingly numerous and increasingly desperate (and depressing) formats of so-called reality-television and makeover shows. Whether such shows are devised to meet public expectations or to create them is entirely another matter. Taken together with a growing public interest in virtual worlds, it would seem as if the entertainment experience that drives many people's lives is becoming more and more distant from what used to be called reality. This is perhaps nothing new. T.S. Eliot wrote with acute perception in 'Burnt Norton', from *Four Quartets* (first published in 1944), 'human kind/Cannot bear very much reality'. Sixty years after the end of the Second World War this observation seems even more perceptive.

The place for artists within an increasingly complex society is itself complex. Whether art can provide a panacea for the accelerating drift away from reality or whether it will be subsumed into it cannot be guessed at with any accuracy, but it is to be hoped that among the art-loving public at least there might be something of a shift of attention towards art that connects with the real world. As can be seen from the artists featured in this book, the ways in which printmaking can be used as a medium are extremely varied. Not all the large number of artists encountered during the research could be included, and it is also certain that only the tip of a very large iceberg of creative activity has been explored. That in itself is a good reason to remain optimistic about the status of print techniques in the future, because the enthusiastic energy of the international printmaking community is palpable.

The role of the visual arts in our developing world society will continue to be an important one, providing an outlet (as always) for the artists' hopes and fears, their dreams, admiration and anger. It may well be that the role of the visual arts as a provider of something decorative to hang on a wall is becoming more

limited, although it is probably not yet at the point of terminal decline. The competing demands and attractions of technology are having their effect: for example, the increasing availability of large plasma-screen televisions and media projectors, together with surround-sound systems, allow living rooms to become cinemas, in which having a picture to hang on the wall has become less of a priority. In the public sphere galleries are showing increasingly large installations that bear little or no resemblance to a framed picture, as demonstrated by the popularity of the large-scale works shown in the massive Turbine Hall of Tate Modern in London, indicative of an increasing appetite for art that is 'something other': big, bold, dramatic and perhaps even thought-provoking. Beyond this – and it's a part of urban life that cannot be ignored – the increasing sophistication of text and image media, whether in printed form or as web graphics, is raising the bar of public expectations ever higher. In turn all these effects are providing students and artists with a widening spectrum of challenges and opportunities, and also driving the development of new and highly sophisticated courses designed to meet current and predicted future demand.

ON THE HORNS OF A DILEMMA

The dilemma faced by the dedicated artist is more acute than ever.

On the one hand (or horn), there is still a secure place for traditional forms of printmaking within the world of the visual arts – and it is to be hoped that this will continue to be the case. Indeed, there are students who discover during their printmaking courses the fascination of techniques such as mezzotint and engraving, and who strive towards high levels of attainment in these forms. Such techniques have served the creative imagination well for centuries and they are equally capable of serving the imaginations of students and artists in the future. There is still a strong market for traditional-medium prints, one that even has the potential to expand; so for the time being the future of works in such mediums, the artists who use them, and those that collect them, seems assured.

On the other hand (or horn), the opportunities and challenges offered by digital-printmaking mediums have an allure that many students find irresistible, especially as the technology is readily (and increasingly cheaply) available for use in domestic as well as in traditional studio situations. Accessibility and affordability are allowing increasing numbers of people to explore the creation of their own digital images, and this growth is unlikely to diminish. In addition, the suitability of digital techniques for producing images for display and sale on the Internet has created a short cut past the traditional gallery setting for displaying and selling prints. The dilemma that faces students and artists comes in deciding which techniques to pursue, or whether it is possible to follow both paths in parallel without one of them compromising the other. In a challenging and increasingly global market such decisions are not necessarily easy, and neither are they straightforward.

There is perhaps a solution. Minoan art depicts the young Cretans leaping over the back of a charging bull by grasping its horns, thereby challenging the symbolic might of the establishment. By combining the use of traditional and digital techniques, some artists may find that they too can grasp the horns of the dilemma and vault into a new situation in which the power of the contemporary establishment can be challenged. The key to this is to accept that digital imaging is just another technique and not the irritating and subversive influence on traditional printmaking that it was once feared to be. The argument that digital prints do not last because of the fugitive nature of the inks no longer applies. Archival materials are now available, with increasing potential longevity that rivals and even promises to exceed the longevity of traditional materials. Besides which, in a time of growing uncertainty the idea of long-term durability has decreasing importance for some artists. There is a view, perhaps that of a minority, that there is no good reason why prints should not be considered to be as disposable and replaceable as fashion, music formats and indeed the technological hardware that underpins much of modern life, all of which are subject to planned obsolescence. Perhaps then the solution to the dilemma is to reduce it to a simple matter of choice – either or both: it matters little provided that the best possible results are the goal.

THE FINGER POINTING THE WAY

So where is all this leading? It is clear, as it is hoped that this book demonstrates, that printmaking has earned its rightful place within the contemporary visual arts. It is also significant that many of the individuals represented consider themselves to be artists who use printmaking as part of their practice, and not primarily to be printmakers in the purist sense of the word. To take this distinction further, the making of art, in whatever form, is just a part of what they do as human beings, using art to articulate their concerns for society, the environment or whatever other issues worry them. This distinction brings them a different set of possibilities from those that were available to (or chosen by) most artists in the mid-20th century, in which the self-perception of being 'an artist' (defined within relatively narrow terms), and the need for this to be recognised by others, was the predominant driving force.

Ever since, perhaps even before, the distant time in the past when our ancestors scratched images into stone or painted them on the walls of deep caves there has been an undeniable and irresistible urge to leave a mark, to communicate an emotion or a desire, or to make work that expresses something of what it means to be human and to share this with others. The evidence of the long chronicle of recorded images that has survived as witness to the past gives reason for optimism. Provided that artists continue to make the best use they can of whatever mediums they use in order to create works of art that communicate their ideas with integrity, then there is little cause to fear that the human spirit might not survive.

Printmakers have for many years included artists who choose printmaking as the medium of communication because of its ability to reach out directly; this factor is unlikely to diminish, and there are good reasons to suppose that it might well increase in importance. The world we live in, the same world where artists make their work, has problems to which there are no easy solutions, and it is inevitable that there will be even greater challenges and conflicts in the future. It is conceivable that artists in the past may well have considered the problem of the relationship of their art to the known world, and they may well have reached similar conclusions. However, our advantage over them is the undeniable speed of international communications, which enables ideas and information to be shared almost instantaneously; besides this, we already know far more about each other than our ancestors did. Consider for example how news and images of the tsunami disaster of 26th December 2004 and its effect on remote and hitherto-little-known communities around the Indian Ocean spread out into the international community, resulting in an unprecedented outpouring of shared grief and sympathy and an in-pouring of donations to aid agencies on an unparalleled scale. Without 24-hour satellite news channels and the mobilising power of the Internet the response might well have been less, and it would certainly have been slower. The arts, if they are to survive and remain valid, need to acknowledge their existence in a world where events such as these will continue to happen, for which solutions must be found.

The moving edge at which the contemporary arts can be found will always be a provocative place. Some of what is produced at the edge may not survive for long, but some will become part of the repository of masterpieces of the visual arts by which future enquirers may measure how far they have travelled. Whatever unpredictable and unforeseeable place they will have reached, it is hoped that they will at least recognise, as do the artists at the edges revealed in this book, that it is indeed better to travel hopefully than to arrive, and that the edge is always somewhere further ...

WEBSITE REFERENCES

Modhir Ahmed
http://www.modhirahmed.com

Cecilia Bakker
http://www.winkapress.com

Lisa Bulawsky
http://www.blindspotgalleries.com

Chila Kumari Burman
http://www.amoment2herself.com

Alicia Candiani
http://www.aliciacandiani.com.ar

Wayne Eastcott
http://ballardlederergallery.com

Marjan Eggermont
http://www.herringerkissgallery.com/meggermont.html

Jim Gislason
http://ballardlederergallery.com

Hammerpress
http://hammerpress.net
http://seexyz.com/index.html

Hanna Haska
http://sitm.pl

Valgerður Hauksdóttir
http://www.hauksdottir.is

John Hitchcock
http://website.education.wisc.edu/hitchcock/index.html

Naoji Ishiyama
http://www2.odn.ne.jp/-ceq83450/english.htm

Davida Kidd
http://www.davidakidd.com

Konstantin Khudyakov
http://www.khudyakov.ru/default.htm

Koichi Kiyono
http://yuriko_mi.tripod.com/Printsaurus/suzuka/artist/
Kiyono/index-Kiyono.html/

Dorothy Simpson Krause
http://dotkrause.com

Monika Lozinska-Lee
http://www.monikalozinskalee.com

Beauvais Lyons
http://web.utk.edu/-blyons

Hugh Merrill
http://www.hughmerrill.com
http://www.chameleon.ayd.org/index1.html

Maria Anna Parolin
http://www.mariaannaparolin.com/index.htm
http://artist.banff.org/parolin

Aine Scannell
http://www.absolutearts.com/portfolios/a/ainescannell

Michael Schneider
http://www.michael-schneider.info

Slop Art
http://www.slopart.com

Michiko Suzuki
http://www.rakunen.co.jp/gallery219/519426/573348

Kestutis Vasiliunas
http://www.arts.lt/1artists/mlv/glc1/htm

Patricia Villalobos Echeverría
http://www.arts/iup/edu/facar/pve

Daryl Vocat
http://www.darylvocat.com

Pete Williams
http://members.tripod.com/-printmkt

Yuan Goang-Ming
http://techart.tnua.edu.tw/-gmyuan

Falun Print Workshop
http://www.fkv.nu/bott.html

Jyväskylä Centre for Printmaking
http://www.jyvaskyla.fi/taidemuseo/grafikkakeskus/
english.htm

Kraków International Print Triennale
http://www.triennial.cracow.pl/mtg_krakow

INDEX

Other Printmaking Books by A&C Black

by Brenda Hartill and
Richard Clarke
0 7136 6396 0 • £14.99

by David Barker
0 7136 6409 6 • £14.99

by Rosemary Simmons
0 7136 6847 4 • £16.99

by Steve Hoskins
0 7136 6341 3 • £14.99

by Colin Gale
0 7136 6702 8 • £14.99

by Rebecca Salter
0 7136 6517 3 • £30.00
Publication date: June 2006

Forthcoming titles include:
Papermaking for Printmakers
by Elspeth Lamb
0 7136 6587 4 • £14.99
Publication date: May 2006

For full details, more titles
and special offers visit
www.acblack.com

2nd edition: by Jane Stobart
0 7136 7463 6 • £14.99

by Sarah Bodman
0 7136 6509 2 • £14.99